# IN SEARCH OF
# AFRICAN AMERICAN SPACE

# IN SEARCH OF AFRICAN AMERICAN SPACE

## REDRESSING RACISM

Edited by
Jeffrey Hogrefe
Scott Ruff
with
Carrie Eastman
Ashley Simone

Lars Müller Publishers

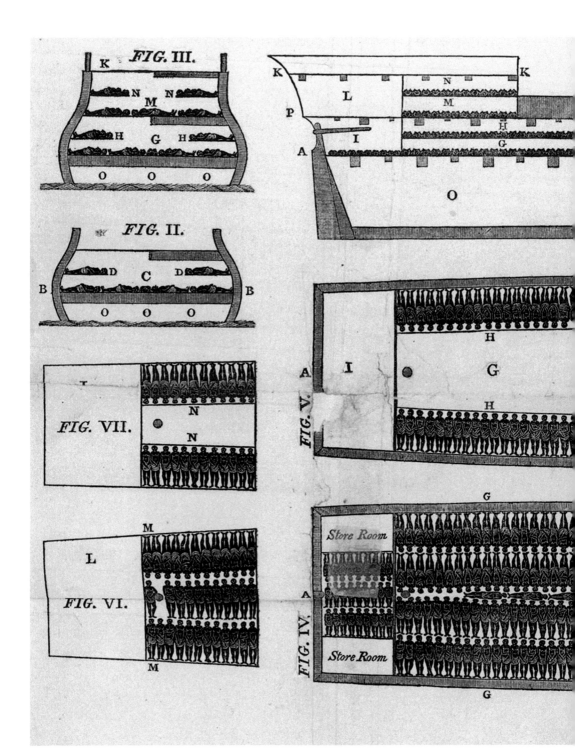

6

FIG. I.

1 Drawing of the *Brookes* slave ship by Thomas Clarkson, 1808

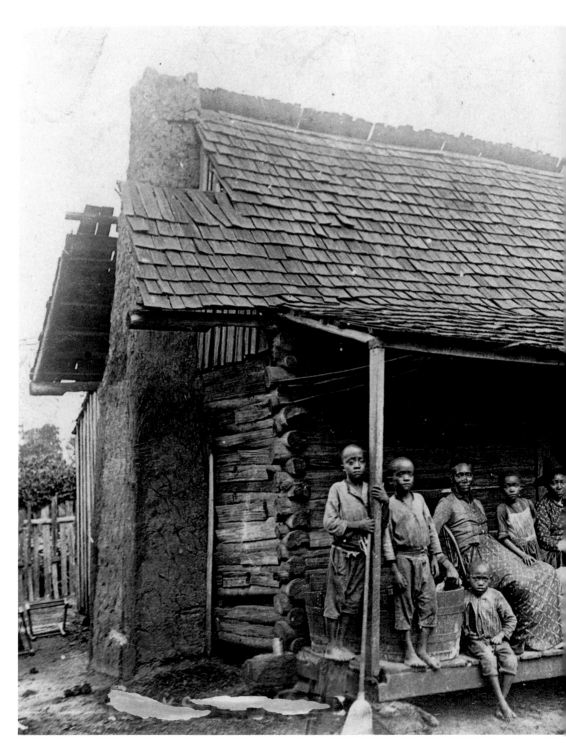

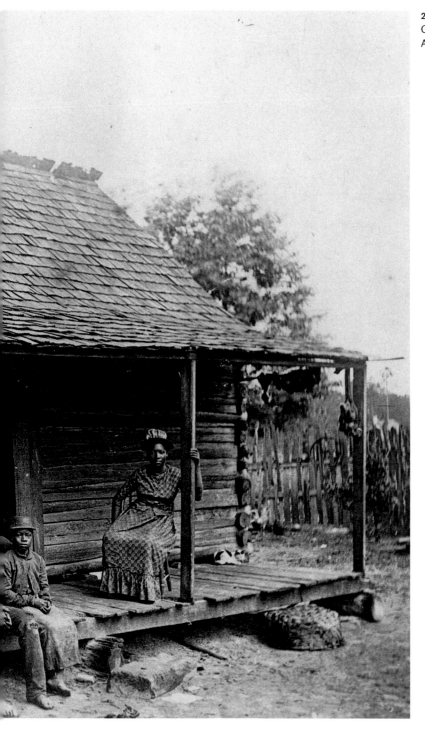

**2** A slave cabin in Barbour County near Eufaula, Alabama, ca. 1936–1938

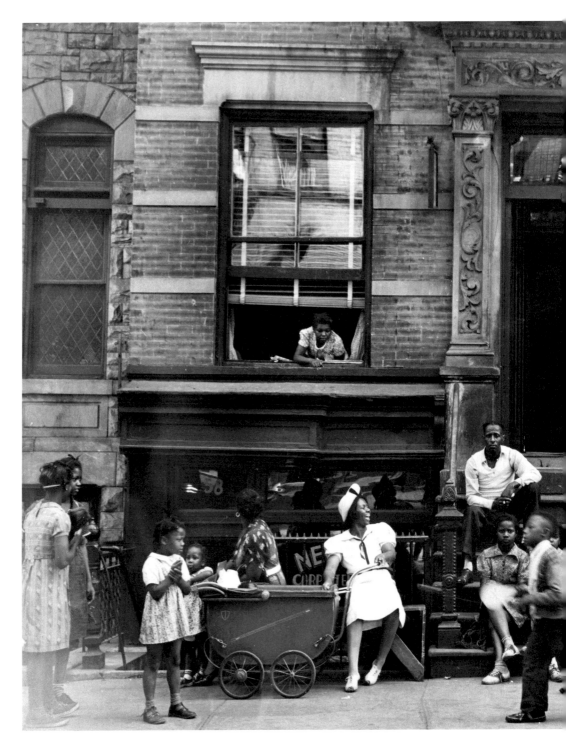

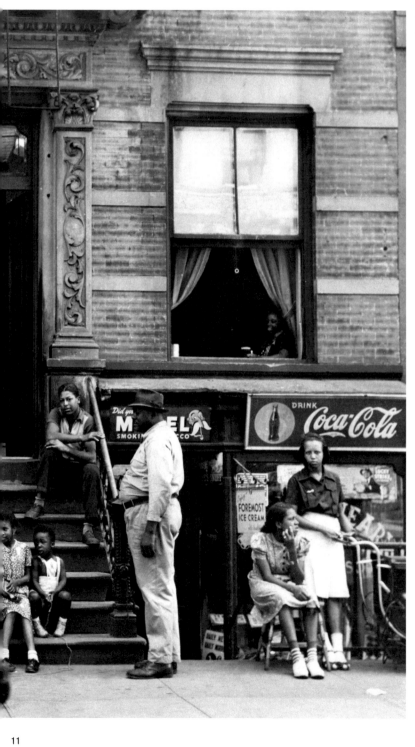

**3** *Harlem Tenement Stoop,*
Sid Grossman, 1939

# CONSTELLATIONS OF FREEDOM: ASSEMBLY, REFLECTION, AND REPOSE

Tina M. Campt

What is African American space? It is a concept perhaps best understood in its simplest incarnation as environments that allow Black communities to thrive. They are spaces that remedy centuries of precarity and enclosure, which have limited the capacity for our people to realize their potential to live unbounded lives. They are spaces that refuse cultural, political, or economic circumstances that diminish, degrade, dehumanize, and destroy Black life. The creation of African American space is, at its core, a practice of refusal.

A practice is an unfinished or ongoing process. It designates a durational temporality that functions as a process of preparation. Practice is also fundamentally social in nature, as it forms a core role in the formation of subjectivity. More specifically, in this case, it is the social process of preparation required to enact new ways of inhabiting freedom. Practice is, in this way, a form of prefiguration; it enacts new forms of Black sociality by allowing us to live the future we want to see, not at a distant point of time to come, but here and now in the present.

Extending this understanding of practice, practicing refusal is both temporal and spatial. It is choosing to live differently as a way of realizing a different kind of community. It is a practice that requires a reconfiguration of spatial relations that enable us to move beyond existing social and spatial constraints. To practice refusal is choosing to live otherwise.

Designer and scholar Mabel Wilson emphasizes that practicing refusal is the choice to do otherwise (not be a domestic, be a factory worker, be a wage earner, be a criminal, be respectable). It is also the choice to be elsewhere (to not work in someone else's home, in the factory, in a job, to be imprisoned, in public housing—but to claim the hallway, the stoop, the kitchen, the

library, the dance floor, and the imagination).[1] Practicing refusal is not a question of heroic or revolutionary acts, nor necessarily mass or organized social movements. It is most frequently a quiet constellation of everyday practices of disorder and rebellion, and furtive acts of pleasure and joy that unfold in quotidian spaces.[2]

As I have argued elsewhere,[3] the practice of refusal rejects the status quo as unlivable and refuses to recognize a social order that renders Black people worthless and expendable. It is a refusal to embrace the terms of diminished subjecthood with which we are presented and utilizing negation as a generative and creative source of disorderly power that allows us to embrace the possibility of living otherwise. The practice of refusal is also a space-making intervention—one that reclaims and embraces the space of the quotidian to create new possibilities in the face of negation.

As a feminist theorist of visual culture, I find profound insights into the practice of refusal that constitutes the long history of African American spatial reclamation in the collaborations of Black artists and writers whose work demonstrates the absence of a singular understanding of what African American space is, and simultaneously testifies to how African Americans actively reshape their spatial arrangements in ways that refuse the strictures of race, class, gender, and generation. Among the multiplicity of these evocative visualizations of African American space, one strikes me as a particularly revealing site of Black refusal and quotidian reclamation: the kitchen. Viewed through the creative frameworks of some of the nation's foremost Black photographers, writers, and thinkers, how do we see this space and how do we encounter it differently?

Published at the height of the Great Depression, Richard Wright's powerful image-text *Twelve Million Black Voices* (1941) creates a striking voice-over for a selection of the now-iconic photographs produced by a team of some of the nation's preeminent photographers commissioned through the Farm Security Act (FSA), created as part of the FDR's Works Progress Administration (WPA) to document the lives of those the program assisted. In the narrative

1 Mabel O. Wilson, personal correspondence with the author.
2 See also Saidiya Hartman, *Wayward Lives, Beautiful Experiments: Intimate Histories of Social Upheavals* (New York: W. W. Norton & Company, 2019, 20–24.
3 Tina Campt, "The Visual Frequency of Black Life: Love, Labor, and the Practice of Refusal," *Social Text* 37, no. 3 (September 2019): 25–46.

he weaves, Wright repeatedly cites the kitchen as a dangerous space of intergenerational enclosure for African Americans. His account reveals the kitchen as a foundational space of captivity for enslaved Black women whose toil carved out a template for domestic servitude that telegraphed forward in time to entrap Black women after emancipation in low-wage and often abusive labor in middle-class white households.

A different incarnation of the kitchen emerges later in Wright's narrative of the Great Migration, where it becomes a vehicle of reenclosure that ensnared Black families seeking a better future in the North. The "kitchenette" (the converted one-room apartment with a small gas stove and sink in which whole families made their lives within the four walls of a glorified kitchen) was rented at extortive rates by white property owners to Black Americans arriving in droves to urban centers. Expanding access to a single kitchen to a larger group of people in a tiny domicile, it reinserted Black families into a new cycle of capitalist exploitation and urban ghettoization by allowing more to inhabit less space, while maximizing the profit of what Wright acidly parodied as the "Bosses of Buildings."

Wright's revoicing of the FSA's photographic archive presents a devastating assessment of the historical arc of hardship and suffering of Black Americans that culminated in the Great Migration. The strains, stresses, and strictures of urban dwellings that forced multiple families and tenants to share the degraded domicile that was the woeful kitchenette recreated the conditions of enclosure they hoped to leave behind. It was these conditions of enclosure that, in Wright's eyes, transformed the domestic spaces Black families came to inhabit in the North from places of intimacy, privacy and safety into spaces of conflict, violence, and despair.

It was this inversion of the meaning of Black domestic space that propelled Black Americans in new urban centers to seek pleasure, comfort, and intimacy elsewhere—in public spaces like the stoop, the street corner, or the club. Yet it was an inversion that must also be understood as a creative practice of refusal that allowed

African Americans to inhabit these spaces in ways that created them anew. The reclamation of Black urban space eventually became the photographic domain of the only Black photographer hired by the FSA, Gordon Parks, who, seven years after the publication of *Twelve Million Black Voices*, joined forces with literary giant Ralph Ellison in 1948 to produce a photographic accompaniment to Ellison's essay "Harlem Is Nowhere" and later in 1952 for "A Man Becomes Visible" (a body of work published posthumously in 2016 as part of the catalogue for the exhibition of the same title, *Invisible Man: Gordon Parks and Ralph Ellison in Harlem*).[4]

The images Parks produced for each of these projects capture African Americans reclaiming the streets, stoops, alleys, and squares of his beloved Harlem and transforming them into dual sites of conflict and community, protest and repose, violence and regeneration. He documented African Americans claiming public space to forge different modes of assembly that constituted a defiant practice of refusal to capitulate to the logics of enclosure that sought to regulate Black movement, aspiration, and imagination.

In Parks's photographs, we see street tussles alongside images of children frolicking in or exploring the gritty terrain of the urban cityscape. We see a soapbox orator holding forth on a step-ladder for a throng of listeners; we encounter him later encircled by a huddle of Black men seemingly transfixed by his words; and we encounter him again continuing his oratory displaying a broadsheet with an illustration entitled "Black Picture of Christ." These images feature informal street assemblies alongside images of solitary children and elderly women claiming the street for reflection and repose. While Wright depicted the streets as menacing spaces that imperiled Black life, Parks allowed us to see not just the peril, but also the possibilities of urban streets as spaces of Black affirmation.

Where Parks reclaimed African American space lived in the public sphere, Roy DeCarava and Langston Hughes's soulful image text

4 *Invisible Man: Gordon Parks and Ralph Ellison in Harlem*, Steidl/The Gordon Parks Foundation/The Art Institute of Chicago, 2016.

*Sweet Flypaper of Life* (1995) returns to the kitchen as a site of Black joy, intimacy, and care. DeCarava's masterful photographic chiaroscuro harmonized with Hughes's ventriloquism of the fictional matriarch Sister Mary Bradley, through whose eyes we view Harlem as an ever-expanding network of family, neighbors, and friends. Their conduit of connection is not only the streets, buses, and subways that transport them through the city and their neighborhood. Hughes's narrative zooms in to linger poignantly on the intimate connections imaged by DeCarava's photographs of the kitchen.

Framed by the loving gaze of Sister Mary, the kitchen unfolds as a multidimensional space, not simply for the domestic labor of preparing family meals. It is a space where neighbors, partners, and kin of all ages cycle into and out of each other's daily lives. It is a space where hair is braided and books are read; a space where drinks are made and music is played. It is the space for Friday night parties filled with slow drags and fast boogies, whoops and howls of laughter, gossip and trash-talking and long embraces. It is a space of nurturing and care, a space of joy and affection, a space of rest and respite.

The kitchen is a space reclaimed with equal force in Carrie Mae Weems's *Kitchen Table Series* (1990)—a work in which she transforms the kitchen into a space of Black feminist agency. Absent from both the images and the text panels that construct this multilayered account of a Black woman's journey to self-realization are the basic accoutrements of the kitchen itself. No sink, no stove, no counter, no refrigerator—the focus of our attention is on the table itself and the evolving cast of figures who move in and out of the frame with Weems. The exposed lightbulb that dangles above the table illuminates the artist's insistence that the kitchen table is not always the vehicle of Black women's subjection. Echoing the kitchen's status in *Sweet Flypaper of Life*, Weems's *Kitchen Table Series* foregrounds women's ability to refuse domestic enclosure and refashion it into a space of pleasure, desire, and intention.

The appliances that mark this space as a site of women's domestic labor are replaced by ritual practices that signify a complex web of relationships forged in and through this distinctive African American space. Playing cards with a companion or a solo game of solitaire; putting on makeup or having your hair curled by a friend; gazing into the eyes of a lover over a meal; mother and daughter reading or doing homework. The kitchen is a space where lovers caress and cohere or where girlfriends counsel and console. It is the space where mothers and daughters stand off and regroup, and a space where a Black woman regains her sense of self, solitude, and strength when relationships go awry. As both author and protagonist of her own story, Weems inhabits the kitchen through a table she commands. It signifies not as a space of domestication, but one of self-making, becoming, and empowerment. Refusing to be captured in the domestic role so often attributed to the kitchen, she uses it as a vehicle to image herself as a subject in her own right, and in doing so reclaims and reimagines the space itself.

The image texts created by Black artists and writers offer us complex insights into the multifaceted nature of African American spaces. They show us that African American space is more than the built environment—it is how such spaces are lived in practice. The social utilization of space among Black Americans finds deep and compelling expression in the still and moving images, drawings, collages, and paintings created by Black artists, and in the eloquent words of Black poets and writers. It demonstrates that the through line of African American space for writers and artists, as well as architects, planners and Black communities across the U.S. is, at its core, a project of visualization—one that deploys a sophisticated spatial imaginary that refuses the precarity of Black life by reclaiming quotidian spaces as generative sites of creativity and possibility.

## Note on Grammatical Style

In "Mama's Baby, Papa's Maybe: An American Grammar Book," Hortense Spillers reveals how grammar can be an act of liberation.[1] Spiller's discourse and the cultural determinacy of language were considered when defining the grammatical style conventions for this volume.

The B in "Black persons" is capitalized to distinguish a category emerging in cultural studies. While "white persons" may have been treated with a similar capitalization convention for consistency, it is assumed that "white persons" are not a distinct cultural category with clearly defined boundaries.

"Slave" is used as an adjective, as in "slave quarters," but is not employed as a noun. Following this convention, "enslaved person" replaces "slave" to honor the personhood of the "slave," who had been reduced to fungible material by the semiotics of the word.

The term "runaway slave," commonly used in ads seeking the retrieval of enslaved persons by the masters they escaped, was replaced with "self-emancipated person," in order to privilege the perspective of self-emancipated persons and not that of slaveholders.

"Slave plantation" is used in place of "plantation" to highlight the historical role of plantations as slave labor camps that served to imprison Black people.

Quotation marks are used in "urban ghetto/slum" to set it apart as a condition instead of a place.

1 Hortense Spillers, "Mama's Baby, Papa's Maybe: An American Grammar Book," *Diacritics* 17, no. 2 (1987): 65–81.

# RHIZOMATIC EXCERPTS
Scott Ruff

This anthology is a record of difficult personal experiences that
have been transformed through creative processes. Each
contributor addresses social, cultural, and/or spatial erasures that
are associated with the afterlife of slavery and become media or
motivation for practices that aim to recover and reveal suppressed
histories. Each contribution, therefore, can be registered as
a cultural catharsis extending from the individual to the collective.
To this end, the varied approaches operate in a manner analogous
to a rhizome, an enmeshed root system that spreads in the
ground and the air and moves in contrast to the obdurate rooted-
ness of colonial empires that take over everything.[1] In lieu of
subverting established order, the rhizome tactically intertwines
with what it meets, forming new relationships and networks.
In the realm of ideation and creative practice, the implication of
rhizomatic thinking is a network of original theories that are related
but not derivative of each other.

The anthology provides one of many entrances to a network
of theories and practices that defy a singular formulation of
African American space. The understanding of African American
Space herein is suggested by the engagement of aesthetics
and politics, and through relationships that generate new forms of
knowledge. When taken together, these new formations serve
to advance the redress of racism through the register of acts that
may be characterized by sublime beauty and love.

1 The operation of the rhizome as
an analogue for social and political
systems that exist outside of the
state was appropriated for the
Black radical tradition by Édouard
Glissant in "The Poetics of Rela-
tion," trans. J. Michael Dash, in
*Caribbean Discourses: Selected
Essays* (Charlottesville: University
of Virginia Press, 1989), 71.

# SPACES OF REFUGE AND DELIGHT

Jeffrey Hogrefe

*We live in a housing project. It hasn't been up long. A few days after it was up it seemed uninhabitably new, now, of course, it's already rundown. It looks like a parody of the good, clean, faceless life—God knows the people who live in it do their best to make it a parody. The beat-looking grass lying around isn't enough to make their lives green, the hedges will never hold out the streets, and they know it. The big windows fool no one, they aren't big enough to make space out of no space.*

–James Baldwin, "Sonny's Blues" (1957)

If African American experience emerges from the structure of slavery, how does architecture relate to that experience? Furthermore, how can the African American person respond to an architectural tradition which fortifies the state?[1] We ask these questions at a time of escalating state violence toward Black people, simultaneous with an emerging Black aesthetics which posits Blackness as essential to the politics of transformation. In American architecture, this has resulted in projects including, for example, the National Museum of African American History and Culture (NMAAHC) in Washington, DC. Its location on the National Mall, in the center of the U.S. capital, reinforces James Baldwin's prescient observation from the middle of the twentieth century that the African American has informed the American in ways that are indelible.[2]

For the most part, American architecture has served to regulate, survey, punish, and even erase the Black person, which is why the African American experience of space has remained outside the study and practice of the discipline until very recently. This is remarkable considering that slavery, a key material practice in the European colonization of the Western Hemisphere, was carried out in the carceral spaces of the slave ship, the slave plantation cabin, and the urban "slum/ghetto." African Americans have fashioned other uses and meanings from these typologies

I am grateful to Ashley Simone, Carrie Eastman, Kari Rittenbach, Ann Holder, Marisa Williamson, Onaje Muid, and Scott Ruff for their comments on various drafts of this chapter and their appreciation for the nuances of the discourse.

1 Vitruvius, *The Ten Books on Architecture,* trans. M. H. Morgan (New York: Dover Press, 1960). While Vitruvius's directives in Book Five may seem to refer to the concerns of an earlier period in history, the much more recent expansion of public housing, the "school to prison pipeline" and prison-industrial complex (the latter resulting from the war on drugs), and neighborhood gentrification today challenge architecture to examine its ongoing role in fortifying the state.

2 "The time has come to realize that this interracial drama played out on the American continent has not only created a new black man, it has created a new white man, too… This [American] world is white no longer and it will never be white again." James Baldwin, "Stranger in a Village," in *James Baldwin Collected Essays* (New York: The Library of America, [*Notes of a Native Son* 1955], 1998), 129.

by appropriating spaces of resistance, through the work of "mak[ing] space out of no space."[3] The term "African American" itself highlights the role of the Americas in the institution of slavery and in the creation of a transnational spatial culture informed by ideological concepts of both Africa and the United States.

African American space, therefore, is a creative and aspirational *interpretation* of space. It is fleeting; informed by cultural dynamics that are reproduced in real time, and subject to erasure as it is being made. It is articulated through speech that is performed. Its contours linger in memory or are marked negatively by fractured space.[4] The direct experience of architecture was, paradoxically, significantly greater during the period when enslaved people designed and built the structures of slavery in the Americas.[5] Recent architectural scholarship has privileged the role that Black people played in constructing those systems, and indeed in the later development of modern architecture.[6] While acknowledging these important historical studies, *In Search of African American Space* instead focuses on the spaces of refuge and delight that have been appropriated in the afterlife of slavery, which the writer and academic Saidiya Hartman has characterized as a "still unfolding narrative of captivity, dispossession, and domination that engenders the Black subject in the Americas."[7] This anthology compiles essays from contemporary architects, historians, and artists engaged with this form of space-making. Space is considered here both in terms of architecture, or designed form; and performance, or everyday practices in real time; as well as how these elements come together and overlap.

The first African enslaved persons were captured and transported to North America in 1619. In 1865 the Thirteenth Amendment of the U.S. Constitution outlawed slavery except in the case of incarceration. This clear dividing line between slavery and freedom, at which point four million persons were granted political agency, of course cannot account for the general exclusion of Africans from the European philosophical traditions that preceded and coincided with more than two centuries of enslavement in the New World, or the restrictive codes and laws enacted in the U.S. after

3 On spaces of resistance, see Bradford Grant, "Accommodation, Resistance, and Appropriation in African American Building," in *Sites of Memory: Perspectives on Architecture and Race,* ed. Craig E. Barton (New York: Princeton Architectural Press, 2001), 109–18.
4 Henri Lefebvre, *The Production of Space* [1974], trans. Donald Nicholson-Smith (Oxford: Blackwell Publishing, 1991), 222.
5 Grant, "Accommodation, Resistance, and Appropriation," 109 (see note 3).
6 On African American subjectivity in European American architecture, see Mario Gooden, *Dark Space: Architecture, Representation, Black Identity* (New York: Columbia University Press, 2015).
7 Saidiya Hartman, *Scenes of Subjection: Terror, Slavery, and Self-Making in Nineteenth-Century America* (New York: Oxford University Press, 1997), 75.

emancipation which ensured segregation. Nor does it take into account the lynching and general mob violence that led to the Great Migration of Blacks from the South to Northern industrial cities in the early twentieth century, nor the "slum clearance" that destroyed countless neighborhoods under the mantle of urban renewal and redevelopment during the middle of the twentieth century, nor the current wave of gentrification that continues to displace African American communities today.

African American studies scholars contend that the passage from slavery to freedom does not begin in legal structures that convey partial citizenship. Rather, freedom develops through both historical and contemporary processes of self-making and by appropriating spaces of resistance in which to anticipate future liberty and self-possession. Despite near constant surveillance, enslaved Africans gathered covertly to practice freedom in "hush harbors" at the fringes of slave plantations, in the oral traditions of praise meetings, and through quilting parties and juba dances that marked celebratory occasions. In undertaking such activities, enslaved persons adapted the phrasing of their masters by sardonically announcing that they were "stealing away"—since they did not legally possess their own bodies.[8] The first order of appropriation enacted in this practice of freedom, and the collective sharing of an informal geography that encouraged escape from slavery, each demonstrate the complex ways in which space could be remade even in captivity.

Hartman's groundbreaking study of racial subjugation during slavery and its aftermath is the result of close readings—against the grain—of oral history interviews with formerly enslaved persons conducted by the Works Progress Administration in the 1930s. In *Scenes of Subjection* (1997), she also draws on Henri Lefebvre's *Production of Space* (1974) to show that despite the terrifying conditions of slavery and its aftermath, the everyday practices of enslaved persons led to various forms of self-presentation that had been "ontologically ruptured" at the moment of enslavement: "The concern is not to recover the past but to underscore the loss inscribed in the social body and embedded in forms of practice."[9]

8 See especially the chapter "Redressing the Pained Body: Toward a Theory of Practice," in ibid., 49–78. Hartman carefully defines the ways in which the enslaved person, both before and after emancipation, practiced what could be considered performances to attempt redress of the pained body.
9 Ibid., 75. See also Glissant, *Caribbean Discourses*, 62 (see note 1).

For Hartman, the appropriation of space "not only enabled needs and desires to be aired but implicitly addressed the relation of the history of violence and dislocation that produced the captive and the possibilities of redress."[10] Her nuanced studies of these practices of opposition lead her to conclude that "Practice is not simply a way of naming these efforts but rather a way of thinking about the character of resistance, of the precariousness of the assaults waged against domination, the fragmentary character of these efforts, the transient battles won, and the characteristics of a politics without a proper locus."[11]

*In Search of African American Space* locates this character of resistance in events inscribed in the social body and embedded in forms of practice in the afterlife of slavery, in works of history, architecture, and performance that are informed by Hartman's study to greater and lesser degrees. The interdisciplinary contributions to the anthology complement existing scholarship in African American studies with new forms of visuality, and also help to deconstruct a master narrative in the Western philosophical tradition that proposes a universal subjectivity supported by legal and political structures. *In Search of African American Space* finds the visuality of slavery and freedom in what and how we see and do not see, in vestibular enclosure, surveillance, and fortification, and in oceanic concepts of freedom and liberty; in Hortense J. Spillers's attempt to devise a new grammar for the rhetoric of the emerging African American subject;[12] in the cut, remembrance, and redress described by Hartman;[13] and in the slave ship's wake, Christina Sharpe's motif encompassing both living and dying— "being awake and, also, consciousness"—in the afterlife of slavery.[14] The promise and hope of this volume is to contribute to such ongoing "wake work."

*In Search of African American Space* began as a symposium, in May 2016, open to colleagues and friends in the historical African American neighborhood of Clinton Hill in Brooklyn, New York, as well as students enrolled in a studio conducted by Pratt Institute faculty member Frederick Biehle, which sought to design a monument, memorial, or museum for the Underground Railroad station

10  Hartman, *Scenes of Subjection,* 72 (see note 7). "The appropriated space of social collectivity, in accordance with Henri Lefebvre's definition of representational space, is 'redolent with imaginary and symbolic elements' that have their source in the violent history of the people."
11  Ibid., 51.
12  Hortense Spillers, "Mama's Baby, Papa's Maybe: An American Grammar Book," *Diacritics* 17, no. 2 (Summer 1987): 64–88. Spillers argues for a close reading of the text of slavery to locate new grammars through ongoing acts of writing against the grain. *Grammar* is used to mean rules of speech and writing and also rules of conduct.
13  Hartman, *Scenes of Subjection,* 65–66 (see note 7).
14  Christina Sharpe, *In the Wake: On Blackness and Being* (Durham, NC: Duke University Press, 2016), 21. "Wakes are processes; through them we think about the dead and about our relations to them; they are rituals through which we enact grief and memory. Wakes allow those among the living to mourn the passing of the dead through ritual; they are watching relatives and friends beside the body of the deceased from death to burial and the accompanying drinking, feasting, and other observances, a watched practiced as a religious observance. But wakes are also "the track left on the water's surface by a ship; the disturbance caused by a body swimming, or one that is moved, in water; the air currents behind a body in flight; a region of disturbed flow; in the line of sight (of an observed object) and (something) in the line of sight of (an observed object); and (something) in the line of recoil of (a gun)"; finally, wake means being awake and, also, consciousness."

at Plymouth Church in Brooklyn Heights. As the movement for Black Lives Matter reached the campus amid urgent calls for activism, Pratt faculty members Thom Donovan, Ann Holder, and Marisa Williamson seized that critical moment to gather together with Scott Ruff and myself for conversations on readings that had been shared informally in hallways and faculty offices while organizing the symposium. The urgency of thinking about African American space at that time was encouraged by Christina Sharpe, who had recently visited the campus to introduce the concept of "wake work" in a talk on the poet Phillis Wheatley, among the first enslaved persons to write poetry in English, who was named for the ship that brought her to the U.S. from Gambia.

Gathering in the afterlife of slavery, we read and discussed a range of texts and shared individual experiences in an effort that was thoroughly collaborative. As a matrilineal descendant of Shawnee people, abolitionists and a civil rights activist, I understand the work of theorizing African American space to have a political potential. We are all historically bound to the painful condition of slavery, a reality which can only be ameliorated through radical collective action, as John Brown once showed.[15] Each contributor to this anthology has added to our understanding of the ways in which African American space is enacted through appropriation, for purposes of refuge and delight. The discussions, talks, and exchanges that led to this volume took place outside of the official course curriculum, through the labors of love that are characteristic of Black studies. It is not merely academic or intellectual respect, but rather also the transformative power of love that makes it possible to continue participating in a discourse in which one is the subject of a painful history. As Toni Morrison once wrote, "Something that is loved is never lost."[16]

The anthology is organized thematically, presenting African American space in a broad cultural context. In part one, "Politics Without Proper Locus," historians Ann Holder and Radiclani Clytus contextualize the development of African American space in everyday practices that arose among enslaved persons in the antebellum period. Architect Scott Ruff contributes an examination

15 "It teaches me, further, to remember them that are in bonds, as bound with them." W. E. B. DuBois, *John Brown,* ed. David Roediger (New York: Oxford University Press, 2007), 156.
16 Toni Morrison, *Beloved* (New York: Random House, 1987), 234.

of the same era, which also identifies contemporary translations of its characteristic architectural typologies. The second part, "Materializing Memory," provides a glimpse of the practices of architects Rodney Leon, Elizabeth Kennedy, Sara Caples, and Everardo Jefferson, for whom typologies of the African Diaspora are significant in grappling with the complex task of memorialization. Architect and artist Yolande Daniels introduces the final section, "Recording Erasure," bridging the spatial practices of memorialization and artistic practices including her own as well as those of artists Walis Johnson and Marisa Williamson, which seek to acknowledge suppressed material, social, and political narratives in performances and installations. Conscious of spatial performances of opposition in relation to built architecture, each contributor to the anthology introduces their work on African American space through personal experience and dedication to practices that have mostly operated outside the academy.

In "The Terrain of Politics: Race, Space, and Vernacular Citizenship," Ann Holder traces the emergence of the African American subject in Antebellum Richmond, Virginia. She proposes the assumption of vernacular citizenship in "the illicit and subversive occupation of spaces, the overcoming of placelessness through mobility and collectivity, and the open practice of 'improper' politics." Urbanity afforded the African American subject space outside of architecture—the streets, alleys, and porches or vestibules of buildings— in-between places that allowed for layered social negotiation of visibility and invisibility. The performance of the emerging Black subject is the topic of Radiclani Clytus's essay, "Black Visuality in Antebellum New York." His analysis focuses on the newspaper accounts of William J. Wilson, who wrote as "Ethiop" from Brooklyn for *Frederick Douglass' Paper* (*FDP*) in the mid- to late-nineteenth century, and described independent constituents of a civic body "emboldened by the promise of democracy." Before photography, the American Anti-Slavery Society primarily controlled the representation of African American people, presenting them as either pitiable objects of persecution or comical objects of flamboyant excess—tropes that still linger in the media. In "Cultural Translations and Tropes of African American Space," Scott Ruff considers

an archaeology of the slave plantation that strips it back to its role as a forced labor camp as the most germane counterpoint to the design of the NMAAHC, which provides a "front porch" typology for African American people to appropriate a space for gathering.

Architect Rodney Leon describes the cultivation of his specific designs for public memorials and monuments by inventing new processes of mediation and logics of representation in "Diasporic Monuments and the Translation of Context." The primacy of African American experience in his approach echoes Spillers's observation on "the national treasury of rhetorical wealth" among African American subjects.[17] "African American space, like African American history," he writes, "must not be seen as separate from American and architectural history at large."

The search for African American space reveals the erasures that continue to obscure the history of African American people. The early nineteenth-century neighborhood of Weeksville, in the Crown Heights section of Brooklyn, was hidden for many years—its recent excavation and transformation into a memorial site are due to more than thirty years of community development. Landscape architect Elizabeth Kennedy and architects Sara Caples and Everardo Jefferson present their designs resulting from this grassroots restoration effort, which has inspired other communities to document and preserve material artifacts to counter forces of gentrification.

Yolande Daniels's reflections in "Embodied Silences: Three Meditations on Maps, Museums, and Monuments" arise from self-directed studies, focusing on material absences that she renders as "negative monuments." In one instance, the revealing spatial erasures she discovers in the official restoration of Casa dos Cantos, a museum dedicated to the Brazilian and Portuguese mining industry in Ouro Preto, Brazil, become a source for narrative poetry. Artist Walis Johnson writes about her performance work in "Walking the Geography of Racism," which she has conducted in Weeksville and in areas of Brooklyn that were redlined in maps produced by the Home Owners' Loan Corporation in 1938.

17 Spillers, "Mama's Baby, Papa's Maybe," 65 (see note 12). For an expression of the same sentiment, see also James Baldwin, "Stranger in a Village" (see note 2).

Marking areas of investment risk based on demographics, the maps reinforced the racialized economy of the U.S. that obstructed Black homeownership, which Johnson points out led to a reduction in municipal services, "urban blight," and later revolutionary action in the 1960s. Through literary fabulation, artist Marisa Williamson introduces a series of imagined performances as Sally Hemings, a woman enslaved by Thomas Jefferson who was also the mother of six of his children. The interpretation of interior life in "Seeking Sally Hemings," is based on the physical circumstances and material objects from her life in Monticello and Paris—floor plans, segregated quarters, décor, and period clothing—because no written records on her remain. Williamson retraces Hemings's steps, seeking to critically define a "space" of her own making; and raising questions about flight, liberation, and fugitivity.

In her book *In the Wake: On Blackness and Being* (2016), Christina Sharpe asks: "How do we memorialize an event that is still ongoing?"[18] The ongoing conditions of capture in the afterlife of slavery inform all of the presentations in this volume, which seek to identify African American space from multiple vantages. Collectively, these dedicated, often individual pursuits provide a catalog of methodologies with which to continue the search for African American space. Excavating the historical record and one's own personal experiences are only two means by which erasures, fragments, and traces of opposition can be studied in the afterlife of slavery.

This compendium of approaches to the aesthetics and politics of African American space in the afterlife of slavery registers catharsis and even hope at a time of renewed acts of violence and degradation toward people of color. What is revealed in the accounts are spaces of refuge and delight, which represent new and aspirational ways of becoming, appropriated from pain and suffering through acts of beauty and love carried out in the redress of racism. The scholarship and creative practices thus comprise insistent wake work. Compiled together here, their dimension and breadth defines new forms of knowledge, practice, and consciousness.

18 Sharpe, *In the Wake,* 20 (see note 14). "That is, if museums and memorials materialize a kind of reparation (repair) and enact their own pedagogies as they position visitors to have a particular experience or set of experiences about an event that is seen to be past, how does one memorialize chattel slavery and its afterlives, which are unfolding still? How do we memorialize an event that is still ongoing? Might we instead understand the absence of a National Slavery Museum in the United States as recognition of the ongoingness of the conditions of capture?"

# THE TERRAIN OF POLITICS: RACE, SPACE, AND VERNACULAR CITIZENSHIP

Ann S. Holder

For their close reading and critical engagement, I am indebted to Judith Smith, Adriana Green, Jade and Jesse McGleughlin, Rachel Kravetz, and Maria Baker. Thanks to Julia DiLaura and Ashley Simone for editorial suggestions, and to Kathleen Coll for her timely interventions. This research would not have been possible without the support of the Global South Center at Pratt Institute, my colleagues there, and director Macarena Gómez-Barris.

Contextualized by current debates on material commemoration in the South, Holder challenges the primacy of official records by presenting a history of the emerging African American subject in the nineteenth century. Elements critical to protest—space, movement, and self-representation—are foregrounded in an examination of what the writer and theorist Saidiya Hartman refers to as "performances of opposition," carried out by African Americans in the urban enclave of Richmond, Virginia, before and after emancipation at the conclusion of the Civil War. Free and enslaved African Americans and poor white persons mixed in the public realm of Antebellum Richmond, giving rise to an urban condition that resulted in the appropriation of private, civic, and interstitial space for practices distinguished here as acts of *vernacular citizenship.* These practices included expressions deriving from and working in opposition to the denial of political subjectivity. Through a close reading of President Abraham Lincoln's arrival in Richmond after the withdrawal of Confederate forces in April 1865, vernacular citizenship is recognized as a definitive form of Black politics, and one that affects agency. Holder argues that such politics are evident today in the democratic demands of Black-led social movements, in everyday practices that affirm subjectivity, and in material expressions that commemorate alternative perspectives.

During her long and prolific career, author Toni Morrison regularly turned to sources of insurgent memory and "rememory" to ground her fiction and criticism. She made known why: "I knew I could not … trust recorded history to give me the insight I wanted."[1] For Morrison, mainstream accounts sustained the bifurcated racial memory foundational to racism in the United States. The recollection and reassembly of historical sources that were deliberately marginalized or ignored offered the best "chances for liberation" from that past, and the clearest path toward the recognition, undoing, and relearning that was always at the heart of her work. Following her lead, this essay turns a critical eye on the power of dominate narratives in recorded history, and the material artifacts that bolster what Morrison considered the perspective of history's "conquerors."

Commemorative artifacts—monuments, designated historical sites, museums, and other forms of memorialization—are all around us. Despite their roots in municipal decision-making and their public claims of universality, most serve as everyday reinforcements of singularly dominant points of view. Their permanency signals a definitive closure of debate. Their familiarity publicly secures what is known and produces facts that are literally chiseled into stone. Even as actual events recede, the visual markers embedded in the landscape silence other perspectives and preclude other readings of the past. The effect is a diminishing of insurgent memories as well as family and community stories, and the burial of acts of resistance—both personal and political—that Morrison understood as crucial to the social remaking necessary to address national legacies of racial brutality.

Enshrining specific narratives is central to the process of commemoration and precisely why time, money, and talent are devoted to the creation of often imposing material remembrances. This raises serious questions for architects, artists, sculptors, designers, and students who become involved in planning or contributing to physical sites of commemoration. For instance, who and what is being commemorated? How are contemporary communities considered in the context of these

1 "First was my effort to … rely on memory rather than history because I knew I could not … trust recorded history to give me the insight I wanted … It was in *Beloved* that all of these matters coalesced for me … Rememory as in recollecting … reassembling the members of the body, the family, the population of the past … the effort to both remember and not know … because they are living in a society and system in which the conquerors write the narratives of their lives … but also … the chances for liberation that lie within the process." Toni Morrison, *Mouth Full of Blood: Essays, Speeches, Meditations* (London: Chatto & Windus, 2019), excerpted in Morrison, "I Wanted to Carve out a World Both Culture Specific and Race-Free," *The Guardian,* August 8, 2019, https://www.theguardian.com/books/2019/aug/08/toni-morrison-rememory-essay.
2 For an introduction to these debates, see Michael Paul Williams, "Monumental Issue Goes Unresolved in Richmond," *Richmond Times-Dispatch,* October 9, 2017, https://www.richmond.com/news/local/williams-monumental-issue-goes-

projects? Which versions of history are amplified and secured? Consequently, what voices and experiences are marginalized?

These questions resonate in two contemporary developments related to U.S. racial histories and national memory that pressure us to think about the historical stakes of material remembrances. First is the bitter backlash against the removal of Confederate monuments in the South. Advocates for removal have been clear about the need to reconceive memorials to the Confederacy as objects that provoke soul-searching rather than veneration and make removal a topic of reckoning, the kind demanded by the racial past and present that has scarred the region and its people so fundamentally, albeit unequally.[2] The defense of Confederate monuments has masqueraded behind the benign slogan of "heritage, not hate," but the centrality of racism and white supremacy to memorializing the Confederacy is undeniable, and appeals to regional pride efface the existence and experiences of Black Southerners [Fig. 1]. Moreover, reaction to removal efforts have revealed the violence synonymous with heritage claims. This was evident in Charlottesville, Virginia in 2017 when a Klan and neo-Nazi rally led to the death of a young counterprotester, and brought national attention to sustained white supremacy and white nationalism.[3]

The second development involves recent efforts to acknowledge the counternarratives, Morrison's rememories, that generations of writers, artists, and historians have employed to represent the inestimable losses and contributions of Americans of African descent. These efforts require an approach comprising three distinct steps: exposing the histories of racial brutality and exploitation, documenting movements of resistance, and recognizing the uniquely democratic vision put forward by Black-led movements demanding full citizenship for all. The Smithsonian's National Museum of African American History and Culture (NMAAHC), in Washington, DC, is a powerful example. Another is the Equal Justice Initiative's creation of two sites in Alabama that document the history of lynching and racial terror, and propose a path to the future not based on denials of the past.[4] A more recent development is the placement of artist Kehinde Wiley's sculpture, *Rumors of War* (2019), first,

unresolved-in-richmond/article_393c 9095-fcee-56b4-ade0-adaa6675 d175.html; and Mitch Landrieu, "On the Removal of Confederate Monuments in New Orleans," *New York Times*, May 23, 2017, https://www. nytimes.com/2017/05/23/opinion/ mitch-landrieus-speech-transcript.html. On documenting the rise of white supremacist violence, see Janet Reitman, "U.S. Law Enforcement Failed to See the Threat of White Nationalism. Now They Don't Know How to Stop It," *New York Times Magazine*, November 3, 2018, https://www. nytimes.com/2018/11/03/magazine/ FBI-charlottesville-white-nationalism-far-right.html. As Reitman shows, public scrutiny has revealed white nationalists eager to engage in public acts of intimidation and violence. On the complexities of and institutional responses to removal demands, see "Controversy over 'Silent Sam' Continues," *NPR*, December 8, 2019, https://www.npr.org/2019/12/08/ 786039689/controversy-continues-over-silent-sam-statue. After protesters tore down a Confederate statue at the University of North Carolina at Chapel Hill, the university announced a $2.5 million settlement paid to the Sons of the Confederacy, to "preserve" the statue. For comprehensive materials related to these events, see "All Monuments Must Fall: A Syllabus," https://monumentsmust-fall.wordpress.com/.

3 The eruption of white supremacist violence in Charlottesville, Virginia, on August 12, 2017, left scores of counterprotesters injured, and resulted in the death of thirty-two-year-old Heather Heyer. In response to the public outcry, Donald Trump made his infamous comment, "very fine people on both sides." The occasion was a "Unite the Right" rally to protest the decision of Charlottesville City Council to remove a statue of Robert E. Lee, an action still thwarted by restrictions in Virginia state law.

4 The National Museum of African American History and Culture, in Washington, DC, was inaugurated in September 2016. Both projects of the Equal Justice Initiative (EJI), The Legacy Museum: From Enslavement to Mass Incarceration, and The National Memorial for Peace and Justice were opened to the public in Montgomery, Alabama, in April 2018. EJI's research and archival collections are focused on "the enslavement of African Americans, the evolution of racial terror, lynching, legalized racial segregation and racial hierarchy in

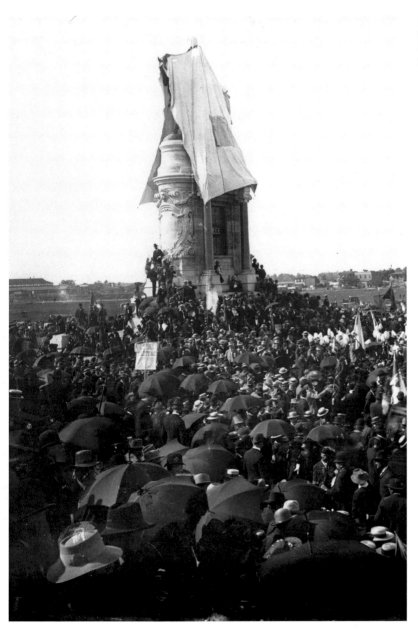

**1** Unveiling of the monument to Robert E. Lee, Richmond, Virginia, May 1890

as a temporary installation in Times Square [Fig. 2], and then as a permanent marker in Richmond, Virginia, where it has begun to challenge and disrupt the pantheon of Confederate idols that line the infamous Monument Avenue.

As commemorations of resistance, each of these examples is much more complex than monuments to great men, or patriotic causes that fortify official historical narratives. Rather than existing as declarations of fact, each of these examples invites viewer-participants to engage, question, and debate singular, simplistic versions of history.

Wiley's statue is a case in point. While far from the solution to the long struggle over the built legacy of Confederate Richmond, it is a breathtaking intervention positioned against the granite facticity that has dominated public representations of the city's heritage.[5] On the whole, the piece evokes iconic heroism. The figure on horseback is modeled on the statue of Confederate cavalry commander J. E. B. Stuart, which stands thirteen blocks away. But on closer inspection, a young man, who on the surface bears characteristics frequently stereotyped as threatening, is revealed. His dreadlocks fly freely, and his features signal African descent. He is clad in Nike sneakers, ripped jeans, and a hoodie, an article of clothing that became a symbol of resistance after the murder of Trayvon Martin.[6] Charging forward, the rider symbolizes fearless engagement with what lies ahead, even as his turned gaze suggests a conscious and respectful look to the past.[7] The scale of the figure, over twenty-seven feet tall, induces respect and authority; the viewer is required to look up in order to fully apprehend the work. The piece directly challenges Confederate and national narratives of heroism and prompts viewers to question received assumptions about the trustworthiness of leadership. Wiley transforms a stereotype into the portent of something new, a fighter who confronts and defies conventional (white) expectations of who has the knowledge and courage to usher in the future.

Wiley's piece is a bold representation of the use of space, movement, and self-representation that have always been critical to African American protest movements.[8] This essay explores those same elements, referring to them as practices

America." According to EJI founder Bryan Stevenson, any hope of racial reconciliation must start with confronting the "pain of this era, endured by people of color." See Debbie Elliot, "New Lynching Memorial Is a Space 'To Talk about All of That Anguish,'" *NPR,* April 26, 2018, https://www.npr.org/2018/04/26/6042718 71/new-lynching-memorial-is-a-space-to-talk-about-all-of-that-anguish.

5 For the unveiling of the Wiley statue in Richmond, see Michael Paul Williams, "400 Years of History Doesn't Sweep Away with Rumors of War Unveiling in Richmond, But It's a Start," *Richmond Times-Dispatch,* December 10, 2019, https://www.richmond.com/news/local/williams-years-of-history-doesn-t-sweep-away-with-rumors/article_06db8228-8f3c-5dec-ac76-991f6661af39.html.

6 Trayvon Martin was a seventeen-year-old Florida high school student, who was followed, shot, and killed by neighborhood watch captain George Zimmerman. Martin, who was African American, was walking back from a convenience store when Zimmerman began tracking him from his car because he claimed Martin looked suspicious. Zimmerman, who is white, claimed self-defense, even though Martin was unarmed. After finally being arrested and charged, Zimmerman was acquitted on the basis of Florida's "stand your ground" law. Martin was wearing a hoodie at the time of his murder; the hoodie became a symbol in the campaign to get justice for Martin, and other young people of color who have been killed in racist incidents. The campaign, and protests after Zimmerman's acquittal was significant for the development of the Black Lives Matter movement.

7 The position of the figure evokes the concept of sankofa, which is often represented by a bird looking back with feet facing forward. Translated from the Akan, it means, "In order to understand our present and ensure our future, we must know our past." In the recent release *Queen and Slim* (2019), written by Lena Waithe, Queen tells Slim that her grandfather said white men are intimidated by Black men on horses because they have to look up at them. See *Queen and Slim,* directed by Melina Matsoukas (Los Angeles: 3BlackDot, 2019).

8 For more direct reflections on the politics of Black space, see Katherine McKittrick, "On Plantations Prisons, and a Black Sense of Place,

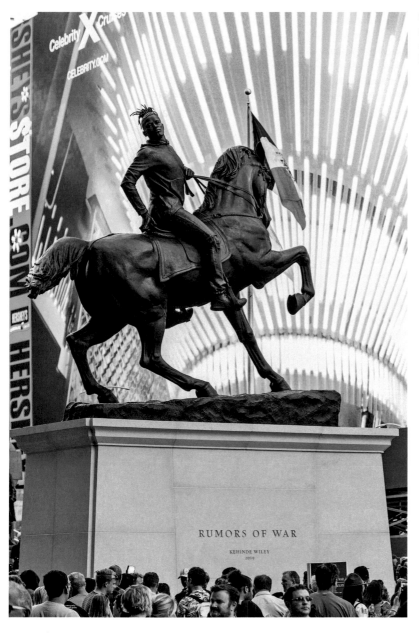

**2** Temporary installation of Kehinde Wiley's *Rumors of War*, Times Square, New York City, 2019

of "vernacular citizenship."[9] In brief, vernacular citizenship signifies the words and deeds developed in response to the denial of political subjectivity to people of African descent in the Americas.[10] It articulates a demand for a participatory and expansive, all-inclusive democracy. Vernacular citizenship bypassed the technical and legal exclusions of formal citizenship, and relied instead on presence and action: the mutually substantiated performance of civic belonging by people denied personhood by the social and political order. Knowledge and improvisation alongside existing networks of underground communication are indispensable to this practice, especially given white-majoritarian presumptions of illegitimacy.

The placement of Wiley's statue near Richmond's Monument Avenue has special significance, not only because the street is key to the debate over Confederate commemoration, but also because Monument Avenue is an example of the way commemoration and official history reinforce each other to preclude alternative memories of place. Wiley's work opens the question of what other stories Richmond's streets might tell. Indeed, the city is an important site for rememory; attention to vernacular citizenship compels an alternative perspective on the city's history of enslavement and emancipation. Signs of resistance can be traced in the deliberate use of spaces in the city by an underground political community well prior to emancipation and, most tellingly, in the eruption of clearly articulated demands for complete social and political transformation with the coming of freedom in 1865.

The remainder of this essay examines practices of vernacular citizenship in nineteenth-century Richmond. By looking at the consensus version of a well-documented historical event—President Abraham Lincoln's visit to Richmond—it is possible to see the myopia of official history. Black Richmonders were central to the story of that day, but their participation has been demeaned and marginalized. Revisiting those events using the framework of vernacular citizenship suggests the power of white racial assumptions to define what is seen, what has happened and what it means, and the possibilities and necessity of confronting dominate viewpoints.

*Journal of Social and Cultural Geography* 12, no. 8 (2011): 947–63; Katherine McKittrick and Clyde Woods, eds., *Black Geographies and the Politics of Place* (Toronto: Between the Lines Press; Cambridge, MA: South End Press, 2007); and Saidiya V. Hartman, *Scenes of Subjection: Terror, Slavery, and Self-Making in Nineteenth-Century America* (New York: Oxford University Press, 1997), 61–65.

9 *Vernacular citizenship* is a term that I use to describe the Black subjectivity that I observed in my research, unacknowledged, below the surface of the slave regime in the Antebellum South and most clearly in cities.

10 For more on the concept of political subjectivity, see Hartman, *Scenes of Subjection* (see note 8). She describes the erasure of humanity when political status is denied. More than failing to recognize specific actions as political, the foreclosure of political subjectivity prevents the recognition of personhood from which any political challenge might be launched.

## Lincoln in Richmond

For the four years of the Civil War, Richmond served as the capital of the Confederate States of America, but in early 1865 the Confederate army abruptly withdrew. On April 3, 1865, Union forces led by Black troops of the Fourth and Thirty-Sixth U.S. Colored Infantry regiments and members of the Fifth regiment Massachusetts Colored Volunteer Cavalry entered the city [Fig. 14]. Upon his arrival in Richmond the next day, Abraham Lincoln was greeted by a massive public celebration. The exuberant welcome was generated predominantly by Black Richmonders.[11]

Lincoln's unexpected and dramatic appearance received extensive coverage in newspapers and popular periodicals. Accounts by witnesses and journalists—both Union and Confederate sympathizers who, as a group, were almost entirely white—furnished the material artists and engravers used to convey the scene to a national audience. These same accounts largely shaped the historical record. Whether contemporaneous or reconstructed, the multiple public versions of Lincoln's appearance share uncanny similarities.

Nearly every report begins with Richmond still smoldering from the fires set by the retreating Confederate army [Fig. 3].[12] In a trip characterized by mishaps, Lincoln finally reached the city in a small, undistinguished boat. He started out on foot from Rockett's Landing, accompanied by Admiral David Porter, a small detachment of sailors, and his twelve-year-old son Tad.

The only bystanders at Rockett's Landing were a few Union soldiers and a group of people, newly emancipated, who volunteered to work with the army to clean up the city.[13] At first Lincoln attracted little attention, but as the workers began to recognize him, they gathered around to thank him and even accompanied the small landing party. Word traveled fast and the procession grew in size and enthusiasm. By the time Lincoln entered Richmond proper, the company of people had grown to several thousand. Some participants had been part of Richmond's free Black community before the war. Most were previously enslaved, their liberation arriving only with

11 Several sources commented that poor white people joined in the celebration; others identified "the crowd" as Black. Admiral Porter relayed the story of a white man who rushed toward Lincoln, alarming the escort, but then "took off his hat, and cried out, 'Abraham Lincoln, God bless you! You are the poor man's friend!'" See David Dixon Porter, *Incidents and Anecdotes of the Civil War* (New York: D. Appleton, 1885), 300. See also Richard J. Behn, "Entering Richmond," *Mr. Lincoln and Freedom*, The Lincoln Institute of The Gilder Lehrman Institute of American History, http://www.mrlincolnandfreedom.org/civil-war/black-soldiers/entering-richmond; and Mike Gorman, *Civil War Richmond*, https://civilwarrichmond.com/.

12 The reference to smoldering fires features in accounts from that of eyewitness Admiral David Porter, to Lincoln biographer Ida Tarbell, and historian Nelson Lankford. See Porter, *Incidents and Anecdotes*, 294 (see note 11); Ida Minerva Tarbell, *The Life of Abraham Lincoln*, vol. 2 (New York: Lincoln History Society, 1907), 228; and Nelson Lankford, *Richmond Burning: The Last Days of the Confederate Capital* (New York: Penguin, 2003), 156.

13 Seeking autonomy from their former owners, many Black Richmonders were eager to work with the Union army. Often paid only in food rations, employment nevertheless granted immediate independence by offering means of feeding themselves and their families. Much of postwar Richmond was cleaned and rebuilt by formerly enslaved people, along with free people of color, who possessed artisanal skills such as carpentry and bricklaying. See John Thomas O'Brien, *From Bondage to Citizenship* (New York: Garland, 1990), 73–77.

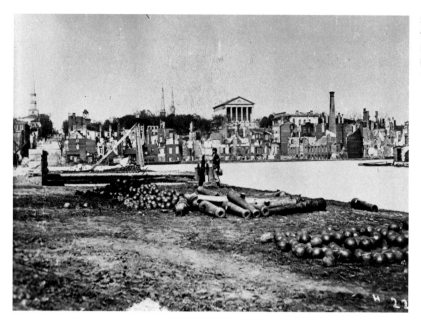

3 View of ruins in front of the Capitol from the Canal Basin after the Evacuation Fire, Richmond, Virginia, 1865

the flight of the Confederate government.[14] There were also white civilian onlookers, some of whom reportedly joined the celebration, even as most of white Richmond retreated behind barred doors and shuttered windows [Fig. 4].

Eyewitness accounts focused almost exclusively on the adulation of Lincoln, treating the predominantly Black participants—at best—as a Greek chorus to the Great Emancipator. Even ostensibly sympathetic witnesses, such as Union soldier Ira Abbott, described the celebrants as hypnotically drawn to the president, writing that the mostly Black participants moved "without apparent volition," and continued to "shout and cry out in rhapsody ... saluting their deliverer."[15] In his memoir, Union Admiral David Porter wrote, "Half of them acted as though demented, and could find no way of testifying their delight."[16] Local witnesses disparaged the cheering throngs that marked Lincoln's triumphant entrance. One described her servants as "completely crazed," while another recorded the "negroes were in a wild state of excitement." Nellie Grey wrote disapprovingly of seeing "negroes run into the street and, falling on their knees before the invaders, hailing them as their deliverers."[17]

14 There were approximately 12,000 enslaved and 2,600 free Black people in Richmond in 1860, although these numbers probably changed considerably during the war. See U.S. Department of Commerce, Bureau of the Census, *1860 Census: Statistics of the United States (Including Mortality, Property, etc.)* (Washington, DC: GPO, 1866), 500–525, https://www.census.gov/library/publications/1866/dec/1860d.html.

15 Ira Anson Abbott, "The Fall of the Confederate Capitol: A Chapter of Reminiscences" [manuscript], ca. 1915. Boston Athenaeum.

16 Porter, *Incidents and Anecdotes*, 297 (see note 11).

17 John T. O'Brien, "Reconstruction in Richmond: White Restoration and Black Protest, April–June 1865," *The Virginia Magazine of History and Biography* 89, no. 3 (1981): 259–81. Reports like Grey's prompted sketch artists—most of whom never went near Richmond—to imaginatively portray the fervor of Lincoln's reception, centering on the president as benefactor among the newly emancipated, overcome with gratitude. The tone of local accounts offered a grim prediction of emancipation, depicting the celebrants as undisciplined and heedless, confirmation that emancipation for Black people meant peril for white people.

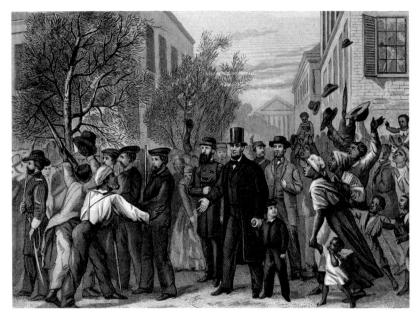

4 *Abraham Lincoln Entering Richmond, April 1865.* Drawing by Lambert Hollis, engraved by John Chester Buttre, published by B. B. Russell & Co., April 1866

5 Detail from *Beers Illustrated Atlas of the Cities of Richmond & Manchester,* Plate K, 1877

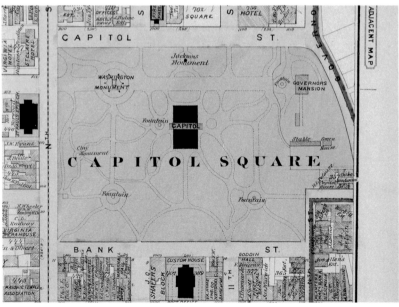

As the procession headed toward Union headquarters in the former Confederate White House, firsthand accounts describe what was perceived as an alarmingly boisterous reception with celebrants pressing in on Lincoln and slowing his progress to a standstill [Fig. 6]. In Admiral Porter's recollection, "The streets seemed to be suddenly alive with the colored race … The crowd immediately became very oppressive."[18] He worried that the small guard of sailors would be overwhelmed. Indeed, several observers reported that when Lincoln finally entered the former Confederate headquarters, he immediately dropped into Jefferson Davis's chair and asked for a glass of water to recover his faculties.

After resting, Lincoln started out again—this time in a carriage.[19] He paused upon sight of the sea of faces that filled Capitol Square and made an impromptu speech [Fig. 5]. There is no official record of his remarks, and accounts differ as to the full extent and political tenor of his comments, but all agree that he announced freedom for the enslaved, and gave advice to his newly emancipated listeners on how best to use their rights.[20]

By placing the president at the center of the day's events and failing to see Black Richmonders as acting deliberately and decisively, almost all accounts of those who made Lincoln's visit triumphant stripped Black participants of their human agency. Caricaturing them as unruly, mindless, and out of control, the primarily white observers, whose impressions were recorded and preserved, in effect asserted that participants could not have intended to do what they actually did: occupy Richmond in ways that expressed their own idea of what freedom meant.[21] But, refusing to "see" the intentions of those who joyously greeted Lincoln required ignoring a similar public celebration that had taken place the day before, after the Confederate army had departed. April 4 was the second day Black Richmonders had seized public space, but without Lincoln's arrival, without the attention his presence brought, we might never have "seen" it at all.[22]

What white eyewitnesses uniformly failed to register was, in fact, the collective expression of political subjectivity by

18 Porter, *Incidents and Anecdotes*, 297 (see note 11).
19 Lankford, *Richmond Burning*, 165 (see note 12).
20 One notable difference was those few reports which claimed Lincoln advised the recently emancipated to use the arms they had carried for the Union if their new rights were denied or withdrawn. Regardless of what Lincoln actually said, Black Richmonders had already showed they did not need his advice to understand what freedom meant to them.
21 The accounts of disorder, disruption, and possible danger laid the groundwork for narratives of Black incapacity, intractability, and insolence that developed—nationally—in the postwar white press. The uncritical reiteration of these narratives in historical accounts has occluded the material revelation of vernacular citizenship as it was publicly enacted.
22 Thanks to my colleague Adriana Green for this point. Green grew up near Richmond, and was struck that this pivotal moment in the city was never discussed in the public schools as part of either local or national history. In a city of monuments, there is no plaque honoring this substantial demonstration for human and civil rights. For an example of contemporary attempts to address the city's monuments, see *Monument Avenue: General Demotion/General Devotion*, a design ideas competition supported by Storefront for Community Design, mOb studio at Virginia Commonwealth University School of the Arts, and the Valentine Museum. It called for proposals to reimagine Monument Avenue and its massive tributes to Confederate luminaries such as Jefferson Davis and Robert E. Lee: https://monumentavenuegdgd.com/national.

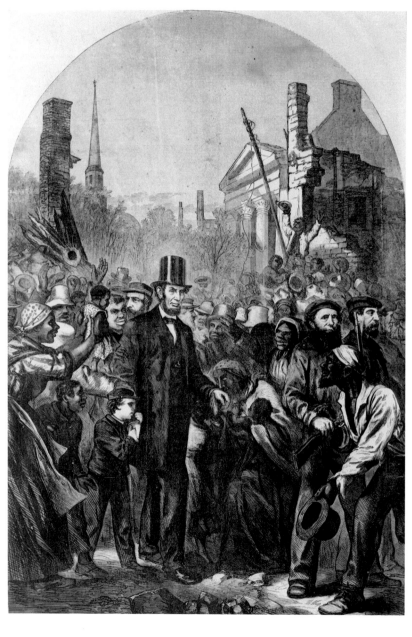

**6** Thomas Nast for *Harper's Weekly*, *Lincoln in Richmond,* February 24, 1866. The depictions of Black Richmonders adhere to the eyewitness reporting about "the crowd" pressing in on Lincoln; the four-column building in the background evokes the capitol, erroneously located amid signs of Richmond's destruction.

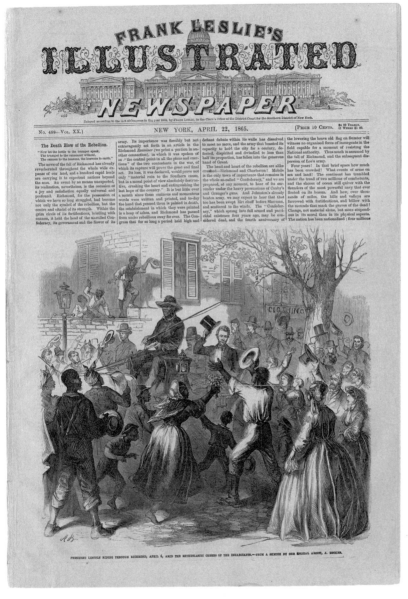

**7** Joseph Becker, *Lincoln's Unfinished Work: Legacy of the Great Emancipator, Frank Leslie's Illustrated Newspaper,* April 22, 1865. Lincoln prepares to enter the carriage in front of the Jefferson Davis residence; African Americans figure prominently alongside white civilians.

Black Richmonders.[23] Free and newly emancipated African American residents seized the president's visit as an opportunity to act together in ways that had long been prohibited. Their warm reception marked a clear break with Confederate distress over Union "occupation." Participants moved freely through the city streets, lay claim to urban thoroughfares, and jammed the sidewalks [Fig. 7].

Most dramatically, Black Richmonders occupied the grounds of Capitol Square. They crossed its gated thresholds, followed its winding footpaths, traversed its manicured lawn, and assembled on the Capitol steps. With the new spirit of citizenship, they moved to enact their freedom.[24] Only T. Morris Chester, the sole Black correspondent to write about that day, recognized the purpose of the collective intention rippling through the square as Lincoln delivered his address. The people, who he described as a sea of "humanity," had gathered on the Capitol steps to "catch a glimpse of him."[25]

### Racial Deference and the Politics of Capitol Square

It is hard to fully appreciate the significance of these acts without understanding the history and spatial politics of Capitol Square, alongside the legacy of racial deference that governed Richmond [Fig. 8]. Thomas Jefferson designed the square after the American Revolution, a property-owners' revolt that set the terms for a new era in the United States. Built on a rise above the city, it was an iconic tribute to the commonwealth's liberty at a time when the most valuable property in Virginia was tallied in human beings, including many whose skilled hands built the Capitol building and landscaped its grounds. In 1818 a decorative iron fence was installed to demarcate the twelve-acre site. The fence came to articulate the explicit exclusion of all Black people from Capitol Square, even those with freedom papers. This site of political authority was limited to residents only.[26] When Jefferson Davis was inaugurated there in 1862 as the first president of the Confederate States of America, Capitol Square became the political center of yet another property-holders' rebellion, this time in defense of human bondage.

23 Many eyewitness sources describe celebrations on the streets by Black Richmonders, even before Lincoln's arrival. His presence simply added formal recognition of the political response already underway. See O'Brien, *From Bondage to Citizenship*, 71–74 (see note 13). A number of scholars have done exquisite work on Richmond that made this interpretation possible. In addition to John Thomas O'Brien, see especially: Elsa Barkley Brown, "To Catch the Vision of Freedom: Reconstructing Southern Black Women's Political History, 1865–1880," in *African American Women and the Vote*, 1837–1960, ed. Ann Gordon, Bettye Collier-Thomas, John H. Bracey, Arlene Avakian, and Joyce Berkman (Amherst: University of Massachusetts Press, 1997), 66–99. Elsa Barkley Brown, and Gregg D. Kimball, "Mapping the Terrain of Black Richmond," *Journal of Urban History* 21, no. 3 (March 1, 1995): 296–346; Midori Takagi, *Rearing Wolves to Our Own Destruction: Slavery in Richmond, Virginia, 1782–1865* (Charlottesville: University Press of Virginia, 2002); Peter J. Rachleff, *Black Labor in the South: Richmond, Virginia, 1865–1890* (Philadelphia: Temple University Press, 1984); and Richard C. Wade, *Slavery in the Cities: The South, 1820–1860* (London: Oxford University Press, 1967).

24 The phrase "new citizens" names the claim of citizenship at the end of the war, prior to official recognition.

25 R. J. M. Blackett, ed., *Thomas Morris Chester, Black Civil War Correspondent: His Dispatches from the Virginia Front* (New York: Da Capo Press, 1991), 294–97.

26 The prohibition was reemphasized in the revised Richmond "Black code" of 1857; see O'Brien, *From Bondage to Citizenship*, 18 (see note 13).

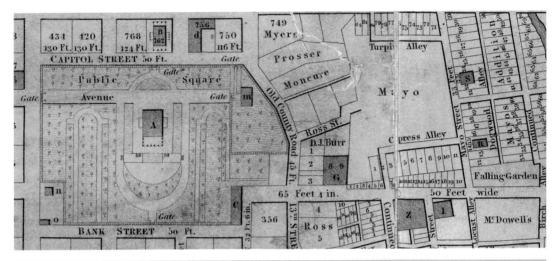

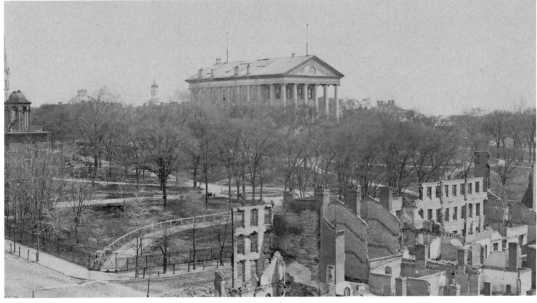

8 Detail of the Map of the City of Richmond, drawn by Micajah Bates, 1835. This map includes a rendering of the recultivated gardens around the capitol and tenements and alleys around the Mayo property, which would become the site of Robert Lumpkin's enslaved persons market.

9 View of burned-out Richmond from the Spotswood Hotel, 1865

Capitol Square regulated the political sphere of Richmond in a very specific way [Fig. 9]. Representing the fantasy of an all-white political body, its prohibitions mirrored the legal statutes banning Black Richmonders from activities that white residents took for granted: smoking in the street, carrying a cane, buying liquor, standing on sidewalks, gathering in groups of more than five or riding (as passengers) in hacks.[27] But even beyond statutory constraints, customary social boundaries required Black people—regardless of status—to yield public space by moving aside, stepping off the sidewalks, and making way on the streets. White Richmonders expected to move through the city without inconvenience or obstruction, and without having to see the Black people who moved and worked around them. These expectations of deference enforced the dehumanization of even free Black residents. The coercion to perform the labor of Richmond and simultaneously produce the white fiction of Black non-presence was a constant, humiliating reminder of invisibility. Antebellum Black Richmonders, whether legally enslaved or technically free, lived the effects of spatial alienation.

In *Scenes of Subjection* (1997), Saidiya Hartman elaborates the link between being rendered invisible and absolute exclusion from even partial grievance mechanisms available to other inhabitants. "Those subjects removed from the public sphere … are formally outside the space of politics."[28] Her well-known formulation, "politics without a proper locus," deftly summarizes the conditions that produced vernacular citizenship: the need for underground politics and the deliberate denial of public legibility. She calls attention to communally understood modes of resistance—illicit gatherings, reparative theft, slipping away, labor slowdowns, feigned illnesses, knowledge acquired in secret, and other acts of defiance—and honors how they "interrupted, re-elaborated, and defied the constraints of everyday life under slavery," while acknowledging that they were overmatched by a system that used pleasures as well as pain, affective investments as well as labor exploitation, and comforts as well as extreme distress to ensure control.[29]

Hartman's analysis clarifies the incredulity of white witnesses in Richmond. Their obliviousness to Black political

27 Ibid., 18–19.
28 Hartman, *Scenes of Subjection*, 65 (see note 8). For the original conference, *In Search of African American Space*, we were asked to reflect on Saidiya Hartman's formulation, "Politics Without a Proper Locus." Although published twenty years ago, Hartman's groundbreaking and influential text remains essential reading for those who engage the historical paradoxes of slavery and freedom. As she shows (61), political delegitimating is inextricable from dehumanization.
29 Ibid., 51.

purpose was not just a failure of perception.[30] It represented committed and habitual allegiance to the organization of political power as white. The "proper" locus which Hartman invokes is etymologically linked to both property and propriety, that is, both laws of ownership and rules of conduct. The right to engage in politics thus required ownership—of self and others —and strict adherence to the customary relations that secured property-holders' power. Her use of "locus" underscores the narrow geographical circumscription of politics, as in the boundary around Capitol Square [Figs. 10, 11]. "Proper locus" thus designated the who and the where of politics through a closed sphere of legitimacy that nullified all other voices. The scenes observed in Richmond on April 4, 1865, were refused the status of politics because of their exclusion from the proper locus. To most white reporters, the occupation of Capitol Square only registered as social disorder, the improper actions of people refusing their proper place and their imposed status as property. Yet the scale and determination of that gathering seems to have taken white viewers off guard, disordered *them*, and left them reaching for ways to reject what was unfathomable.

What kind of work is necessary to understand dominant white reaction as charged backlash against a yet unrecognized set of political claims? In other words, what other ways of looking do we need to see vernacular citizenship, which made the bold response to emancipation possible, in practice before the end of slavery? Answering this question requires a deeper perspective on the antebellum history of Richmond's African American community, and starts with reading Richmond— along with Charleston and New Orleans—as an antebellum Black city.[31]

## Black Cities

Black cities were home to proportionally large Black populations with an indelible public presence. Through the 1840s, Richmond was mostly comprised by people of African descent and African American culture was palpable to those able to perceive it [Fig. 12]. Despite white desire for the invisibility of Black people, demands for labor made that impossible, political

10 Albert Lybrock, architectural drawing (elevation) of the capitol, 1858

11 Albert Lybrock, architectural drawing (sections) of the capitol, 1858

30 A typical account is Admiral Porter, "What a fine picture it would have made—Mr. Lincoln landing from a ship-of-war's boat, an aged negro on his knees ... a dozen more trying to reach him to kiss the hem of his garments." Porter, *Incidents and Anecdotes*, 296 (see note 11).

31 For a contemporary take on Black cities, see Marcus Anthony Hunter and Zandria F. Robinson, *Chocolate Cities: The Black Map of American Life* (Berkeley: University of California Press, 2017).

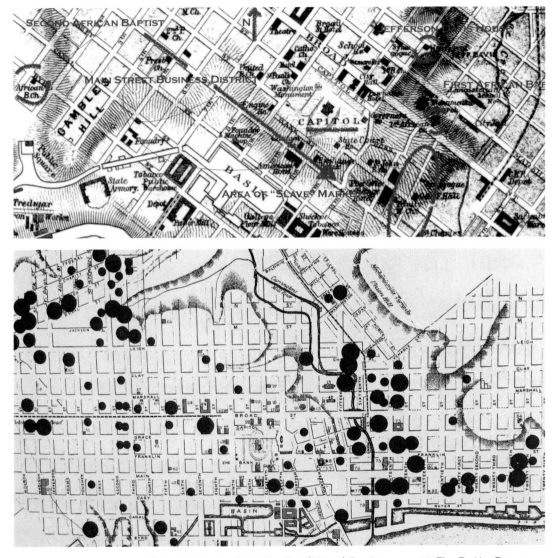

**12** A. D. Bache for the U.S. Coast Survey, detail of the Official Records Atlas, Plate 89, #2, 1864. Clockwise: Jefferson Davis residence, where Lincoln met with Union command; First (African) Baptist Church, Main Street, where free people of color participated in the commercial life of Richmond; and Second (African) Baptist Church

**13** Elsa Barkley Brown and Gregg Kimball, detail of population distribution map showing density of free people of color in Richmond, 1852

and social exclusions were impossible to duplicate in everyday urban life.

Bringing Black cities into focus is difficult, but there are clues in the reactions of visitors from Europe or from the North. Whether traveling for business or sightseeing, outsiders to the region were apparently startled by the scale and diversity of Black presence in the public life of antebellum Black cities. Unlike white locals, they voiced their impressions in letters, travelogues, and memoirs. Observing 1840s Richmond, the Englishman J. S. Buckingham was amazed that in "walking the streets…you appear to see and meet ten times as many blacks."[32] Other travelers used the derogatory language of the times: Swedish women's rights reformer Fredrika Bremer wrote that "Negroes swarm the streets" of 1850s Charleston, and a visitor to Richmond in the same era echoed Bremer, describing that city as "literally swarming with negroes."[33]

Demographics certainly played a role in the atmosphere noted by these travelers. But the real numbers were probably amplified by the public nature of urban work, and the compact character of walking cities. Black people performed the tremendous daily labor needed to sustain trade-based economies. Markets, roads and railroads, construction sites, and docks bustled with highly organized groups of Black workers, both enslaved and free. Enslaved domestic workers were often in the streets, carrying messages, selling and purchasing food and fuel, or transporting people and household goods.[34] Mixed housing and work sites precluded the kind of segregation later claimed as a fixture of Southern life.

However, the Black city was more than numbers and public labor. Richmond residents encountered one another across gulfs of inequality; proximity across lines of race, status, and sometimes class was typical. Thirty-two percent of the free Black men residing in the city were artisans or craftsmen.[35] Some worked for white employers in interracial shops; others owned their own businesses and jostled for space and customers with other tradesmen on Main Street. Domestic workers, free and enslaved, often lived in or near the homes of the wealthiest Richmonders. Free and enslaved people, poor white and

32 James Silk Buckingham, *The Slave States of America* (London: Fisher, Son & Co., 1842), 426–27. Buckingham was alert to the contradictions because he knew the population statistics of Richmond and was aware his perception of the Black city was at odds with reality. However, he shares the inability of white locals to recognize how the labor of Black residents was linked to Richmond's economic prowess. His glowing report of the city's commercial success spans for several pages without one reference to the people whose labor made that possible.
33 Adolph B. Benson, *America of the Fifties: Letters of Fredrika Bremer* (New York: The American Scandinavian Foundation, 1924), 96; and Wade, *Slavery in the Cities,* 17 (see note 23).
34 This provides further explanation for why Black people could hardly be prohibited from urban public and street life, even their movement through the city facilitated an underground communicative economy.
35 Herbert Gutman, "Persistent Myths About the Afro-American Family," in *The Slavery Reader,* ed. Gad J. Heuman and James Walvin (Abington: Taylor & Francis, 2003), 259.

Black residents, and recent European immigrants intermingled in a variety of tenements, divided houses, rented rooms, and backyard shacks. They fraternized in the cook shops, gaming parlors, and alleyway taverns that catered to the needs and scant pleasures of the urban poor.[36] They traded, bartered, exchanged, and stole together in order to survive on the margins of Richmond's economy. The public sphere vibrated with status diversity, and the broad racial spectrum of the antebellum slave regime [Fig. 13].

Even as the city's population shifted in the 1850s and 1860s, becoming statistically "whiter," a vibrant African American culture suffused the city. Many enslaved persons in Richmond were industrial workers, and this shaped the social and spatial contours of urban life. Whether in iron, tobacco, or flour processing, these workers often "lived out" by independently contracting for employment and paying a percentage of their wages to absentee owners.[37] What remained went toward food and rent—promising a precious degree of autonomy. Black Richmonders used their numbers, their movement across the city, and their sites of social life and labor to create a parallel underground universe—though always under constraint and surveillance. Errands, back-door entrances, and alleyways meant opportunities to forge a social world which also surreptitiously moved resources, information, goods, and sometimes people.

Black churches played an important role in the decades before the Civil War. Founded in 1841, First (African) Baptist was situated on Broad Street, one-and-a-half blocks northwest of Capitol Square. The church offered a public space of worship for a congregation composed of free and enslaved Black residents. In careful collaboration with the appointed white minister, members used church activities to raise money, build community leadership, develop skills in interpretation and "preaching" (public speaking), and perhaps most astonishingly, maintain a system of contact between residents and friends and family who had emancipated themselves.[38]

More clandestine were the secret societies that provided financial support to the Black city's most vulnerable residents and the underground schools that accounted for its high literacy

36 Takagi, *Rearing Wolves*, 45–52 (see note 23).
37 O'Brien, *From Bondage to Citizenship*, 26–30 (see note 13).
38 Ibid., 69–70.

rates. Subterranean networks abounded: at least eight different conductors on the Underground Railroad lived in Richmond and the city operated as an information hub reaching into the adjacent countryside.[39] None of these activities existed outside the regime of slavery. They built on or used in-between spaces of the urban landscape.[40]

Despite the relative autonomy of some Black inhabitants, enslavement and its horrors saturated Richmond. The notorious Lumpkin's jail, a hub of the domestic slave trade, was only one block west of First (African) Baptist. There, enslaved people awaited deportation further south as part of the most lucrative form of antebellum trade. Virginia planters responded to diminishing yields in the upper South by selling the only property that still had value. Friend and family networks were torn apart in the quest to bolster planter fortunes.

## Vernacular Citizenship in the Black City

As the picture of Richmond as a Black city becomes clearer, we can see practices of vernacular citizenship erupt in the surprise, agitation, discomfort, and anger recorded by history's self-appointed scribes. Once again, travelers' accounts are useful, whether documenting the closed arrogance of white proponents and beneficiaries of the slave regime, or the unexpected moments of Black subjectivity that contrasted with expectations of people otherwise only defined by subservience and bondage. The aggrieved tone of elite white Southerners, in speech and written prose, betrays public confidence in the institution of slavery, and the assertion that enslaved persons were content with their lot. Opening any antebellum newspaper reveals the contrary; in bounty listings for the return of self-emancipated persons, these same men and women take pains to dehumanize those they considered their property, going so far as to ridicule the desire for freedom.[41] Despite the hostility of this published record, palpable signs of vernacular citizenship can be parsed from the attitudes and practices of Black Richmonders who left little else behind.

As outsiders to the region, visitors were more blunt about the contradictions of enslavement than the local white elite.

39 John Hope Franklin, *The Emancipation Proclamation* (Wheeling, IL: Harlan Davidson, Inc., 1995), 67–68. Franklin discusses the effective networks of information exchange that existed from the cities to the countryside before and during the Civil War.

40 The story of Henry "Box" Brown is well-known as an example of the possibilities and ever-present threats of enslavement under these circumstances. Brown worked in a tobacco factory and rented a house for himself, his wife Nancy, and their three children. He paid Nancy's owner a regular sum not to sell her away. The betrayal of this arrangement supposedly inspired Brown's famous and successful bid for freedom by mailing himself in a box from Richmond to Philadelphia. Although well publicized at the time, little attention was given to the unique urban conditions that made "Box" Brown's life possible, or the devastating loss that made his risky escape desirable. Another example is Mary Jane Richards Denman, aka Mary Bowser, a co-conspirator of the (white) Church Hill resident, abolitionist, and Union spy Elizabeth Van Lew. Even though she had been emancipated by Ven Lew, Denman passed herself off as an enslaved, skilled domestic "borrowed" from Van Lew's household by the Confederate president's wife. As such, she was able to pass critical information to Union forces.

41 These listings were typically called runaway ads, embedding the legitimacy of human ownership in the characterization of these actions. "Runaway" implies the act of self-emancipation as a betrayal of an obligation, the defiance of ownership.

Traveling through a society based on slavery triggered much description; thoughts that tumbled onto pages sometimes reveal the same racial assumptions held by the white Southerners they considered political enemies. A few, like English women's rights activist and amateur painter Barbara Bodichon, were candid about their unease with "the strange mixture of races of people" and baffling racial protocols. She compared a disorienting visit to New Orleans with time spent living in (French colonial) Algiers.[42] But Bodichon was atypical in that she frequently initiated conversations with Black residents rather than observing them from a distance.

J. S. Buckingham was so unsettled by the sight of 1840s Richmond that he evoked the independent Black nation of Haiti for comparison. The spectacular Sunday afternoon promenade of fashionably dressed African Americans reminded him of the first successful revolution against a slave regime. Noting the women's "white muslin and light silk gowns" and the men's "white trousers, black stock[ing]s and broad-brimmed hats," Buckingham contended, "one might almost imagine one's self to be at Hayti, and think that the coloured people had got possession of the town, and held sway, while the white were living among them by sufferance."[43] His mention of the revolution that rocked the Euro-American world may have been ironically aimed at an English readership, but it also suggests the anxiety that accompanied observations of Black autonomy through sartorial expression.[44]

In the mid-1850s Connecticut-born landscape architect and social critic Fredrick Law Olmstead also seemed to lose his bearings. While observing two passengers on the train to Richmond, he imagined them to be a white master and his "colored" servant. He was surprised and quite taken by the latter, a "fine-looking, well-dressed, and well behaved … young man," noting reluctantly that of the two, the "white man … was much … less like a gentleman."[45] Once in Richmond, Olmsted found himself musing on the city's "fashionable streets." Catching the Sunday promenade more than a decade after Buckingham, he described men in the "finest French cloths, embroidered waistcoats, patent-leather shoes, resplendent brooches,

42 Joseph W. Reed, Jr., *An American Diary 1857–8: Barbara Leigh Smith Bodichon* (Boston: Routledge, 2019), 67. Bodichon was among the most deliberate of the travelers in seeking out and describing actual relationships with Black Southerners, as opposed to only recording her observations of them.

43 Buckingham, *Slave States*, 427 (see note 32). His reference to Haiti was certain to unnerve any readers from the U.S. South. The Haitian revolution was a recurrent nightmare for the white elite who used it to rationalize the brutality and bloodletting of regional reaction to real or imagined uprisings.

44 See Sophie White, "'Wearing three or four handkerchiefs around his collar, and elsewhere about him': Slaves' Construction of Masculinity and Ethnicity in French Colonial New Orleans," in *Dialogues of Dispersal: Gender, Sexuality and African Diasporas*, ed. Sandra Gunning, Tera Hunter, and Michele Mitchell (Oxford: Blackwell, 2004), 132–53.

45 Frederick Law Olmsted, *A Journey in the Seaboard Slave States: With Remarks on Their Economy* (New York: Dix & Edwards; London: Sampson Low, Son & Co., 1856), 18.

silk hats, and kid gloves," while "the colored ladies ... dressed not only expensively, but with good taste and effect, after the latest Parisian mode." After admitting involuntary admiration, Olmsted turns to mockery, comparing the sharp styles of the "dark gentry" to the pretensions of New York's working classes who dressed in "fancy" ready-mades.

These impressions reflect a time when surface attributes were central to judgments of character.[46] The fulsome descriptions of attire suggest the dissonance experienced by white outside observers, and significantly, the role of style in projecting a politics of self-respect among Black residents of Richmond.[47] Sartorial choices were vital measures of social and cultural meaning in the underground Black city.[48] The awkward scorn of Buckingham and Olmsted, as well as the compulsive description of details, reveals discomfort with fashion as a form of political subjectivity, and perhaps the realization that although they could watch, the promenade was not for them.

White locals rarely conveyed the racial vertigo expressed by travelers. The city's white elite mostly ignored the working Black city. They regarded poor, mixed neighborhoods as sites of squalor and immorality.[49] Their reactions to Black autonomy appeared in different form—disdain and ridicule—which also inadvertently reveals vernacular citizenship in practice. Backhanded acknowledgments of resilience surface in police reports and court actions targeting Black inhabitants who seemed (to white observers) unruly, improper, and out of place, as well as in the bounty listings that filled column inches in every local newspaper.[50]

The daily press featured the rough-and-tumble world of non-elite Richmond in reports on "Local Matters," where theft, fighting, gambling, and intoxication were routine. White and Black Richmonders, longtime residents and new immigrants, free people of color, hired workers, and enslaved people were often involved in these stories, in ways that sometimes challenged status norms. For example, in July 1858, "Two negro women—Betsy Martin and Sarah Fortune ... (were) punished for assaulting and beating Mary Jane Meekins (no race disclosed, so probably white)." In another case, "A negro girl in the service

46 See an analysis of linking character, manner, and appearance in Shawn Michelle Smith, *American Archives: Gender, Race, and Class in Visual Culture* (Princeton, NJ: Princeton University Press, 1999).
47 I am indebted to Sophie White's argument that dress was a valuable channel for social and economic agency aimed not only, or even primarily, at setting boundaries in relation to the white planter class but also establishing codes of subjectivity and respect within and among people of color. White, "'Wearing three or four handkerchiefs'" (see note 44). See also Shane and Graham White, *Stylin': African American Expressive Culture from Its Beginnings to the Zoot Suit* (Ithaca: Cornell University Press, 1998), 5–84; and Monica L. Miller, *Slaves to Fashion: Black Dandyism and the Styling of Black Diasporic Identity* (Durham: Duke University Press, 2009).
48 Obtaining an item of decorative attire, even something as small as a scarf or a hat for those whose clothing was dictated by their status, delivered a public message of personhood that could be reciprocated by and among other Black people in the Black city. As Sophie White shows, for some, this possibility was worth making considerable sacrifices. See also O'Brien, *From Bondage to Citizenship*, 27 (see note 13); and White and White, *Stylin'*, 88–89 (see note 47).
49 The white elite were trained to disdain labor, and therefore also the laborers who sustained the city's commercial activity. The working Black city was unseen by them and simultaneously subjected to enforced rituals of racial deference. Black laboring publics engaged in secondary work—halting jobs, moving out of the way, and so on to ensure the unobstructed movement of white city residents—even while pressed by certain tasks, and submitting to demands for immediate assistance by any white person.
50 Violations of custom or law by Black residents were characterized as unfathomable transgressions. Anxiety over challenges to the slave regime status quo can be read in press satisfaction with severe sentencing (in Richmond, often thirty-nine lashes) and the confidence that such punishment would prevent recurrence.

of C. P. Burruss ... was before the Recorder yesterday and soundly punished, for assaulting Nancy Gibson (again, likely white) in her own yard." From the same period, "a slave named Daniel ... was tried for breaking into the clothing store of Mr. E. D. Keeling," while James Mercer, "a free negro" was sentenced for theft of a horse.[51] It is impossible to know the motive behind any of these acts, but accusations of assault often resulted from Black people's self-defense against threats or punishment. Likewise, it is worth considering the sartorial implications of why "Daniel" would break into a clothing store, and whether James Mercer's act was theft, or the repossession of disputed property.[52]

There was more clarity in the bounty listings, postings published under the column headed "Runaways." The aim of these advertisements was to recapture people who had claimed their freedom through self-emancipation, and they contain some of the most detailed depictions of enslaved people written by elite white Southerners. Provided as an aid to bounty hunters, these portrayals echo the sartorial observations of travelers' accounts and make it possible to read beyond the outraged entitlement of the white authors to locate anxieties about how enslaved and quasi-free Black residents expressed autonomy and inscribed signs of political resistance in their bids for freedom.[53]

Key elements of the listings—self-naming, self-fashioning, obtaining and using literacy, asserting unrecognized relationships of family and community, and claiming self-emancipation—defied the contemporaneous characterizations of Black people on which the slave regime was built. The advertisements also, unwittingly or unwillingly, rendered the subterranean counterpublic visible. Samples from a July 1858 issue of Richmond's *Daily Dispatch* are typical. On July 2, "CHARLES" left James N. Shine, wearing "a frock dark jeans coat ... black slouch hat," and carrying his good coat, "a white and blue check" in his saddlebags. The ad suggests he may have returned to Clarke County, where he had lived until the prior year and where, in Shine's reproachful words, "he *said* he has a wife." Seventeen-year-old "ELENORA," was the subject of a listing on July 13. The complainant, Martin Taylor, sarcastically notes

51 "Local Matters," *Richmond Daily Dispatch*, July 3, July 9, July 15, and July 22, 1858; in *The Daily Dispatch* (Richmond, VA) 1850–1884, Chronicling America: Historic American Newspapers, Library of Congress, Washington DC, https://chroniclingamerica.loc.gov/lccn/sn84024738/issues/1858.
52 For the focus on clothing, see White and White, *Stylin'*, 34–36 (see note 47).
53 *Quasi-free* is a term coined by historian John Hope Franklin. It has been used to designate the status of technically free people of color (sometimes called Free Africans), who were not enslaved, but did not have the rights of citizens. It has also been used to describe technically enslaved people who lived on their own, contracted work independently or had unusual freedom of movement. It is a deliberately ambiguous term. See John Hope Franklin, *The Free Negro in North Carolina, 1790–1860* (Chapel Hill: The University of North Carolina Press, 1943).

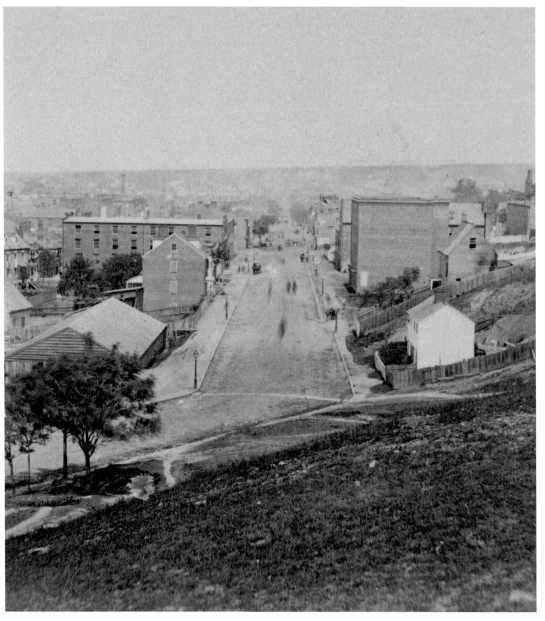

**14** Main Street Richmond, where Black troops of the Thirty-Sixth U.S. Colored Infantry and the members of the Fifth Massachusetts Colored Cavalry entered the city on April 3, 1865, liberating it from the Confederacy.

that, "she *calls herself* Elenora Hill," and admits, "She can read and write very well, and I have no doubt but what she has procured free papers, and is now going about as a free woman."[54] Taylor's assumption that Ms. Hill had no right to name herself competes with his desire to affect her recapture; his grudging disclosure of her self-naming, and the sizeable $200 reward imply that he was highly motivated to regain his control over her, and to block whatever freedom Hill could achieve living as a literate woman of color in the heart of the slave regime.

However much these listings meant to mock their subjects, their descriptive density explicitly asserts that the people described had their own ideas, identities, and political subjectivities. From the slaveholders' own words, it is clear that they saw but refused to accept, and knew but refused to acknowledge, the personhood of the people they exploited as property. This schizophrenic disavowal was critical to the exercise of dominance by the slave regime. If the denial of Black humanity governed public and political discourse, its ragged edges reveal the workings of vernacular citizenship.

Expressions of vernacular citizenship were legible to their intended audience; the enslaved and quasi-free people of Black Richmond knew how to read the signs. The result was a network of social, familial, and political relations that could sometimes thwart the reach of (white) surveillance and hypervigilance, if never overturn or permanently evade them. Locating practices of vernacular citizenship acknowledges the covert and subversive links among people of similar or affiliated condition, and the unseen collectivities that preceded emancipation.

## Conclusion

The energetic mobilization of Black Richmond in April 1865 is the most important piece of evidence that the people who seized public space had already developed specific visions of freedom, and decisive plans to make it their own.[55] These actions constituted a distinct public claim of vernacular citizenship. They did not erupt spontaneously but arose from an everyday urban underground, an alert and knowledgeable communal network.

54 "Runaways," *Richmond Daily Dispatch,* July 2, July 10, and July 13, 1858 (emphasis mine); in *The Daily Dispatch* [volume], https://chroniclingamerica.loc.gov/lccn/sn84024738/issues/1858. Taylor divulges that Hill had friends in Richmond, and on Church Hill, where he was certain she was being sheltered. This suggests that self-emancipation was not in fact an individual act, but also dependent on networks of friends, family, free people of color, and perhaps even sympathetic white people.
55 The few historians who have written about the occupation of Capitol Square have suggested that Black Richmonders were celebrating their vision of a belatedly unified nation, finally accountable to the founding principle of liberty for all. While important, this analysis remains partial, and it is insufficient for understanding the deeper implications of an explicitly spatial challenge to the meaning of freedom. See especially Kathleen Ann Clark, *Defining Moments: African American Commemoration & Political Culture in the South, 1863–1913* (Chapel Hill: The University of North Carolina Press, 2006), 52.

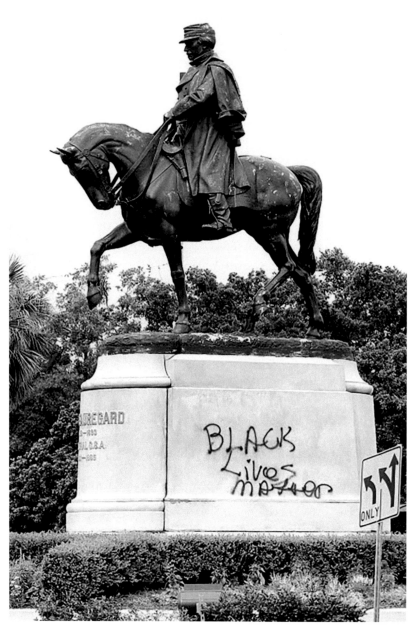

**15** Statue of Confederate General P. G. T. Beauregard with spray-painted text, New Orleans, June 28, 2015. This was one of many activist efforts to recontextualize Confederate monuments as part of ongoing campaigns for their removal. The statue was removed on May 16, 2017, after a 6–1 vote by the New Orleans City Council.

With reflective hindsight we can see this moment very differently by focusing on the people who formed Lincoln's procession, cheered for their own liberation, defied customary deference, and joyfully broke the rules. Most of those assembled lacked the forum to make any pronouncements, but they did speak with their bodies and their actions. They occupied streets and sidewalks, they entered restricted spaces, engaged in prohibited actions, and asserted their right to physical and spatial presence. They used their numbers to speak communally. The thousands who gathered to receive Lincoln in Richmond did more than welcome him, they enacted their freedom as a purposeful political body.[56]

The seizure of Capitol Square by citizens of the Black city shifted the political terrain. The long history of vernacular citizenship revealed itself through the illicit and subversive occupation of spaces, the overcoming of placelessness through mobility and collectivity, and finally, the open practice of improper politics. This enactment of freedom thus reframed the "proper locus" as the center of activity by and of the people, in any given place, on any given day.

Placing people at the center of the account, however, is far from straightforward. It requires another angle of sight and a different kind of historical process. Projects commemorating resistance must account for these layers of visibility, invisibility, and hypervisibility. Those doing the commemorating must ask: how do we see what we see? Through what frameworks and historical accounts? Who and what remains unseen?[57] These sight lines determine whose story is told, who counts in its telling, and whether the publics who engage the work will be stirred to see more than what they brought to the encounter. Unpacking these questions suggests why it is so challenging to materially commemorate the resistance *inside* the slave regime—whether through museums, memorials, monuments, or text.

If recovering the politics of Black resistance—or rehearsing of Black suffering—simply performs a reversal of the moral compass, then the project grants readers and viewers distance from past brutalities and fails to confront the modes and proc-

56 The suggestion to look at this scene from the perspective of those celebrating emancipation—whose voices and experiences went unrecorded—may be obvious to some. For others, it may be an entirely novel idea.

57 One clear way to begin this process is through collaborative design, involving community historians and stakeholders from the outset.

esses of dominance still embedded in the present.[58] The commemoration of resistance must create discomfort with dominant politics today, and confront the presumed "proper locus" of the present [Fig. 15]. Fortunately, practices of vernacular citizenship informed a definitive strand of Black politics that lives on in the work of artists such as Morrison and Wiley, and in the democratic demands of Black-led social movements.[59]

58  Octavia E. Butler struggles with what it means for the descendants of enslaved people to confront past brutalities, and the impossibility of reconciling them with the present in her novel Kindred (Boston: Beacon Press, 1979).

59 Ann S. Holder, "Citizenship at the Crossroads," paper presented at the ACS, Crossroads in Cultural Studies, Seventh International Cultural Studies Conference, Kingston, Jamaica, July 5, 2008.

# BLACK VISUALITY IN ANTEBELLUM NEW YORK

Radiclani Clytus

An earlier version of this essay was published in 2018 as: "Visualizing in Black Print: The Brooklyn Correspondence of William J. Wilson: AKA 'Ethiop,'" *J19: The Journal of Nineteenth-Century Americanists* 6, no. 1 (Spring 2018), https://muse.jhu.edu/issue/38422.

Clytus discusses accounts of an emerging nineteenth-century Black aesthetics and corresponding opposition to the denial of social and political subjectivity in media ranging from arcades and panoramas to penny newspapers. Before photography, the visual representation of African American people was primarily controlled by the American Anti-Slavery Society, which presented the African American subject as a pitiable object of persecution. At the same time, Northern periodicals depicted newly enfranchised African American citizens as comical objects of flamboyant excess. Countering these patronizing visual representations, Clytus examines the pseudonymous correspondence of William J. Wilson, whose observations as "Ethiop," the Brooklyn correspondent for *Frederick Douglass' Paper,* demonstrate an active and even sardonic Black subjectivity performed through the act of writing. Wilson's journalism provides an elegant account of his contemporaries as independent constituents of a civic body—a people emboldened by the promise of democracy through the expansion of literacy.

*All the world are taught to look at both their deeds and men through a magnifying glass of their own construction, which invariably pronounces upon all favorably. You look and behold! It is good!—To look at our men and deeds, they bid us turn the other end of the glass; and as we do so, it pronounces with equal facility upon all, unfavorably. Let us have a glass of our own, my dear Douglass, and we, too, may see and teach others to see our own men and deeds as they ought to be seen—as they are. Of its utility, none can fail to be convinced. The blacks have great men; but the world has to be shown them. They produce noble deeds; but the world must witness their exhibition, and this we must do ourselves.*

Ethiop, "From Our Brooklyn Correspondent," *Frederick Douglass' Paper,*
July 30, 1852

American literary history has not been particularly receptive to William J. Wilson's contribution to the canon of Antebellum letters.[1] This is unfortunate, because Wilson was an accomplished sketch writer whose skillful use of visual tropes and arch commentaries on Black expressive culture influenced how a generation of African Americans debated the politics of racial representation. As William Wells Brown asserts in *The Rising Son; or, The Antecedents and Advancement of the Colored Race* (1874), Wilson not only stood "at the head" of "our men of letters" but, through his "acute powers of conception ... and aquaintly-curious felicity of diction," he also roused readers "to a sense of our capabilities."[2] While writing under the pseudonym of Ethiop as the official Brooklyn correspondent for *Frederick Douglass' Paper* (*FDP*), Wilson insisted on nothing less than the graphic representation of African American subjectivity and routinely urged Black Northerners to also "paint our own picture [and] chisel our own busts."[3]

Wilson had good reason to lament the material reproduction of Black imagery within the antebellum public sphere. The second quarter of the nineteenth century saw a boom in Black periodicals, but few of these newspapers could rely solely on Black subscribers. Nor did they possess the necessary resources

1 To date, much of the scholarship on Wilson's literary career has centered on his "Afric-American Picture Gallery" (1859), an ekphrastic column in Thomas Hamilton's *Anglo-African Magazine* (1859–1860) that invited readers to tour an imaginary art gallery displaying portraits of Black subjects and other themes pertaining to American slavery. This essay provides some preliminary context to both Wilson's *Anglo-African* writings and his subsequent use of the nom de plume "Old Boy In 'Spects'" for Frederick Douglass' Washington, DC–based newspaper *New National Era* (1871–1874). For the academic reception of Wilson's writing, see Mia Bay, *The White Image in the Black Mind: African American Ideas about White People, 1830–1925* (New York: Oxford University Press, 2000); Craig Steven Wilder, *A Covenant with Color: Race and Social Power in Brooklyn* (New York: Columbia University Press, 2001); John Ernest, *Liberation Historiography: African American Writers and the Challenge of History, 1794–1861* (Chapel Hill: University of North Carolina Press, 2004); Ivy G. Wilson, *Specters of Democracy: Blackness and the Aesthetics of Politics in the Antebellum U.S.* (New York: Oxford University Press, 2011); and Carla Peterson, *Black Gotham: A Family History of African Americans in Nineteenth-Century New York City* (New Haven: Yale University Press, 2011). For a digitized edition of the columns, see "African-American Picture Gallery" (1859) in "Just Teach One: Early African American Print," *Commonplace: The Journal of Early American Life,* ed. Leif Eckstrom and Britt Rusert, http://jtoaa.common-place.org/welcome-to-just-teach-one-african-american/introduction-afric-american-picture-gallery/.

2 William Wells Brown, *The Rising Son; or, The Antecedents and Advancement of the Colored Race* (Boston: A. G. Brown, 1874), 444–45.

3 William J. Wilson, "From Our Brooklyn Correspondent," *Frederick Douglass' Paper,* March 11, 1853, in *African American Newspapers: The Nineteenth Century,* https://library.udel.edu/databases/afronews/. Accessed March 5, 2013.

to develop illustrated content. Thus, the formation of a modern Black visual culture arose from two highly politicized sites of production.

On the one hand, Black visual representational practices were transformed by the American Anti-Slavery Society (AASS), a collective of majority white evangelicals and free-thinking secularists who opposed slavery based on moral principle. Motived in part by Christian duty and the moral economy of Adam Smith, they routinely circulated images of enslaved persons and distressed wards to encourage sympathy for African Americans [Figs. 1, 2]. While AASS motifs focused on the physical abuse of the enslaved and also highlighted the social and political deprivation of free Black communities, significantly, many illustrations also trafficked in sensational tropes of cruelty [Fig. 3]. This pictorial shorthand—common to slave narratives and the visual rhetoric at large—could be read by a symbolically literate public. The 1838 broadside *Printers' Picture Gallery: Memorial of the American Anti-Slavery Society* [Fig. 4] offers a particularly clear example of how such icons and Black subjectivity in the nineteenth century were effectively intertwined. Here, various tableaus of African and African American life are represented proximate to emblems of reason derived from the Enlightenment tradition of progress, implying that for true Revolutionary Americans, the abolition of slavery was not unlike proposals for free education or public orphanages. These atomized symbols of Black personhood overwhelmingly secure the theological narratives deployed by abolitionists, but reveal very little about the actual condition of enslaved and nominally free African Americans. Beyond understanding the iconographic legibility of simple depictions of cruelty and violence, the formidable rhetoric framing these images must also be recognized as laying claim to the totality of African American experience [Fig. 5]. Such representational practices were anathema to Wilson and the Republican virtues of self-reliance and bourgeois respectability that he and other Black representatives attempted to inspire in *FDP's* readership.

At the opposite end of the ideological spectrum, mainstream white publications systematically caricatured Black

—VOL. 1. No. 4.—

# THE
# AMERICAN
# ANTI-SLAVERY
# ALMANAC,

FOR

# 1839,

BEING THE THIRD AFTER LEAP-YEAR, AND THE 63D OF AMERI-
CAN INDEPENDENCE. CALCULATED FOR NEW YORK;
ADAPTED TO THE NORTHERN AND MIDDLE STATES.

What has the North to do with Slavery?

" Have no *fellowship* with the unfruitful works of darkness, but rather *reprove* them."

NEW YORK:
PUBLISHED FOR THE AMERICAN ANTI-SLAVERY SOCIETY.

**1** *What has the North to do with Slavery?* Woodcut illustration. Title page of the *American Anti-Slavery Almanac,* American Anti-Slavery Society, 1839

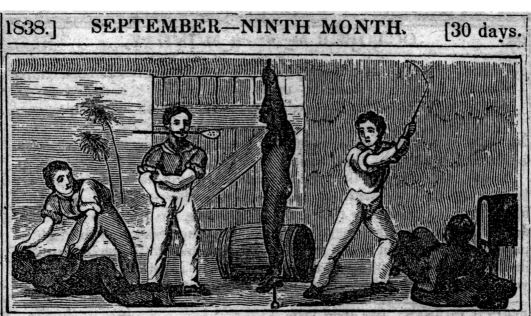

**2** David Claypoole Johnston, *All men born free and equal?* Woodcut illustration from *Oasis* by Lydia Maria Child, 1834

**3** *Sometimes a slave is tied up by the wrists* ... Woodcut illustration in the *American Anti-Slavery Almanac*, 1838

4 *Printers' Picture Gallery, Memorial of the American Anti-Slavery Society.* Engraved broadside, 1838

5 John Andrews, *Anthony Burns*. Wood engraving of the life of Anthony Burns, drawn from a daguerreotype, ca. 1855

Northerners as unfit for civic enfranchisement, rendering Black urban life as a grotesque menagerie of social ineptitude and moral degeneracy. Illustrations by E. Z. C. Judson (aka Ned Buntline) and George Foster, which began as gritty serials in New York newspapers, sought to make sense of the socioeconomic upheaval in the emerging world metropolis. Under the guise of investigative journalism, Judson and Foster, along with contemporary genre painters and caricaturists, normalized the city's tumultuous social relations at the expense of free Black communities. To counter the dominant construction of American civic identity as white and mostly middle-class, Wilson adopted the literary mode of flânerie and transformed Black street life in New York into an affective spectacle of native, democratic insouciance. Yet the true complexity of his writing comes into view in the optical prescription for "a glass of our own"; a glass in which Wilson sought to reconfigure those racial epistemologies that compelled African Americans to perceive their Black identity through the derisive lens of self-contempt.

Much has been made of the heroic, masculine, and fetishist discourse that defined the parameters of Black subjecthood before the Civil War era. Robert Fanuzzi, Tavia Nyongó, John Stauffer, Maurice Wallace, and Fionnghuala Sweeney have mined the antebellum historical record for the myriad ways in which representative Black male bodies both complied with and resisted hegemonic cultural prescriptions of nineteenth-century Black manhood.[4] More recently, Sarah Blackwood has revealed how Frederick Douglass and Harriet Jacobs used prephotographic visual technologies and the evidentiary power of the image to reinforce their literary representations and simultaneously challenge pictorial "distortions" of African Americans.

American literature has badly neglected how imaginatively Wilson and other writers depicted Black cultural life by manipulating figural vision in print. Wilson wrote in a vivid and appealing manner that contrasted stock representations of African American subjects. I will argue that the brunt of his intervention is borne out by his correspondence as the fictional persona Ethiop, who realized the vibrancy of Black New York

4  Ibid. See also Robert Fanuzzi, *Abolition's Public Sphere* (Minneapolis: University of Minnesota Press, 2003); Tavia Amolo Ochieng' Nyongó, *The Amalgamation Waltz: Race, Performance, and the Ruses of Memory* (Minneapolis: University of Minnesota Press, 2009); John Stauffer, *Black Hearts of Men: Radical Abolitionists and the Transformation of Race* (Cambridge, MA: Harvard University Press, 2002); Maurice Orlando Wallace, *Constructing the Black Masculine: Identity and Ideality in African American Men's Literature and Culture, 1775–1995* (Durham: Duke University Press, 2002); Robert Levine, *Martin Delany, Frederick Douglass, and the Politics of Representative Identity* (Chapel Hill: University of North Carolina Press, 1997); Fionnghuala Sweeney, "Visual Culture and Fictive Technique in Frederick Douglass's *The Heroic Slave*," *Slavery and Abolition* 33, no. 2 (June 2012): 305–20; and Sarah Blackwood, "Fugitive Obscura: Runaway Slave Portraiture and Early Photographic Technology," *American Literature* 81, no. 1 (2009): 112.

as a pedagogical marvel for the African and Anglo-American readership of *FDP*. Furthermore, Wilson embraced the genre of urban spectatorial literature. His fascination for the social practice of Broadway promenading both magnified the "noble deeds" of Black men and inaugurated a tradition of Black belles lettres. Ethiop's shrewd and often humorous repartee with *FDP* correspondent James McCune Smith, or Communipaw, also established a performative Black epistolary culture—or staged belletrism—wherein authorial eloquence encourages a new logic of visual experience, to both read and rehearse.

It is not difficult to understand why Wilson was recruited to Douglass's assembly of journalists. Scant biographical details that can be traced in newspapers, census records, and city registries reveal his considerable rank within New York's community of formerly enslaved and free persons of African descent. Most notably, Wilson was principal of Brooklyn's African Free School, or School Number One, from 1843 to 1863. He was also a founding member of the Egyptian Institute, a literary society that would later transform into Siloam Presbyterian Church, in Bedford Stuyvesant, Brooklyn. For nearly thirty years, Wilson championed reforms spearheaded by the Negro convention movements and was a key figure in Black benevolent and anti-colonization societies such as the New York Committee of Thirteen. He was born in rural New Jersey in 1819 and ensconced in Brooklyn by 1842. According to the 1860 Brooklyn census he owned three properties and a haberdashery in New York City, resided in the affluent interracial neighborhood of Brooklyn Heights, and possessed assets totaling some $9,000.[5]

Wilson's debut as the official Brooklyn correspondent for *FDP* on December 11, 1851, implies that his discourse is modeled on that typical of urban spectatorial literature from the antebellum era. Ethiop's pronouncement to employ his "own eyes and ears, and arrive at my own conclusions," so as to provide running commentary on "NEW YORK AS NOW," that is, on "MEN, and THINGS in NEW YORK," signals what Dana Brand and Wyn Kelley have described as the genre's aim to present the nineteenth-century city "as something that can be

5 See 1860 Federal census, Kings County, City of Brooklyn, Third District, Eleventh Ward, 1350/1595. Monetary value has not been adjusted to reflect present-day value.

read and grasped in its entirety."[6] As Jonathan Prude suggests, cities in the Antebellum North were "worrisome and puzzling exactly because they were so incontestably changeful," such that "there was a generalized desire, indeed a broadly felt necessity, to develop a firmer understanding of the urban milieu."[7]

The demystification of New York's public culture is readily apparent in the burgeoning American periodical literature from the 1820s onward, which sought: "With moral purpose—to educate and unify a diverse population—a firm commitment to middle-class values and virtues, and a mission to establish new critical standards of tastes."[8] Writers such as Washington Irving, Lydia Maria Child, Nathaniel Parker Willis, and James Alexander Houston arranged bewildering modern experiences into nonthreatening (often epistolary) narratives pitting the aloof, observant spectator against the city's unruly masses.

These perambulating wordsmiths are not, however, exactly analogous to Charles Baudelaire's concept of the flâneur, despite some kinship. The strolling observers, or *homme des foules,* outlined in "The Painter of Modern Life" (1863) and later developed by Walter Benjamin, seek "to lose all selfhood in a quasi-mystic (or quasi-orgasmic) fusion with 'la foule,' considered as an undifferentiated and anonymous mass."[9] By comparison, Wilson's Ethiop is a wandering spectator who sees the city objectively by ocular means. Notwithstanding Ethiop's faith in New York as a flourishing world metropolis and incomparably extravagant habitat, his attitude toward the city is marked by acute ambivalence. Most of his correspondence from Brooklyn relishes carnival crowds and unchecked commercial sprawl, while nonetheless resolutely indicting the prevailing race-based socioeconomic order. While the Parisian flâneur celebrated the anonymity of the individual in the city, Ethiop criticized the city's regard for the individual person of color.

The language Ethiop deploys to critique New York's social order is full of rhetorical allusions to popular literature, especially E. Z. C. Judson's *The Mysteries and Miseries of New York* (1848) and George Foster's *New York by Gas-Light* (1850). In both Judson's and Foster's work, Black New Yorkers are adjacent to Manhattan's criminal underworld: Black women are

6 William J. Wilson, "From Our Brooklyn Correspondent," *Frederick Douglass' Paper,* December 11, 1851; Dana Brand, *The Spectator and the City in Nineteenth-Century American Literature* (Cambridge: Cambridge University Press, 1995), 17. See also Wyn Kelley, *Melville's City: Literary and Urban Form in Nineteenth-Century New York* (Cambridge: Cambridge University Press, 1996).
7 Jonathan Prude, "Engaging Urban Panoramas: City Views of the Antebellum North," *Commonplace: The Interactive Journal of Early American Life* 7, no. 3 (April 2007), https://www.common-place-archives.org/vol-07/no-03/prude/. Accessed March 5, 2013.
8 Kelley, *Melville's City,* 64 (see note 6).
9 Richard Burton, quoted in Martina Lauster, "Walter Benjamin's Myth of the Flâneur," *Modern Language Review* 102 (2007): 147. For differential analysis of the nineteenth-century wandering spectator and Baudelaire's flâneur, see chapter 1, "Urban Space," in Kelley, *Melville's City* (see note 6) and chapter 4, "The Flaneur in America," in Brand, *The Spectator and the City* (see note 6).

characteristically present as diseased harlots consorting with drunkards and rowdies, while Black men figure as profligate regulars in grog shops and oyster cellars. Even the well-to-do Peter Williams, the Black proprietor of the storied dancehall Almack's, also known as "Dickens's Place," is described as a degenerate eccentric who "regularly gambles away [his profits] at the sweat-cloth or the roulette-table as fast as it comes in."[10] Popular among "thieves, loafers, prostitutes … [and] honest, hard-working people," the licentious quality of Williams's haunt in the Five Points neighborhood is only rivaled by its utter lack of architectural integrity: "The outside is of boards, discolored in various places and mismatched—as if they had been gathered together from the remnants of some pig-pen wrecked in a barn-yard. Jack-plane nor ruler never violated their mottled surfaces, and as to grooving and smooth-edging, they are as innocent of it as a wrangling couple."[11]

This mode of reportage takes its cue from earlier journalistic representations of Black urban life that encoded Black expressive culture with the taint of delinquency [Fig. 6]. Crime columns from the 1820s and 1830s regulated the mobility of all Black New Yorkers by delimiting their public profile as a mild, if threatening, nuisance. As Patrick Rael writes, inexpensive "print media sought to engrave the permanence of black degradation on the mind of an eagerly consuming public."[12] For example, the grotesquely disproportionate physiognomy of Black visages and bodies in Edward W. Clay's print series Life in Philadelphia (1828–1830) and Life in New York (1829–1835) [Fig. 7] both presage and sanction urban spectatorial literature's articulation of an inadequate and "unincorporable" black populace; for example, by linking the African American affinity for sartorial self-fashioning to crude and unmistakable representations of Black racial difference.[13] Most of these caricatures, which coincided with gradual emancipation—Pennsylvania in 1783, New York in 1827—held up Black dandyism as a "crime of fashion," to borrow Monica Miller's suggestive phrase, satirized Black speech with exaggerated malapropisms, and otherwise represented African Americans as innately inferior imitators of Anglo-American culture.[14]

10 George Foster, New York by Gas-Light and Other Urban Sketches, ed. Stuart M. Blumin (Berkeley: University of California Press, 1990), 145.
11 Ibid., 141.
12 Patrick Rael, Black Identity and Black Protest in the Antebellum North (Chapel Hill: University of North Carolina Press, 2002), 160–61.
13 Ibid., 164.
14 Monica L. Miller, Slaves to Fashion: Black Dandyism and the Styling of Black Diasporic Identity (Durham: Duke University Press, 2009), 21.

Broadway Sunday 3 May 1840.

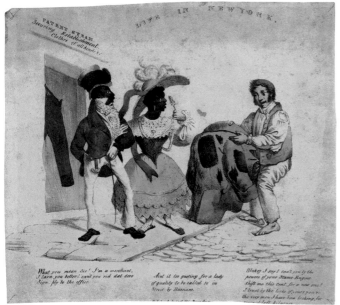

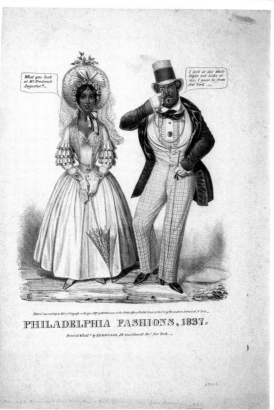

6 Anonymous, *Broadway Sunday*. Ink on paper, 1840

7 Edward W. Clay, *Life in New York,* "What you mean Sir! I'm a merchant, I larn you better! can't you rid dat dere Sign!" Lithograph, printed and published by Anthony Imbert, 1829–1835

8 Edward W. Clay, *Philadelphia Fashions, 1837,* "What you look at Mr. Frederick Augustus?" Lithograph, printed and published by Henry R. Robinson, 1837

Clay's *Philadelphia Fashions, 1837* [Fig. 8] provocatively illustrates how de facto sumptuary laws sought to curtail Black self-fashioners from transgressing the perceived boundaries of caste associated with dress. The elegantly attired couple pictured, Mr. Frederick Augustus and an unnamed companion, at first appear to be an exception to Clay's parody. However, Augustus's phallic disposition and sartorial ambition are in keeping with the racial lampooning of *Life in Philadelphia* and *Life in New York,* especially in the pejorative use of dialect: "What you look at Mr. Frederick Augustus?" Reply: "I look at dat white loafer wot looks at me, I guess he from New York."[15] Despite a seemingly subversive confrontational gaze, the lithograph's interpellation of the white loafer from New York as presumed viewer conscripts Augustus's "emboldened Black look" into the humorous mode of dandy caricature that it appears to challenge. For Clay's cunning sketch, even the idea of Black scopic resistance serves the interests of white hegemonic representational practices. In the most debilitating sense, Augustus's subjectivity is reduced to its outward expression, and thus handily objectified.

Fueling anxiety about Black sartorial refinement was the reality of a new class of Americans poised to compete for the social, political, and economic resources once reserved for white Northerners. To signify understanding of the greater possibilities that emancipation would avail them, Black New Yorkers readied themselves for civic enfranchisement by not only dressing the part, but also walking it. Consequently, Ethiop's representation of himself as a genteel dandy capable of gaining entrée to the "FASHIONABLE-SIDE" of Broadway [Fig. 9] both delineated the character of Gotham and suggested to *FDP* readers that expressive street culture yielded a crucial aspect of civic belonging:

MY DEAR DOUGLASS:—Feeling in a rather genial, or as the boy said in the potential mood, one fine afternoon last week, I brushed up my hair, put on my best collar, and made myself look as smart as possible, for one of my cut: and pulling on my gloves, sallied forth from my lodgings,

15 Edward W. Clay, *Philadelphia Fashions, 1837* (New York: Henry R. Robinson, 1837).

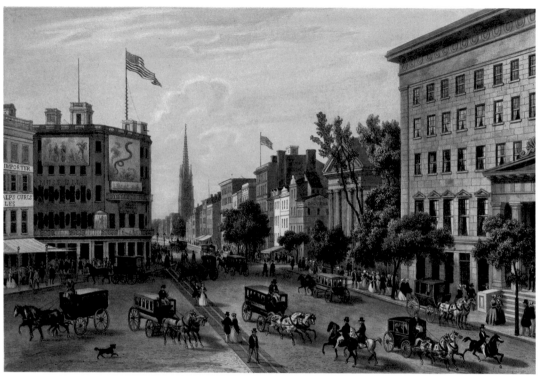

**9** August Kollner,
*Broad-Way.* Lithograph by
Laurent Deroy, printed
by Cattier and published
by Goupil & Co., ca. 1850

jumped upon the boat, and passed over into Gotham, and took a stroll about that mysterious city … Thus thinking, and sauntering up Fulton St., gazing at the wondrous sights in the shop-windows, and out of them, I was suddenly brought to a dead halt—Broadway was before me. It has been, my dear Douglass, I believe, your good fortune to cross the Atlantic, amidst peril and danger; and yet I doubt it, if at any time, you were surrounded by half as much of either as I was in my attempts to gain what is called the "FASHIONABLE SIDE" of this great thoroughfare … If, my dear sir, Gotham was one vast show, you, the looker on, you would readily perceive that the whites exhibited the two features, wealth and poverty; while the blacks exhibited an intermediate one. You would see, as I saw in this human tide, wealth, fat, proud, pompous, arrogant, overbearing, rioting in purple and fine linen, regardless of the wants around it, and as deaf to the cries of misery, as the idle flies of a midsummer's day. You would see, as I saw, shrunken-framed, thin-visaged, sunken-eyed, tattered poverty, with tottering step, reeling in uncertainty, and shaking its bony fingers, and cowering before this pomp of wealth and pride.[16]

By conflating the difficulties surrounding his leisurely perambulations with Douglass's racial struggles aboard the *Cambria*—on his trip to England, Douglass was forced to accept a berth in steerage despite his first-class ticket—Ethiop clarifies the political stakes involved in his self-presentation as a man of means. Writing as a flâneuring Black dandy for *FDP,* Ethiop reclaims that maligned subject position to establish an articulate representational discourse where there had previously been only the hypervisibility of inarticulate Blackness. This textual visualization, which speaks on behalf of the men and women of Ethiop's "cut," is inseparable from the Black dandy's characteristically brazen performativity, and the revolutionary self-possession that it signified.

The idea of Broadway as a veritable battleground for connoisseurs of fashion was understood by antebellum New

16  William J. Wilson, "From Our Brooklyn Correspondent," *Frederick Douglass' Paper,* February 26, 1852.

Yorkers. In his epistle "Broadway in August" (1843), the celebrated poet and flâneur Nathaniel Parker Willis delivered one of literature's more scathing critiques of the city's transparent inequities: "The great haunt of distressed—the Alsatia of poverty and crime—the lair of the outcast of hope and pity—borders Broadway on the East. In their recoil from the fiendish abandonment of the Five Points, the last platform between despair and death—the unhappy come to the limit of Broadway and look across."[17] To promenade toward Battery Park was to self-consciously engage in one of the city's most striated forms of social theater. At six o'clock, designated as the "grand promenade hour," with the street divided into a "shilling side," where the poor toiled and schlepped, and a "dollar side" (or "fashionable side"), where genteel shoppers aimlessly jaunted, promenaders projected or maintained their sense of civic status by adhering to or defying those sartorial distinctions between leisure and labor, rich and poor, white and Black. In this way, attire and the performance of gentility were essential to the antebellum African American notion of space. Overcoming the public stigma of second-class citizenship required the material and existential investment of the Broadway promenaders in the performance of bourgeois sociability. If only the "well-practiced citizen" was capable of "regain[ing] the fashionable side of Broadway," as Foster claimed, then "nothing could more effectually stamp you as vulgar than to be seen stumbling over the crockery-crate and second-hand furniture of the shilling pavement."[18]

The flamboyant and unruly traffic that converged onto Broadway from the vicinities of Little Africa (Greenwich Village), Black Broadway (Church Street), and Negro Plantations (Five Points) reveals a people emboldened by the social promise of democracy [Fig. 10]. This public competition for the right of self-possession is nowhere more aesthetically apparent than in Thomas Benecke's popular genre lithograph *Sleighing in New York* (1855) [Fig. 11]. However the illustration's quaint veneer of pseudorealism elides the darker aspects of the city's shifting political and economic landscape. Amid ostensibly festive social relations, the empowerment of New York's

17 Nathaniel Parker Willis, "Broadway in August," *The New Mirror,* August 19, 1843, 320.
18 George Foster, *New York in Slices: By an Experienced Carver* (New York: W. F. Burgess 1849), 9.

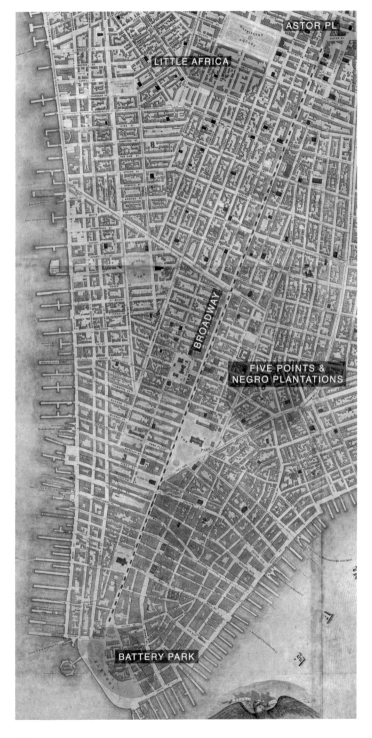

10 John F. Harrison, detail of Lower Manhattan from Astor Place to Battery Park. *Map of the City of New York Extending Northward to Fiftieth Street,* published by Matthew Dripps, 1852

expanding middle class is presented as a traffic contest: a bour-
geois couple narrowly averts an encounter with two transport
companies mired in gridlock. To reinforce the importance of
this rather quotidian affair, the scene is staged in view of P. T.
Barnum's American Museum.

The setting reflects Benecke's desire to reach a wider print
market and even encourages those ideologies of race and nation
that Barnum's exhibits often produced. Commencing with the
white steed that dramatically establishes the lithograph's focal
point, viewers are led through a chain of interpretations from
everyday symbols of antebellum life to the fray of urban types
and well-known themes from American pictorial art: snow-
ball-tossing ruffians; plaid-shawled beaus; rose-cheeked maid-
ens; the pomp of heraldry, and so on.

What ideological agendas are sanctioned by the easy plea-
sure of Benecke's tale of social hierarchy? Is there any signifi-
cance to the view of Broadway from the portico of the historical
Saint Paul's Chapel? What can be obliquely observed, here, is
the inscription of white bourgeois subjectivity as a benign racial
order. In keeping with the practice of disallowing African Amer-
icans access to public transportation and positions of civil
service (note the fireman riding atop a sleigh decorated with
emblems of local civic pride and national belonging), the only
Black figures in *Sleighing* are the couple molested as they prom-
enade north on the fashionable side of Broadway (situated in
the right foreground) and the two obscured coachmen engaged
in their menial labor as they travel south (in the background)
on the shilling side of the street.

*Sleighing* presents Black disenfranchisement as the founda-
tion for and backdrop to white bourgeois success. Not only is
the snowballed Black dandy's right-of-way obstructed by the
white couple's sleigh, but his impaired vision also accentuates
his and his companion's degraded circumstance. These comedic
insults effectively mark our Black promenaders as the brunt
of everyone's joke and signals the symbolic consolidation of
white subjectivity. As Patrick Rael so fittingly asserts, "White
[N]ortherners might concede that all white men had an equal
chance in the race of life," but the Black dandy, in the hands

11 Thomas Benecke,
*Sleighing in New York.*
Lithograph, colored by
hand, printed by Nagel &
Lewis and published by
Emil Seitz, 1855

of the mainstream press and graphic illustrators, "promised that no matter how unsuccessful one might be in that competition, someone would always be lower, and observably so."[19]

Reading Ethiop's belletristic record of flâneuring as a direct response to mainstream representations of Black Northern life (or a by-product of transatlantic abolitionism's Anglophilic fixation), however, undermines the self-expressive sovereignty prescribed in this essay's epigraph. Of course, antebellum African American thought is uniquely predisposed to paradigms of resistance, but scholars and critics should not presume Black cultural imagination of that era prioritized the political objectives of antiracism over and above Black collective self-regard and artistic innovation.[20] While Ethiop's "magnifying glass" certainly serves a counterrevolutionary Black representative politics, it is equally concerned with enabling intraracial awareness and shattering the debilitating lens through which African Americans were conditioned to see themselves. "Nor am I 'comely,' my dear Communipaw," Ethiop wrote, "especially when looked at from the *Anglo Saxon stand point,* and through the *Anglo-Saxon lenses* … both of which I suppose … you and I unfortunately have been taught to pay too much reverence."[21] Indeed, in his most pertinent passage on misapprehended Black self-regard, he reflects:

> I ought, perhaps, enlighten as now youthful understanding upon the meaning of aping. A word, then. Because the blacks perchance keep hotels, eat good dinners, or bathe, drive, fish, or have good music … as set forth in *that Bridge-port letter,* still this is no proof that they are aping whites. By no means. Because the blacks write plays, or read plays, get highly sentimental, get in love, even to the depth of Pauline, when dreaming of the beauties of *Como,* beside the *Prince Melnotte,* still these are no proofs of their aping the whites. Aping, my dear Communipaw, does not consist in doing the same as others: but in the motive that actuates the deed, as for example: Ceazar (though he could neither read nor write) took notes of his master's sermon, simply because he saw the village Squire Deacon Grimes take

19  Rael, *Black Identity and Black Protest,* 163 (see note 12).
20  See Elisa Tamarkin, *Anglophilia: Deference, Devotion, and Antebellum America* (Chicago: University of Chicago Press, 2007), 180.
21  William J. Wilson, "From Our Brooklyn Correspondent," *Frederick Douglass' Paper,* April 8, 1852.
22  Ibid., January 4, 1855.
23  Ibid., July 30, 1852; emphasis mine.
24  Wilson, "From Our Brooklyn Correspondent" (see note 21). Given its startling resemblance to the form and function of DuBois's symbolic use of the veil, Ethiop's "magnifying lens" for racial sightedness may be an influential precursor to DuBois's concept of double consciousness. Because both thinkers also theorized comparable prescriptions for Black reform, I am inclined to argue the metaphors are not mere coincidence. Like DuBois's notion of the "Talented Tenth" (1903), Ethiop repeatedly stressed the "necessity of a [culturally refined and] *monied class* among us here, who, feeling their true position would stoutly maintain their ground" and guide the "masses" of African Americans.

notes. "Ceazar," said his master, who, after looking at his hook and trammel scrawls, "this is nonsense!" "Just what I thought all the while you was preaching it," said Ceazar. This was aping. On the other hand, Thomas reads *Campbell's Pleasures of Hope* to a large audience for his and their benefit, notwithstanding his white preceptor had done the same thing before. This was not aping. Is the difference plain enough now my sir?[22]

What Ethiop proffers through his motif of optical magnification—"*we, too, may see* and teach others to see our own men and deeds as they ought to be seen—as they are"—is a direct challenge to those racial epistemologies that governed antebellum Black representation.[23] And yet, the revelations in Ethiop's "glass of our own" should not be reduced to a mere referendum on the graphic images that portrayed Black New Yorkers in a derogatory light. Rather, we should understand Ethiop's exhibitions of Black expressive culture as an outright subversion of the intraracial gaze that W. E. B. DuBois would later describe as double consciousness.[24] Hence, Black belletrism is not intrinsically symptomatic of "aping," nor should it be seen through the singular lens of a counterhegemonic contemporary discourse that obsessively identifies rhetorical resistance in Black cultural productions.[25] In Black belletrism, African Americans were encouraged to see themselves "as they are" and to recognize their social and aesthetic role in an ever-evolving representative democracy.

This measure of leadership that Ethiop qualifies as his "Black Aristocracy Pill" has its roots in Nathaniel Parker Willis's contemporaneous notion of the "Upper Ten Thousand," or the "Upper Ten," coined to refer to New York's hereditary gentry. That usage is etymologically relevant to, and clearly predates, DuBois's frame of reference. Moreover, DuBois's thesis commemorates the activism of several Black abolitionists who participated in *FDP's* correspondence column, whom he also cites throughout "The Talented Tenth." William J. Wilson, "From Our Brooklyn Correspondent," *Frederick Douglass' Paper,* January 15, 1852. For more on Ethiop's "Black Aristocracy Pill," see Wilson/Ethiop's columns dated March 25 and April 22, 1852. For more on the phrase "Upper Ten Thousand," see John Russel Bartlett, *Dictionary of Americanisms,* 2nd ed. (Boston: Little, Brown and Company, 1859), 494.
25 For a more substantive critique of the ahistorical recuperation of African American literature as resistance literature, see Jeffrey Ferguson, "Race and the Rhetoric of Resistance," *Raritan* 28, no. 1 (Summer 2008): 4–32; Kenneth W. Warren, *What Was African American Literature* (Cambridge, MA: Harvard University Press, 2011); and Ivy G. Wilson, "The Brief Wondrous Life of the *Anglo-African Magazine*; Or, Antebellum African American Editorial Practice and Its Afterlives," in *Publishing Blackness: Textual Constructions of Race since 1850,* ed. George Hutchinson and John K. Young (Ann Arbor: University of Michigan Press, 2013).

# CULTURAL TRANSLATIONS AND TROPES OF AFRICAN AMERICAN SPACE

Scott Ruff

W. E. B. DuBois's theory of double consciousness, Booker T. Washington's pragmatic industriousness as embodied in the "can-do" space, and Saidiya Hartman's discourse on everyday practices including appropriation of space, are used in this essay to examine the National Museum of African American History and Culture (NMAAHC) in Washington, DC, and Monticello, the slave plantation designed by Thomas Jefferson in Charlottesville, Virginia. The museum and the slave plantation were conceived according to contrasting approaches to the visibility of African American space: Monticello established optical as well as legal segregation through processional paths of magnificent vistas intended for the white body and hidden paths of containment and surveillance for the enslaved Black body, while the distinct presence of the NMAAHC on the National Mall in Washington is marked by a stark contrast to its surroundings. Appropriating sankofa, the Ghanaian concept of looking to the past to inform the future, Ruff describes early typologies of African American space and draws attention to their translation in the design of NMAAHC public spaces.

*"For the master's tools will never dismantle the master's house."*

–Audre Lorde[1]

The National Museum of African American History and Culture (NMAAHC) is a sign and signifier of African American space. Its presence in the landscape of Washington, DC, reinforces the centrality of African American people to the history of the United States [Fig. 1]. The building, which is based on a design by Black architects Philip Freelon, David Adjaye, and Max Bond (FAB), opened following a ceremony conducted in 2016 by Barack Obama, the first Black president of the U.S. It represents a collective consciousness of African American space that has long been obscured by historical repression of the legacy and lineage of African American people. The institution is an interplay of programs and types, simultaneously a museum, monument, memorial, and mundane space. NMAAHC thus provides space for the social collectivity of African American people and their allies, and for the archive of African American history and achievement. Forms and practices which survived the vicissitudes of slavery—ironwork methods, the porch, the stoop, the slave cabin, the shotgun house—are evoked throughout the building and expressed through performances of opposition fostered by the interstitial spaces embedded in the building. These distinctive effects are evident materially, spatially, and phenomenally in the corona, the exterior screen surrounding the museum. Inside, narratives that engage the histories of African people are articulated in permanent exhibitions. The building's cultural coding and the message conveyed by its program evince African American space—space that performs in opposition to the European architectural legacy that informed both the urban planning of the nation's capital and the design of slave plantations.

The placement of the NMAAHC is seemingly contradictory; by locating a structure that signifies African American space on the National Mall, the designers and their client, the Smithsonian Institution, have perpetuated a culture of separateness, a condition that began in the ship's hold, was sustained by slave

1 Audre Lorde, "The Master's Tools Will Never Dismantle the Master's House (1984)," in *Sister Outsider: Essays and Speeches* (Berkeley: Crossing Press, 2007), 110–14.
2 The obelisk form of the Washington Monument makes an uncanny reference to the severed penis of Osiris, the sun god of Egyptian mythology. It can thus be read as an appropriation of an African story in honor of George Washington, a major slaveholder.
3 "The National Museum of African American History and Culture, for starters, enacts a particular spatial intervention, whose semiotics aren't subtle: As many have noted, it's a big, beautiful brown thing interrupting a series of white-marble buildings." Huey Copeland and Frank B. Wilderson III, "Red, Black, and Blue: The National Museum of African American History and Culture and the National Museum of the American Indian," *Artforum* 56, no. 1 (September 2017): 253–61.

plantation quarters, and continues in the "urban slum/ghetto." For that same reason, it arguably also creates a pilgrimage site, a place of refuge, delight, and collective reflection for African American people and their allies in the way that "hush harbors" operated as secret gathering spaces on slave plantations. While the museum's design holds the African American narrative apart, its pivotal location on the National Mall provides dramatic contrast to the surrounding buildings, made of heavy stone and concrete. The diaphanous brown structure is poignantly positioned on the northeast corner of the Washington Monument Grounds, with views to the White House, the Washington Monument, and the Jefferson Memorial; the nation's first and third presidents were also significant slaveholders.[2] To the south, the NMAAHC is flanked by the National Mall, to the east the National Museum of American History, and the U.S. Department of Commerce to the north [Fig. 2].[3]

This chapter provides architectural interpretations of African American space through critical lenses—the veil and double consciousness, pragmatic industriousness, and performances of opposition in the afterlife of slavery—adapted from African American thinkers W. E. B. DuBois, Booker T. Washington, and Saidiya Hartman. DuBois authored the foundational study, *The Souls of Black Folk* (1903); Washington founded the Tuskegee Institute, a historic Black university in Tuskegee, Alabama, in 1881; and Hartman's *Scenes of Subjection: Terror, Slavery, and Self Making in Nineteenth-Century America* (1997), has been an important resource for this anthology. While Hartman is understandably critical of the patriarchal stance of her male predecessors, all three thinkers position the African American subject as separate, although in conditions that take various form.[4] DuBois's notion of the veil, or double consciousness, describes a doubled world in which the African American is one person to white people and another person to Black people.[5] Washington proposes an isolated, can-do industriousness where Black people are removed from the gaze of white society to live in utopian self-sufficiency. Slavery and its afterlife—the ongoing tyranny of white supremacy—have positioned the African American outside of architecture, in a vestibular

4 Saidiya V. Hartman, *Scenes of Subjection: Terror, Slavery, and Self Making in Nineteenth-Century America* (New York: Oxford University Press, 1997). Hartman refers to "performances of opposition" in the "afterlife of slavery" to evoke the effects and ongoing presence of the enslaved body today.

5 For DuBois the veil is neither a distorting nor interceding object of passivity. Rather, the veil opens and reveals, granting African Americans ("American Negroes," as DuBois then knew them), a kind of second sight. "After the Egyptian and Indian, the Greek and Roman, the Teuton and the Mongolian, the Negro is a sort of seventh son, born with a veil, and gifted with second-sight in this American world—a world which yields him no true self-consciousness, but only lets him see himself through the revelation of the other world. It is a peculiar sensation, this double-consciousness, this sense of always looking at one's self through the eyes of others, of measuring one by the tape of a world that looks on in amused contempt and pity." W. E. B. DuBois, *The Souls of Black Folk* (New York: Oxford University Press, 2007), 8. This second sight requires what I describe as a critical *looking-at-again*; a practice necessary to understand how racist systems operate, how they succeed, and how they fail. In *Nichomachean Ethics*, Aristotle referred to this as anticipatory or tacit knowledge of the vernacular. By necessity a virtue, second-sightedness is a positive consequence of learning to live as an enslaved person and descendant of formerly enslaved persons. Second-sightedness also informed the paths of the Underground Railroad and wayfinding through informal geography. The spatial intelligence of the self-emancipated person—traveling thousands of miles in the woods by night during winter—remains outside the scope of academic study although embedded in the bones of descendants of enslaved African Americans.

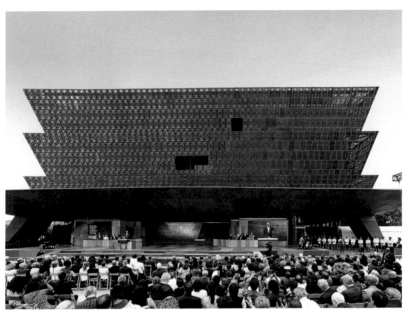

**1** National Museum of African American History and Culture, opening ceremony, 2016

**2** View south toward the Washington Mall, with National Museum of African American History and Culture to the west, 2016

condition which also applies to the oceanic passages of the transatlantic slave trade and the self-organizing undercommons that sustains Black aesthetics.[6] In contrast to the idealism of DuBois and Washington, Hartman is interested in real performances of opposition that "appropriate space for the expropriation of the object" to meet the challenges of hypervigilance: always being observed, always having to run, and always feeling trapped or enclosed. Even pleasure becomes a form of domination.[7] For Hartman, "The appropriation of space consequent to everyday practice not only enabled needs and desires to be aired but implicitly addressed the relation of the history of violence and dislocation that produced the captive and the possibilities of redress."[8] She posits that performances of opposition lead to increased spatial consciousness for the pained body.

The concepts of double consciousness, pragmatic industriousness, and the performance of opposition provide a critical and intellectual context for African American identity in architecture, through which typologies such as the slave cabin, the slave plantation, the shotgun house, the front porch of the segregated small town, and the stoop of the urban neighborhood can be articulated. These typologies in turn reflect spatial-

6 The term *Black aesthetics* here derives from Fred Moten and Stefano Harney's *The Undercommons: Fugitive Planning and Black Study* (New York: Minor Communications, 2013). Black aesthetics as a transformative politics begins in the sonic forms and moves out to include all creative practices in world shaping and world making as a collective practice.
7 Hartman, *Scenes of Subjection*, 75; 10–12 (see note 4).
8 Ibid., 72.

constructs found in the design of NMAAHC. Another is sanko-fa, the Ghanaian concept of looking back and reconnecting to one's roots or place of origin. This narrative theme often manifests in civic works but also exists in the vernacular tradition. The sankofa is a bird that builds its nest with material that remains from the previous nest. Because the NMAAHC collects disparate artifacts of the African Diaspora in the Americas for the purposes of information and education, the building can also be described as a sankofic condensation. Its design references the tiered capitals of the caryatid veranda posts from the palace of the Ogoga palace in Ikere, Niger, "an inverted pyramid which can be taken to invoke an honorific status …"[9]

In contrast to the African references of the facade, the permanent collection contains examples of the mundane dwellings that African American people have occupied since slavery. Yet even more compelling is the reconstruction of slave housing, based on historical records, including a cabin from the Point of Pines slave plantation on Edisto Island, a South Carolina Sea Island [Fig. 3].[10] The presentation of this spatial artifact is contradictory and complicated. It is at once a symbol of a time and place that evokes visceral pain in the present, and a key example of African American material culture from a critical era. Made of unrefined wood, the horizontal slats of "Point of Pines Cabin" allow light and air to pass through the structure, providing only a bare shelter from the elements. In his memoir, *Up From Slavery* (1901), Washington describes just such a shelter from his own childhood, a "cabin … without glass windows; it had only openings in the side which let in the light, and also the cold, chilly air of winter. There was a door to the cabin—that is, something that was called a door [but] it was too small … [t]here was no wooden floor in our cabin, the naked earth being used as a floor."[11] Likely added by the sharecroppers who occupied the NMAAHC cabin in the decades after the Civil War, its wooden floor and doors are a significant improvement on the living quarters Washington recalls, a fact which also makes its exhibition more palatable for an audience uncomfortable with the more grim realities of the slave condition. An artifact of inhumanity, the slave cabin that Washington grew up in also

3 A slave cabin moved from Edisto Island, South Carolina, on display in the NMAAHC exhibition *Defending Freedom, Defining Freedom: The Era of Segregation, 1876–1968*

9 Mario Gooden, *Dark Space* (New York: Columbia Books on Architecture and the City, 2016), 111.
10 Haleema Shah, "This South Carolina Cabin is Now a Crown Jewel in the Smithsonian Collections," *Smithsonian Magazine*, November 2, 2018, https://www.smithsonianmag.com/smithsonian-institution/south-carolina-cabin-has-become-crown-jewel-smithsonian-collections-180970681.
11 Booker T. Washington, *Up from Slavery* (New York: A. L. Burt Company, 1901), 3.

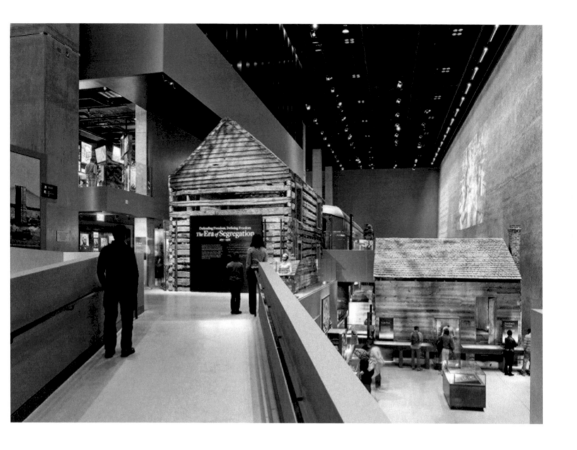

shaped his desire for material betterment, an essential compo-
nent of his pragmatic philosophy. He insisted that the Tuskegee
Institute buildings be constructed with great care and craft, in
contrast to the degraded slave quarters in which he and many
of the institute's original students and faculty were raised.[12]

The NMAAHC is arguably part of a continuum of settings
that contain the Black body and define African American space
through conditions of apartness and hypervigilance; from slave
ship to slave plantation, shotgun house to contemporary mass-
incarceration cell, and finally to a museum that surveys these
structures of imprisonment while also distancing the viewer
from the brutality of this same history. Surrounded by U.S. gov-
ernment buildings on the National Mall, the museum itself is
located in close proximity to those spaces where political events
were staged and legislation enacted to regulate the Black body, 12 Ibid., 149.

from the 1857 Dred Scott decision that denied Black civil rights, to the 1863 Emancipation Proclamation liberating enslaved persons, to the 1963 March on Washington for Jobs and Freedom, when hundreds of thousands of Black people convened on the Mall to demand civil and economic rights. Yet the relationship of the NMAAHC structure to its context—the site of significant events that have shaped African American space—is only subtly addressed by the general siting and massing of the building [Fig. 4].[13] While providing an experience for African American people to learn about their enslaved past, the museum's permanent exhibitions present a teleological overview from slavery to personhood to Obama and Oprah that is not consistent with the experience of most people. African American studies scholar Frank Wilderson has cited the assertion of the lead architect, Adjaye, that the museum has "a specific message alongside a universal message"; taking this to mean "that Black commodification has to be made palatable to white people."[14] Wilderson's point speaks to the essence of African American space, a space which exists outside of time in a transhistorical present. Black commodification can be understood as an omnipresent condition, from the slave ship to the slave plantation to the contemporary exploitation of Black sports and entertainment figures.[15]

In many ways, the museum perpetuates the cultural impact of Thomas Jefferson's Monticello slave plantation, arguably one of the most significant architectural renderings of African American space [Figs. 5–6]. As such, it provides a rhetorical foil to the NMAAHC here. Black commodification was also made palatable to white people in the design of Monticello, which framed a white viewpoint and maintained a Black enclosure. It strictly separated inhabitants by race and influenced the architecture of slave plantation houses that followed.[16] The spatial partitioning of Monticello also informed the design of separate facilities for Blacks and whites under Jim Crow segregation, as well as city planning in the North and South at the turn of the twentieth century. Once a design—especially an urban design—is in place, it can be difficult to undo. Those who live in once-segregated cities of the South and North still live under

4 Framed view looking west from the National Museum of African American History and Culture, 2016

13 Gooden, *Dark Spaces,* 112 (see note 9).
14 Copeland and Wilderson, "Red, Black and Blue," 263 (see note 3).
15 Ibid., 254. Although an apt comparison, Wilderson notes that the commodification of Black sports and entertainment figures today is of a different category than the commodification of enslaved persons historically, because African Americans have since acquired political agency that was denied to their ancestors.
16 Craig Barton, "Race and Memory in the Urbanism of the American South," in *Sites of Memory: Perspectives on Architecture and Race* (New York: Princeton Architectural Press, 2001), 4–5.

the inherited burden of a racist structure. Undoing racism therefore implies the undoing of those architectural structures that formally marginalize Black people.

The five-thousand-acre slave plantation, Monticello, was designed by Thomas Jefferson, the third president of the United States and the only president trained as an architect. It was built with the forced labor of enslaved persons. The plantation house was based on plans drawn by Andrea Palladio, an Italian Renaissance architect who designed villas that separated laboring quarters from residential quarters. Palladio's plans were determined with perspectival devices so that the spatial relationships defined in fact obfuscate the master's view of workers and services, and emphasize pastoral vistas of forests and fields typically arranged in a harmonious relationship with the main dwelling [Fig. 5].[17] Jefferson owned six hundred enslaved persons in his lifetime; Monticello housed up to four hundred. Yet a visitor to Monticello saw few enslaved persons but for butlers, maids, and servers, since the vistas from the portico were oriented to overlook the slave quarters and fields. The house slaves were lodged in windowless bunkers with brick or earthen floors that were carved into the sides of the building, which they passed through using hidden corridors. Even Sally Hemings, the enslaved person by whom Jefferson had six children, lived in one such windowless bunker in the South Wing [Fig. 7].[18] For years, a public bathroom for visitors to Monticello was erected over the top of the slave quarters. Preservationists have only recently revealed this sequestered space as it was, the poverty of which may explain why it was erased by earlier preservationists. Jefferson's efforts to disguise the slave quarters and facilities at Monticello is further evident in Mulberry Row, a series of buildings where more slave lodgings, workhouses, and housing for nonenslaved workers had been established. Archaeological work is still ongoing there, but Southern slave quarters typical to the same era were small, single-room shacks that housed multiple persons, not unlike the six-by-nine-foot jail cells that today house two persons. Surveillance and circumscription of the enslaved body was consistent throughout the slave plantation house and fields, as it is today in the design of cities and prisons.

17 Jack McLaughlin, *Jefferson and Monticello: The Biography of a Builder* (New York: Henry Holt, 1988), 62–63.

18 Farah Stockman, "Monticello Is Done Avoiding Sally Hemings's Relationship with Jefferson," *New York Times*, June 16, 2018, https://www.nytimes.com/2018/06/16/us/sally-hemings-exhibit-monticello.html.

By the standards of a modern prison, the slave cabin is an inhumane structure—it barely provided shelter of any kind, as Washington emphasized. In fact, in the years after the Civil War only a few prisons were built in the South. People serving sentences were housed in former slave plantations such as Angola, now the Louisiana State Penitentiary, and the largest maximum-security prison in the U.S. The inmates work in the field as enslaved persons did over a century ago.[19] "The logical extension of the plantation and acts of racial violence, as well as urbicide, is the prison industrial complex."[20] Slave quarters were generally hidden in the tree line, pushed to out-of-the-way parts of towns, sited on the margins and edges of the plantation, the village, the city, and the society—an isolation which encouraged alternative practices of mapping.[21] From this highly controlled space, the enslaved person could find refuge along the peripheries of the slave plantation, in the woods, and in "hush harbors" documented in antebellum slave cultures.[22] Despite the enforced conversion to Christianity, African religions were still practiced by enslaved persons in the woods.[23] Those fleeing enslavement were leaping into the unknown, erratically moving north, led by stars, landscape, rumors, and coded messages embedded in songs or sewn into quilts with occasional assistance from human guides.[24]

Enslaved persons who could be bought and sold at the whim of their owners were accustomed to a placeless condition. Yet in the era after slavery, enfranchisement and Black home ownership in particular were met with legal challenges, burning crosses planted by the Ku Klux Klan, firebombing, and even lynching for the slightest infraction—in vigilante actions that persisted through the twentieth century.[25] Referring to the pervasive violence in the lives of formerly enslaved persons, the shotgun house was so named because its interior walls were aligned such that if a gun were fired at the front door, the bullet would pass straight through the interior and out of the back of the house [Figs. 8, 9]. In comparison to the slave cabin, the shotgun house was solidly built with wooden floors and finished walls. Its narrow, ten-to-fifteen-foot wide clapboard structure was divided across the width into two or three

19 Thadious M. Davis, *Southscapes: Geographies of Race, Region, and Literature* (Chapel Hill: University of North Carolina Press, 2011), 257–334.
20 Katherine McKittrick, "On Plantations, Prisons and a Black Sense of Place," *Social and Cultural Geography* 12, no. 8 (December 2011): 955.
21 "The conditions of bondage did not foreclose black geographies but rather incited alternative mapping practices during and after transatlantic slavery, many of which were/are produced outside the official tenets of cartography: fugitive and maroon maps, family maps, music maps—were assembled alongside 'real' maps (those produced by black cartographers and explorers who document landmasses, roads, routes, boundaries and so forth. These ways of understanding and writing the world identify the significant racial contours of modernity." Ibid., 949.
22 Albert J. Raboteau, *Slave Religion: The Invisible Institution in the Antebellum South* (New York: Oxford University Press, 2004), 3.
23 Ibid., 10.
24 Jacqueline L. Tobin and Raymond G. Dobard, *Hidden in Plain View: A Secret Story of Quilts and the Underground Railroad* (New York: Anchor Books, 1999), 3.
25 "Many narratives of resistance from slavery to the present share an obsession with the politics of space, particularly the need to construct and build houses. Indeed, black folks equate freedom with the passage of a life where they would have the right to exercise control over space on their own behalf, where they would imagine, design and create spaces that would respond to the needs of their lives, their communities, their families." bell hooks, "Black Vernacular: Architecture as Cultural Practice," in *Art on My Mind: Visual Politics* (New York: The New Press, 1995), 147.

**5** Aerial view of Monticello

**6** Drawing of the west elevation of the plantation house at Monticello

7 Recently excavated room of Sally Hemings at Monticello, 2017

sections, each connected by a door.[26] The shelter could be customized in a variety of ways. And so the shotgun typology can be conceived as both modular and fractal, open to addition and aggregation. (The recursive structure of fractal forms is common in sub-Saharan Africa.[27]) The adaptation of the shotgun house to individual needs and desires marks another signature development in African American space.

The front porch was often added to the typical shotgun house in reference to the West African veranda.[28] For Blacks compelled to live on the "other side of the tracks," experiencing the city meant crossing the street when whites approached and traveling by way of networked back alleys. In this context, the porch served not solely as a casual intermediate space, but also as a multiuse environment that expanded the possibilities for public and private performance since it could either be opened or closed to the street [Fig. 10].[29] As both part of the private home and a semipublic social space, the porch was a place from which to see, and to be seen, outside the gaze of white authority.[30] And today the porch remains a site where African American people radically engage with the public sphere [Fig. 11]. In urban environments throughout the United States, the stoop

26 John Michael Vlach, "The Shotgun House: An African Architectural Legacy, Part I," *Pioneer America* 8, no. 1 (January 1976): 47–56.
27 Ron Eglash, *African Fractals* (New Brunswick: Rutgers University Press, 1999), 20–21.
28 James Deetz concludes that the American porch was adapted from the West African veranda by anonymous enslaved African persons. See Deetz, *Small Things Considered: An Archaeology of Early American Life* (New York: Anchor Books, 1996), 228–29.
29 "The outdoors and all public places then become the 'place' that is most problematic for interactions between blacks and whites, because by its very nature the out-of-doors and the in-public cannot be so completely policed and controlled as to prevent all infractions or to render Black bodies invisible." See Davis, *Southscapes*, 80 (see note 19).
30 See hooks, "Black Vernacular," 145–55 (see note 25).

and the street corner have substituted for this particular structural role of the porch. The greater visibility of the stoop and street corner also make them richer and more dynamic sites for performing opposition, or appropriating space for possible redress.[31] These sites are commonly seen as free spaces of gathering for residents and passers-by, as depicted in the film *Do the Right Thing* (1989), which circulates through the social collectivity of a number of stoops on one block in Brooklyn.[32] The public-private mediation of performances staged on both porch and stoop also indicates the uneasy relationship of the African American person to spaces that regulate the body and demand a state of hypervigilance. As vestiges of an ancient African architectural form, these sites and their continued proliferation are central to the development of African American subjectivity.[33]

In seeking to create an institutional space of memory and for gathering, the design of the NMAAHC also references the stoop and the porch by drawing upon "narratives that were emotionally important," according to Adjaye.[34] Along with the Yoruba column and the ironwork of the corona, the museum's large entry porch can be understood as a formalization of "hush harbors."[35] This is also a sankofa gesture: a looking backward, connecting, and moving forward again. Another aspect of sankofa is the manner in which the building's form is explicitly derived from an African crown. Other such sankofa gestures abound in the museum, as in the outer skin of the building that recalls African lattice work and African-American ironwork, and also refers to DuBois's veil—a critical element to see through, to operate behind, and through which to be seen by observers. This extraordinarily beautiful veil doubles as skin, a challenging interface at the limit of visibility and visuality.[36]

If the slave plantation is an inevitable counterpoint in a discussion of African American architecture, then the "hush harbor" refers to those spaces which have been cleared for performances of opposition within the built environment. The museum design can be considered a landscape of hush harbors as much as a building, through its synthesis of inside and outside, allowing both public and private exchange.[37] Made of glass and steel, the museum seems to occupy its site lightly, a fact

31 Hartman, *Scenes of Subjection*, 7 (see note 4).
32 *Do the Right Thing*, directed by Spike Lee (Brooklyn, NY: 40 Acres and a Mule Filmworks, 1989).
33 See Davis, *Southscapes*, 77–134 (see note 19).
34 David Adjaye, quoted in Mabel O. Wilson, *Begin with the Past: Building the National Museum of African American History and Culture* (Washington, DC: Smithsonian Books, 2016), 73–74.
35 Ibid., 75.
36 Ibid., 79–82.
37 Ibid., 74.

**8** Shotgun house on William Street near Railroad Street, Donaldsonville, Louisiana, 2007

**9** Sketch of a typical shotgun house by the author, 2020

amplified by the sun which illuminates the interiors by day [Fig. 12]. At night, luminosity is generated by lantern [Fig. 18]. Upon entering the building, the horizontal space of the entry porch is continued through the exhibition spaces above, supported by four large piers. Considering the external appearance of these spaces, and the impression of their airy suspension, one might expect to find a field of small support columns. Nevertheless, this porch, which denotes the entrance to the seemingly symmetrical building, is in fact a large interstitial zone that serves as connective tissue between the upper and lower portions, revealing the concourse below and the northern edge of the floating mass [Figs. 13, 15–17]. This design expands on the concept of the porch as a simple transitory zone proceeding from and sheltering the entrance of a space by transforming the typology geometrically. Not only does the porch here provide a social and formal connection between interior and exterior, but also between the museum's upper and lower levels. It is tethered to the north end by a small bridge, allowing one to walk through the building as if it were a covered outdoor space [Fig. 14]. Or one can descend from the porch by way of a spiral staircase, which provides an umbilical link between the concourse level below and the main public gathering space on the ground floor [Fig. 19]. Therefore, the porch of NMAAHC can be said to extend to the womb of the Earth itself. Understood in layers, the museum reveals itself to be a series of nested spaces starting from the bounded exterior garden and front porch, continuing through a shell that is both a material relic and threshold into the core of the exhibition spaces, where permanent displays point toward an imagined future of protective enclosures inside and outside of architecture [Fig. 20].

Through the simple if conceptually complex invocation of the past in the present, Adjaye draws upon a longer prehistory of African American space, with a sankofa approach that looks backward to ancestral precedent for new perspective. This critical looking-at-again from within and without—from the margins—attends careful readings of African American space, and it operates through the products and projects of African American industriousness. African American space must renegotiate

**10** Lesson on a porch, home demonstration work, ca. 1930–1939

**11** A birthday party on a Brooklyn stoop on Mac-Donough Street between Throop Avenue and Marcus Garvey Boulevard, from online visual essay "Goodbye Bed-Stuy," by Mattia Insolera

the boundaries of radical public engagement specific to an afflicted group obliged to carve spaces for themselves—for remembrance and redress—from the cut, where, as Fred Moten has written (after Hartman), the performance of the object meets the performance of humanity.[38] These are places akin to the twenty-minute saxophone solo in John Coltrane's *Love Supreme* (1965) which lingers devotionally in the air.

The museum and the slave plantation exist in uneasy correspondence as African American space; each memorializes a past that is continuous, evident in the contemporary violence against African American people and erasures of African American heritage and culture. Former predominantly African American neighborhoods not far from the NMAAHC, such as DuPont Circle or the Shaw District, have been nearly erased in a city that is gentrifying rapidly and eliminating affordable housing. The analysis of African American space here—in monuments, memorials, and mundane expressions—is open-ended and evokes Christina Sharpe's question, "How can we memorialize an event that is still ongoing?"[39] In some ways, the intensive archaeology of the slave plantation distinguishes it as a museum in evolution, allowing for the reinterpretation, appropriation, and contestation of the historical record. For example, I imagine a time when the slave plantation will be stripped to its base foundation, revealing the bowels and inner workings of the forced labor camp that it in fact was. This radical deconstruction of the glamorous slave plantation houses, with their elegant enfilade rooms, has already begun at Monticello and several other historical sites. That process, too, is a significant starting point for African American space.

The NMAAHC functions best as a place of social collectivity, as a front porch that provides a setting for performances of opposition on the National Mall. Its form initiates a new conversation between Black people who previously had to occupy the public space of the Mall to advocate for rights and recognition and now have a foothold on the Mall for remembrance and redress. In the afterlife of slavery, this porch is a privileged position.

38 See Moten and Harney, *The Undercommons* (see note 6).
39 Christina Sharpe, *In the Wake: On Blackness and Being* (Durham: Duke University Press, 2016), 20.

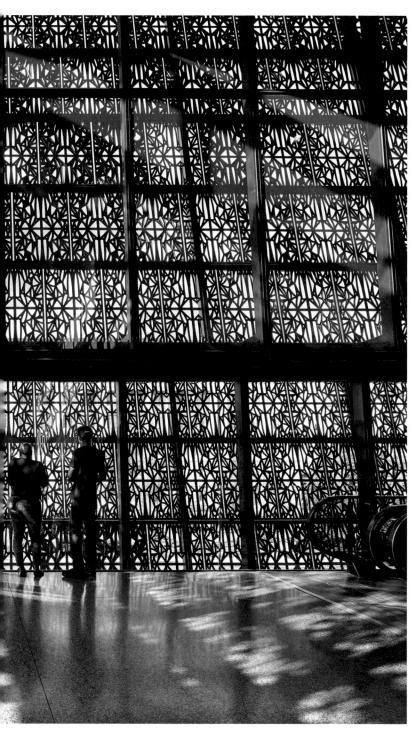

**12** Interior of the Corona, National Museum of African American History and Culture, 2016

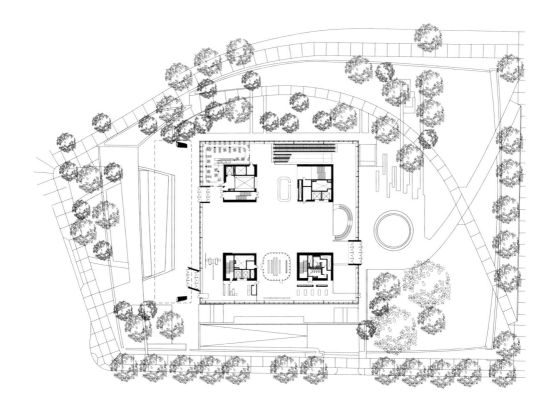

**13** Site plan, National Museum of African American History and Culture

**14** Section

**15** Lower concourse plan

**16** Ground-floor plan

**17** Third-floor plan

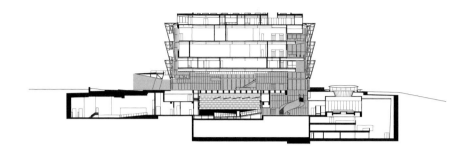

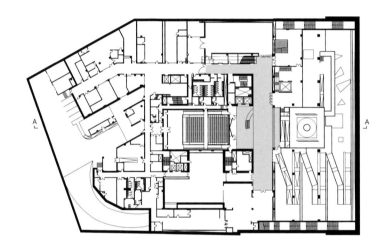

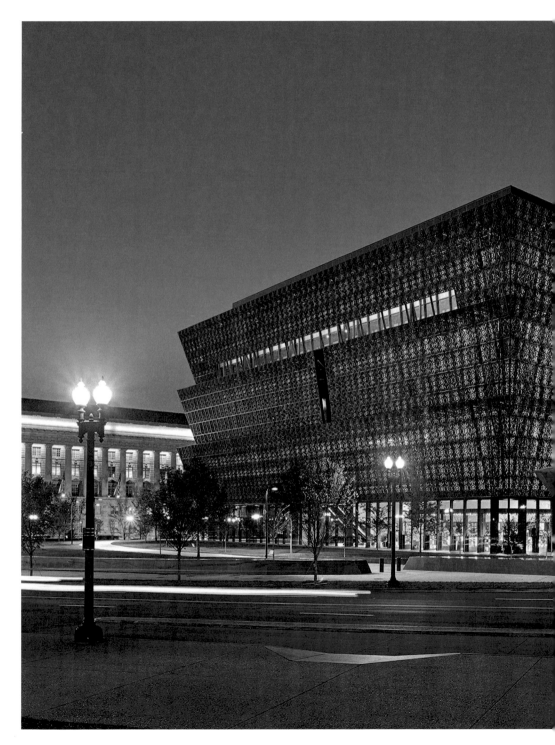

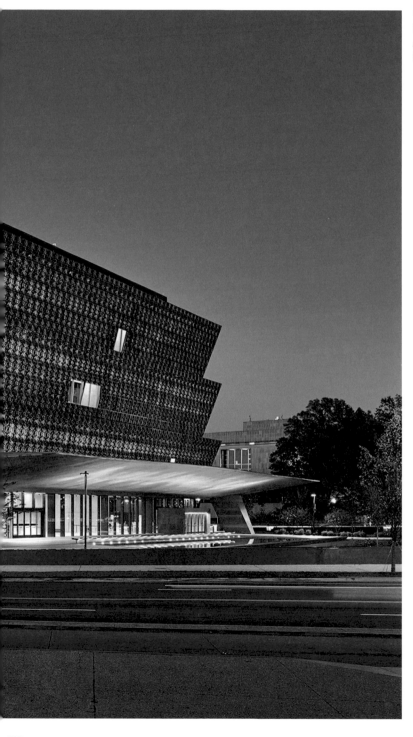

18 Night view, National
Museum of African
American History and
Culture, 2016

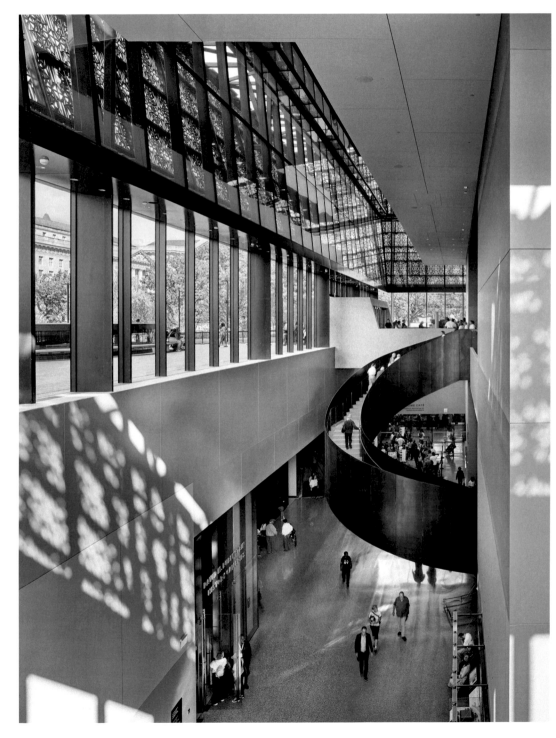

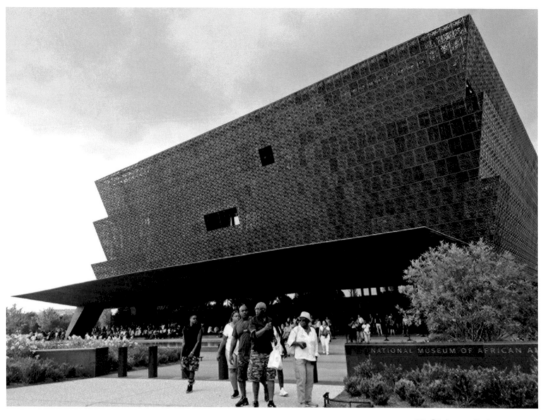

**19** Staircase to lower concourse, National Museum of African American History and Culture, 2016

**20** Front entrance, National Museum of African American History and Culture, 2017

# DIASPORIC MONUMENTS AND THE TRANSLATION OF CONTEXT

Rodney Leon

African American history and experience is intrinsic and fundamental to a collective consciousness of the Americas, including the United States. In retelling the story of Haitian Independence in the early nineteenth century and its long-lasting effects, Leon reestablishes and reasserts its relevance in the contemporary context. His practice and discourse maintain that African American space, much like the historical contributions of the African Diasporic people, must be reincorporated and reclaimed in the architectural domain. Leon discusses the ways in which personal reflections, African typologies, and the language of contemporary architecture provided sources for the design of two public monuments in New York City: The African Burial Ground Memorial, a site where the remains of 15,000 were discovered paved over by construction; and The Ark of Return, which commemorates the trans-atlantic slave trade. Both works attempt to spatialize the past, emphasizing and materializing history where it had been obliterated or forgotten. This type of erasure is opposed by the permanence of architecture.

## African American Space

There is/was/will be space that is/was/will be primarily designed
and constructed for, or reflective of, or affected by, the social,
economic, political, and historical relations called "African Ameri-
can." Because of this, I ask the following questions: What proc-
esses have been used to create these spaces, or can be used
to develop such spaces? How does one construct space that can
be identified as African American?

An understanding of context is critical here, though I do not intend
what architects traditionally mean by that term. I do not mean
the conditions that have to do with physical form or physical space.
I am not referring to the physical environment, or any process of
mapping the empirical relationships that exist in that environment.

Rather, by context, I mean the less tangible elements of culture
and history: society, the arts, economics. These are unseen
but present aspects of architecture, which can be used as tools
to generate an architectural narrative, and specifically, one for
African American spaces.

Cultural context as it pertains to the African American has been
underemphasized and ignored. The reasons for this are twofold.
As an act of self-preservation on the part of the African American,
concealing one's context can ensure safety by also concealing
one's self. Conversely, the particularity of this cultural context has
been sidelined, or even maligned, by those wishing to maintain
power through institutions of oppression. As students, as architects,
and as citizens, if we are ignorant of the hidden contexts that
we call "African American," we risk obscuring or neglecting the
potentials of African American space.

Like African American space, African American history has been
muted and dematerialized. Cultural contextuality—that is, attention
paid to context in the fullest sense—which reemphasizes, recon-
structs, and rematerializes, is necessary today. African American
space, like African American history, must not be seen as sepa-
rate from American and architectural history at large. It is a funda-

mental part of our collective consciousness and identity as Americans. In fact, African American space is inherently American. And in order for African American space to be considered, African American history and culture must first be acknowledged and understood. Rematerializing the African American context in architectural form reveals that which has been concealed. The power of architecture is to return to us our context. If it cannot return what was stolen, it can establish the memory of loss and pay tribute to resilience. Only by identifying and recognizing its existence, can African American space emerge from the limited and restrictive psychological confines of slavery and racism.

The African American cultural experience is one that is unique to, and defined by, the American experience. Africans were stolen to make America, and as a result, African Americans are, in every way, essential to what we name "American." Stolen labor, skills, and knowledge informed the building of everything from the Southern slave plantations to the large cities of the East Coast.

Some manifestations and evolutions of African American culture are familiar in mainstream American culture. Consider the African American contributions to music: from Negro spirituals to gospel, jazz, rhythm & blues, rock 'n' roll, soul, funk, house, and hip-hop. Cultural anthropologists and historians have since illustrated the connections between these genres and the African oral tradition of call and response. This demonstrates how rich histories can be referenced and cultural traditions reconfigured to operate under another set of conditions.

Just as the African American context, beginning with the African oral tradition, has been at the heart of American music, it can provide limitless material for constructing the narratives of Black space within the spheres of memorialization, design, and architecture. The impact of slavery on African American society is often considered, but its consequential impact on American society as a whole does not receive the same type of attention. This lack of acknowledgment is a blatant disavowal of the significant

1 Citadelle Henri
Christophe, northern Haiti

role that Americans of African descent had in building the United States and the Western Hemisphere.

My perspective is formed by my context as an African American of Haitian descent. Haiti was the first independent Black republic in the Western Hemisphere and was freed and founded by formerly enslaved people who banded together in armies to defeat French, British, and Spanish forces.[1] The Citadelle Laferrière, conceived and constructed after Haitian independence in 1804, was the largest of a series of fortifications built by Haitians to defend their country from attacks by French and other European forces; it is still one of the largest fortifications in the Western Hemisphere [Figs. 1, 2].[2] Located at the top of a mountain in northern Haiti, the Citadelle allowed nineteenth-century Haitians a vantage point over the adjoining valleys and the Atlantic Ocean.

The French invasion the Citadelle was built to deter never came, but the enemies of freedom and liberty found other ways to punish the nation through repayment plans, trade embargos, and political interference. The lingering results of these long-term interventions have made Haiti one of the poorest countries in the

1 For a comprehensive history of the Haitian Revolution, see C. L. R. James, *The Black Jacobins: Toussaint L'Ouverture and the San Domingo Revolution* (London: Penguin, 2001).
2 See Victor-Emmanuel Roberto Wilson and Jacqueline Van Baelen, "The Forgotten Eighth Wonder of the World," *Callaloo* 15, no. 3 (Summer, 1992): 849–56.

**2** Citadelle Henri Christophe, northern Haiti, interior courtyard

world today.[3] However the Citadelle remains a beacon and significant cultural icon: a work of architecture that monumentalizes the ongoing project of liberation as it simultaneously memorializes those who suffered and those who continue to suffer in the afterlife of slavery.

My identity as an African American of Haitian descent brings me to the context of the Citadelle Laferrière; in turn, the Citadelle brings us to the greater context of diaspora and African American history.

Consider the narrative of liberation. The Haitian armies' defeat of France precipitated the sale of the Louisiana territories to the United States. The United States was able to acquire 828,000 square miles of land west of the Mississippi River in a single purchase.[4]

3 Doctor and medical anthropologist Paul Farmer has documented the local impact of international policy on Haiti's economic and social development. See Farmer, *The Uses of Haiti*, 3rd ed. (Monroe, ME: Common Courage Press, 2006).

4 Edward E. Baptist, *The Half Has Never Been Told: Slavery and the Making of American Capitalism* (New York: Basic Books, 2014), 47.

Without the abolition of slavery in Haiti and without the successful war for Haitian independence, France would not have sold the Louisiana territories to the United States, which therefore would likely not resemble the nation as it exists today.[5] Without this sequence of events that instantly doubled the country's area, would the project of western expansion have occurred at all?

Now, consider this narrative: In 1790 Jean Baptiste du Sable, a Haitian explorer, became the first permanent resident and founder of what is today the city of Chicago.[6] The city was founded by a Black man from Haiti.

The narrative continues. Chicago hosted the 1893 World's Columbian Exposition, where Haiti had constructed a pavilion. The pavilion was inaugurated by the noted abolitionist, renowned author, former ambassador to Haiti, and former enslaved person, Frederick Douglass.[7] Recall that Haitian independence had been realized in 1804. By 1893, not yet one hundred years later, a formerly enslaved population had governed a nation-state. That this new republic, like the forty-five others at the Exposition, demonstrated its exceptionalism through a pavilion exhibition, testified to the potential of liberation. Paradoxically, the success of Haiti in the nineteenth century was its undoing in the twentieth, for this success threatened, and reignited, the vengeance of racist institutions.

My retelling of these narratives is emphatic because it is the context that informs the work I do. In my academic and professional practice, I strive to understand the culture and history at the basis of modern identity, and seek formal architectural language reflecting this condition.

The typology of memorials in urban space has been ideal for my study of context because they engage the public at the intersection of culture and history, where important social and political issues come to a head. They are physical manifestations of this intersection, evoking memory and emotion.

**3** A map that locates the "Negros Buriel Ground" and is referred to as *A plan of the city of New York from an actual survey, anno Domini, M[D]CC,LV,* created by Maerschalck and printed by G. Duyckinck, 1755

5 On the economic and political pressure Napoleon faced due to the Haitian Revolution, see Phillippe R. Girard, *The Slaves Who Defeated Napoleon: Toussaint Louverture and the Haitian War of Independence, 1801–1804* (Tuscaloosa: University of Alabama Press, 2011).
6 See Lawrence Cortesi, *Jean Du Sable: Father of Chicago* (Philadelphia: Chilton Book Co., 1972).
7 Frederick Douglass, "Remarks at Dedication Ceremonies at the Haitian Pavilion, World's Columbian Exposition, Chicago" (1893), Frederick Douglass Papers, Manuscripts Division, Library of Congress, Washington, DC, https://www.loc.gov/item/mfd.25024.

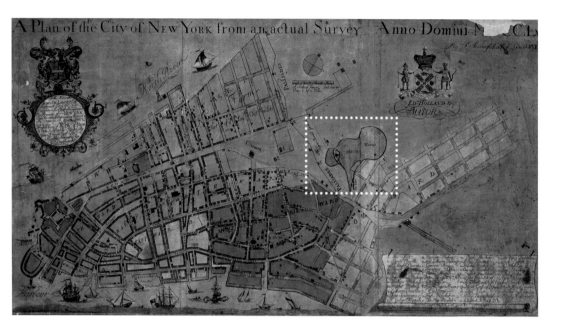

At times, exploring this context is complex and contradictory. Because memorials are both personal and public, designing them requires making a space for individual reflection and contemplation as well as gathering and celebration. Urban memorials ask a future-oriented public to pause in consideration of the past.

### The African Burial Ground Memorial

There is a misconception of American slavery as an exclusively Southern institution, but in fact, after Charleston, South Carolina, New York City had the largest slaveholding population in the United States during the eighteenth century. Under colonial Dutch rule, Africans and people of African descent in the city were permitted to bury their dead in cemeteries within its boundaries. However when the English took over New York, people of African descent and other subjugated peoples were forced to bury their dead beyond the city limits. Many did, in land just north of Chambers Street [Fig. 3]. Located on what is now Duane Street, between Broadway and Foley Square, north of City Hall, this burial site covered approximately seven acres and is estimated to contain the remains of 15,000 people.[8]

8 Andrea E. Frohne, *The African Burial Ground in New York City: Memory, Spirituality, and Space* (Syracuse: Syracuse University Press, 2015), 1, 10.

Over time, New York expanded and buildings and infrastructure were constructed on top of the burial ground, such that it was hidden from view and forgotten. Most modern city dwellers in Lower Manhattan went about their days, not knowing about the bodies that lay beneath their feet, until the early 1980s when the burial site was uncovered during the early phases of construction for a federal building. Subsequent archaeological excavation unearthed more than four hundred skeletal remains of men, women, and children.

It was necessary that I contend with this history and this context in order to create a memorial at the African Burial Ground, and I began by considering collective memory and worked to uncover any additional obscured history. The task was to convey all of this—what had heretofore been concealed—via the architecture of memorialization. A medium of communication and education, this type of architecture can facilitate the reconstruction of lost narratives, and has the power to transform a space with meaning. The context of the burial ground is broad and extends even beyond the immediate condition that exists beneath the seven acres in downtown Manhattan, for this land and those buried in it are undeniably linked to the transatlantic slave trade and to the African Diaspora. The African Burial Ground Memorial honors the more than four hundred people whose remains were recovered, as well as the 15,000 whose remains will likely never be unearthed. But it is also a sacred space dedicated to the millions of Africans stolen into slavery, whose bodies were buried in other grounds, in other lands.

As part of the tribute at the African Burial Ground Memorial, seven sarcophagi containing hand-carved coffins with the remains of the exhumed were reinterred. Although this reinterment ceremony took place in 2003, the sarcophagi are presently visible on the site as seven mounds in a grove of seven trees. It is common for visitors to place flowers upon these mounds. The alignment of the sarcophagi and the mounds of earth housing them, along with other elements of the memorial, follow the orientation of the original eighteenth-century gravesites rather than that of the current city grid. The tension thus created between the memorial and the surrounding buildings is deliberate.

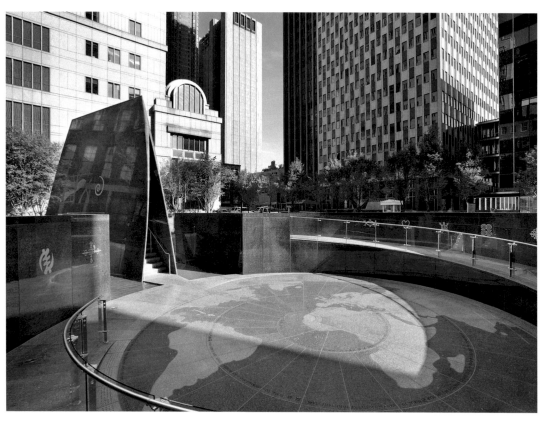

**4** African Burial Ground Memorial, view of Libation Court looking toward the Ancestral Chamber, 2007

One element of the memorial, the Ancestral Chamber, serves as
a transitional space between the secular world of the city and
the sacred space where the remains are buried. A vertical element,
it is visible on approach and distinct from the fabric of the city.
It rises twenty-four feet high, a distance which represents the
depth of the original burial site below street level [Fig. 4]. The curved
form and stone material are inspired by traditional African monu-
ment typologies.

On the exterior northern side of the Ancestral Chamber is the
Wall of Remembrance, upon which is engraved the Adinkra symbol
of sankofa and the words:

> For all of those who were lost
> For all of those who were stolen
> For all of those who were left behind
> For all of those who were not forgotten [Fig. 5]

Originating from what is now known as Ghana and Ivory Coast,
the Adinkra symbol is believed to have been carved on one
of the eighteenth-century coffins excavated from the site. It is a
symbol that represents looking to the past in order to understand
the future.

On the exterior southern side of the Ancestral Chamber is the
Memorial Wall, upon which is engraved a plan of the entire burial
ground, overlaid with the contemporary street grid of Lower
Manhattan [Fig. 6]. The burial ground site is approximately sixteen
times larger than the memorial site and the effect of these simul-
taneous mappings conveys the enormity of the original gravesite
and thus a sense of the enormity of the population that it served.

To access the interior of the Ancestral Chamber, the visitor passes
through the Door of Return [Fig. 7]. This element of the memorial
is an unobscured reference to the "Door of No Return," through
which Africans passed as they boarded the ships that bore
them into slavery [Fig. 8]. The Ancestral Chamber is a metaphorical
vessel that transports the visitor back in time, back to the homeland,

**5** African Burial Ground Memorial, view looking south toward the Wall of Remembrance, 2007

**6** African Burial Ground Memorial, view of the Memorial Wall Map that depicts the extent of the African Burial Ground, 2007

**7** African Burial Ground Memorial, view through the triangular oculus, 2007

and in descending the stairs of the Chamber, back in proximity to the ancestors.

At the bottom of the stairs, in the Circle of the Diaspora, signs, symbols, and images from Africa, Latin America, and the Caribbean are engraved around the perimeter wall surrounding the Libation Court. These images and the text that accompanies them establish a sense of the complexity of African culture, the diversity of the African legacy, and the breadth of the Diaspora itself.

The Libation Court can also be reached by the processional ramp, but either route results in the physical and psychological separation of secular street life from the spiritual and sacred space of the memorial. Inscribed on the surface of the Court is a map centered on the West African coast, showing the migration of culture from Africa to North America, South America, Central America, and the Caribbean. Visitors move through the memorial to the Court by stair or ramp, circling the walls, reading texts and moving their hands over engraved lines. The site of eighteenth-century burial is where present-day ritual takes place, linking ancestral traditions to consciousness now.

### The Ark of Return, Permanent Memorial to the Victims of Slavery and the Transatlantic Slave Trade

The design competition for The Ark of Return established a three-part theme—"Acknowledge the tragedy, Consider the legacy, Lest we forget"—which inspired me to research the triangular slave trade in order to better understand and communicate the tragic history of the forced removal of an estimated fifteen million people from Africa over a four-hundred-year period.

During my research, I reviewed historical drawings and maps illustrating the slave shipping routes as well as plan and section drawings of the slave ships themselves. The maps demonstrated the immense scale, complexity, and global impact of the triangular slave trade. The slave ship drawings forced me to consider the relationship between the human body and the vessel, and between the human body and other human bodies. Ships were packed

**8** Door of No Return,
Gorée Island, Senegal

with hundreds of people who spent months in transit across the
Atlantic Ocean, subjected to unimaginable psychological and
physical conditions. Ultimately, I also identified and documented
sixty-six slave transshipment points along the coastline of the
African continent. The most infamous location is a slave-trading
post on Gorée Island, off the coast of Dakar, Senegal, where
men, women, and children were likely held captive for months and
then forced through the infamous Door of No Return [Fig. 8] onto
slave ships for transport to the Western Hemisphere.

This research provided me not only with necessary historical
context but also inspired a formal language to communicate this
history and my ideas [Figs. 9, 10]. The form of The Ark of Return
is based on the triangulation of the slave trade maps, the organi-
zation of the slave ships, and in specific counterpoint to the Door

**9–10** The Ark of Return, conceptual sketches

of No Return. Triangulation is clearly present throughout the overall design, reinforcing the three-part theme and transforming both map and ship to inspire healing [Figs. 11–14].

The Ark of Return punctuates the UN Plaza, drawing visitors to it across the open expanse. Upon approach, the triangular aperture on the west side of the memorial becomes visible, revealing a glimpse of the memorial's first element, a three-dimensional map on the interior wall. The map is a reminder of the global scope of the transatlantic slave trade, below which the phrase "Acknowledge the tragedy" is engraved.

The procession through the Ark continues with the second element, a full-scale human figure lying in a triangular niche, facing a wall engraved with images of slave ships. Inscribed in marble below the figure, "Consider the legacy," bids contemplation of the victims of the Middle Passage, emotionally connecting visitors to the scale of suffering, while the figure's outstretched hand offers a symbolic physical connection [Fig. 14].

The third element is a triangular font cantilevered above a reflecting pool, pointing metaphorically forward toward the future. Just below the font, the names of the sixty-six transshipment points are engraved. These locations are invoked in the desire to return the spirits of lost souls to their ancestral homes. "Lest we forget" appears here, cautioning present and future generations against repeating past sins.

On March 7, 2016, I visited Gorée Island, off the coast of Senegal, and specifically, La Maison des Esclaves. Built in 1776, its exclusive purpose was holding enslaved persons after capture and preceding export. The architecture of La Maison des Esclaves—with its wings of windowless cells into which families were separated, and courtyard in which the captured were appraised—is that of oppression. This place on Gorée Island, overlooking the Port of Dakar at the edge of the Atlantic Ocean, is often considered the final exit point for enslaved persons forced to depart Africa. They were marched from their cells, through

**11** The Ark of Return,
view through the triangular
oculus, 2015

12 The Ark of Return,
view southwest toward the
United Nations entrance
plaza, 2015

**13** The Ark of Return, view
south toward the United
Nations General Assembly,
2015

**14** The Ark of Return, "Trinity" figure, 2015

**15** Door of No Return
with the author

the courtyard, underneath the second-story structure of the house,
and through the Door of No Return. While a tour of La Maison
des Esclaves suggests this very route, I instinctively did not take it.
Instead, I walked along the shoreline to enter the courtyard from
the ocean side, empowered to perform "the return." That gesture
of defiance—of intentionally breaking, or reversing a practice—
is more than the documentation of history and tragedy. In memori-
alizing, action is required to facilitate healing. This act of return
is one that I hope inspires others upon visiting the African Burial
Ground and The Ark of Return [Fig. 15].

# WEEKSVILLE REVISITED

## HERITAGE CENTER LANDSCAPE
Elizabeth J. Kennedy, Landscape Architect

## HERITAGE CENTER BUILDING
Sara Caples and Everardo Jefferson, Architects

A significant example of African American space, pursued historically and in the present day, is expressed in the community of Weeksville in Brooklyn, New York. Weeksville was founded in 1838 by formerly enslaved persons and freedmen who sought to create a self-sustaining community after slavery was outlawed in New York State. It was distinguished by its urbanity, size, and physical and economic stability, and operated at the interstices of the agricultural economy and the Industrial Revolution. A civic body of independent constituents thrived in the community until the late nineteenth century, but did not long survive the expansion of the City of Brooklyn's street grid. The last remaining structures of this utopia were rediscovered in 1968, and after years of community activism, the Weeksville Heritage Center was established to archive and preserve the area's history. Elizabeth Kennedy provides a comprehensive narrative of Weeksville and reflects on her design for its interpretive landscape. Sara Caples and Everardo Jefferson recount their inspiration for the institution's building and many integral details, as well as their design approach and process. The Weeksville Heritage Center opened to the public in 2014.

# HERITAGE CENTER LANDSCAPE

Although most people associate slavery in America with the South, African and Native American enslavement was also legal in New York State until 1827. Furthermore, few know or acknowledge that for more than one hundred years, New York City was built and maintained by the labor of one of the largest populations of enslaved persons in the United States; New York's population was second in size only to that of Charleston, South Carolina.[1] As the practice of enslavement in New York was ended gradually between 1799 and 1840, the Dutch settlers largely responsible for the state's agricultural production discovered that they could not sustain dairy farming, which required expansive acreage, without enslaved labor.[2] In deciding to farm more land-efficient and lucrative vegetable produce, as a result, many Dutch farmers sold non- and less-arable land to consolidate their holdings and operations, which made large swaths of land available for development.[3] Some previously enslaved persons and freedmen were thus able to purchase this land, and they began to form villages and hamlets in still-rural counties to continue the work they knew, although newly laboring for themselves. It was within this context that a number of African American entrepreneurs came together in Brooklyn, specifically, to establish Weeksville as one of the first communities of freedmen in the United States. By advertising in Frederick Douglass's newspaper, *The North Star,* the Weeksville founders attracted investors among formerly enslaved persons who desired agency, community, and the right to vote—which at the time, was only possible for Black voters in New York through property ownership.[4] James Weeks, for whom the community was named, was one such investor, and is believed to have self-emancipated in Virginia and subsequently worked along the Brooklyn waterfront.[5] Weeks acquired eight plots of land that were previously part of the Lefferts estate, where there was an existing community of formerly enslaved persons and freedmen.[6] The eastern limit of Weeksville extended to Hunterfly Road, a Lenape trail leading to Sheepshead Bay that was appropriated by Dutch colonists in the seventeenth century [Figs. 1, 2].

1  Ira Berlin and Leslie M. Harris, eds. *Slavery in New York* (New York: The New Press, 2005), 1–6.
2  Judith Wellman, *Brooklyn's Promised Land: The Free Black Community of Weeksville, New York* (New York: NYU Press, 2017).
3  Ibid., 24–28.
4  Bennett Liebman, "The Quest for Black Voting Rights in New York State," *Albany Government Law Review* 11 (2018): 387.
5  Wellman, *Brooklyn's Promised Land,* 51 (see note 2).
6  Ibid.

Although numerous self-sustaining rural African American settle-
ments arose throughout New York State from the mid-nineteenth
century through the turn of the twentieth, Weeksville is distin-
guished by its urbanity, size, and relative physical and economic
stability. At its peak, the community was able to support at
least seven Black institutions, including a branch of the African
Civilization Society, the Howard Orphan Asylum, the Home
for Aged Colored People, and Colored Free School Number 2.
Weeksville was densely developed, and its original lots were
smaller than those of the Hunterfly Road houses now part of the
Weeksville Heritage Center.[7] Historian Judith Wellman describes
the residents as "cosmopolitan and activist."[8] They were pri-
marily tradespeople and professionals whose political views were
expressed in *The Freedman's Torch,* one of the first African Ameri-
can newspapers-cum-textbooks. Since enslaved persons were
prohibited from learning to read, subscribers were instructed how
to do so through the newspaper itself. Weeksville also served
as an important place of refuge; self-emancipated persons
from the Southern slave plantations found sanctuary there, and it
provided a safe haven for Black people who left Manhattan during
the brutal New York City draft riots of 1863.[9]

Weeksville was resilient in the face of urban change. Although
many lots aligned with the farm grid south of Atlantic Avenue did
not survive the expansion of the City of Brooklyn's street grid
after the Civil War, new community structures were developed to
replace the old [Fig. 3].[10] Even if much of the materiality of Weeks-
ville's original community was lost, the identity of the place
remained intact until the middle of the twentieth century. Moreover,
collective memory has kept this history alive, and has also driven
the effort to sustain Weeksville's legacy and to evolve its narrative
in a new era.

The three original Weeksville structures that remain on Hunterfly
Road, and the land on which they sit, represent a powerful
starting point for contemporary restoration of the site. A trace
of Weeksville was always present in the immediate neighborhood;
the ruined houses, askew from the present-day grid, obviously

7 Berlin and Harris, *Slavery in
New York,* 255 (see note 1).
8 Wellman, *Brooklyn's Promised
Land,* 31, 40–79 (see note 2).
9 Berlin and Harris, *Slavery in
New York,* 255 (see note 1).
10 Wellman, *Brooklyn's Promised
Land,* 9 (see note 2).

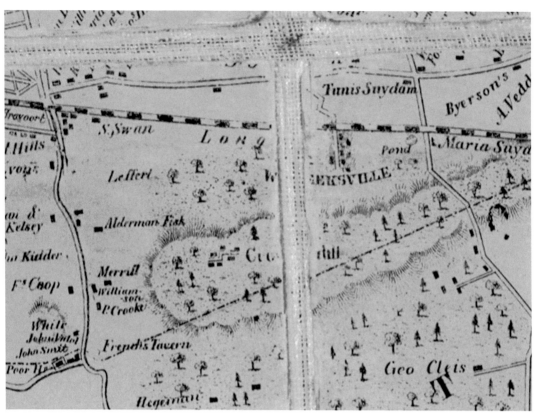

1 A map that locates
Weeksville, from *Kings
County Atlas*, 1849

**2** Route of Hunterfly Road through Brooklyn Farmlands. Frederick Van Wyck, originally printed in *Keskachauge: Or the First White Settlement on Long Island,* G.P. Putnam's Sons, 1924

**3** Hunterfly Road houses, 1904

signified its existence. But it was not until 1966, when urban designer James Hurley and pilot Joseph Haynes flew over the site and identified Hunterfly Road from the air, that interest was spurred beyond the surrounding neighborhood, and efforts to preserve Weeksville began with the founding of The Society for the Preservation of Weeksville and Bedford-Stuyvesant History in 1971. The Society became active in the community by, for example, involving and training young people and senior citizens to participate in its work, by supporting community gardens, and by planting trees to commemorate the lives of local men and women lost to violence. Customs were established in the neighborhood to ensure the legacy of Weeksville, while at the same time, the place began to resonate as a sacred site for African American communities.

Work by the office of Elizabeth Kennedy, Landscape Architect (EKLA) for the Weeksville Heritage Center began in 1998 when the Society for the Preservation of Weeksville and Bedford-

ST. MARKS AVE.

BUFFALO AVE.

**4** Diagram of Weeksville Heritage Center interpretive landscape, 2009

Stuyvesant became eligible for discretionary funding from the New York City Council. The firm was first retained as part of a team of consultants by the city's Department of Cultural Affairs (DCLA) and Department of Design and Construction (DDC) to develop interpretive master and restoration plans for the site occupied by the houses on Hunterfly Road and the surrounding land. The Weeksville Heritage Center comprises the landmark site under the jurisdiction of the city's Landmarks Preservation Commission (LPC), and the surrounding "interpretive" site where the education center building is located [Fig. 4]. In 2006 the historical landscape was restored to respect not only the archival record, but also the Society's efforts to preserve, in situ, the spirit of African community.

EKLA designers subsequently worked with Caples Jefferson Architects to develop, in conjunction with the Weeksville Heritage Center building, a landscape in dialogue with the historical houses of Hunterfly Road. The design of the place evolved through two overlapping stories: A historical one inspired by the houses and by an archaeology of land use, and a contemporary one established by the proposed building. The landscape would relate to the farm

grid of the 1830s, while the new building, which was inspired by a hybrid of African symbolism, would connect to the modern urban grid [Fig. 5].

The site was understood as a timeline—in this way, and in others, it was magical. EKLA used historical photos and alignments to document and diagram this history. Lost to vacancy, the early twentieth-century wood-frame houses that had been built around the historical Hunterfly Road houses were demolished so that much of the site was cleared. On this specific condition, Jonathan Lerner writes: "The once-hidden houses, themselves rural in character, [are] now seen at a distance unusual in this dense urban context."[11]

One goal of the landscape design was to acknowledge the erased pathway of historical Hunterfly Road, the Native American foot-path along which the old houses had been built. To achieve this, the topography of the site was manipulated through the creation of subtle mounds. A path was inserted through these mounds to highlight the course of the historical footpath as it cut across the site. In the Weeksville Heritage Center landscape, the material of this path becomes soft surface stabilized gravel at a certain point to acknowledge the fact that the original was a simple dirt road.

The orientation of the new meadow corresponds to the historical farm grid. There is also lawn area designated for active use and swales that separate landscape elements and collect site run-off. As Lerner observes: "Seen in long view, the result is a formal arrangement with the lawn areas a foreground.... The wildflower break in the swale is the end of the foreground, then the meadow is the mid-ground, and the background is the houses. The meadow is planted with a random-seeming mix of little bluestem, wild rye, and clover."[12] Sculptures further engage the landscape. It was a specific intention to foster a sense of overgrowth and aban-donment, thereby referencing not only the lost agricultural history of Weeksville but also the neighborhood's recent experience of urban decay.

11 Jonathan Lerner, "Unearthed and Unforgotten," *Landscape Architecture Magazine*, September 9, 2014, https://landscapearchi-tecturemagazine.org/2014/09/09/unearthed-and-unforgotten.
12 Ibid.

A second project goal was to emphasize the site's historical land-use patterns.

Fragments of the city's land use history can be found in off-grid street alignments and slivers of undeveloped land behind multi-story apartment buildings. The richness of these interstices is lost when their meaning as places is underestimated or ignored. Ordinary places are fragile: their significance hides in plain sight, meaningful to those whose stories are grounded there, and invisible to others who are, or are content to remain, outsiders.

In resilient communities, loss or erasure is inevitably followed by a quest to recover that which has gone. From its founding by freedmen seeking lost agency to the establishment of the Weeksville Heritage Center as an important cultural institution, the long narrative of Weeksville embodies this search.

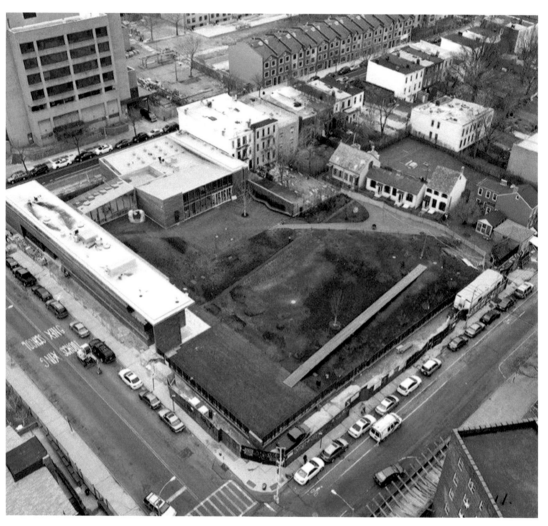

**5** Aerial of Weeksville
Heritage Center landscape
showing bridge crossing
ruins, 2009

**6** Long view of meadow and Hunterfly Houses, Weeksville Heritage Center, 2014

# HERITAGE CENTER BUILDING

Weeksville is a living cultural resource. The dual mission of the Weeksville Heritage Center is to preserve the rich history of this community and to serve as a dynamic institution fostering contemporary African American culture through scholarship, art, and performance. The relationship between the historical houses of Hunterfly Road, the farm, and street grids is emphasized in the landscape design of the site. This continues in the design of the new building, in that its entry is located precisely where Hunterfly Road intersected with the urban street grid. In addition, there is a rich distinctiveness where modernist forms meet African symbolism throughout the Weeksville Heritage Center.

When Caples Jefferson was founded in the late 1980s, we pledged to conduct more than fifty percent of our work in communities underserved by the design professions. As such, our projects are based in predominantly African American and Latinx communities whose constituents respond to different architectural cues than those we were trained to acknowledge as students of architecture at Yale University. We seek ways to speak directly to the rich histories and spiritual aspirations of the communities we serve. To this end, the specificity of place and the specificity of circum-stance are of paramount importance to the design we practice. Rather than pursue a singular solution or singular means of expressing African American culture, for example, we attempt to broaden a project's architectural language and respond with precision to each distinctive challenge.

When we began work on the Weeksville Heritage Center, the Weeksville Society urged us to look beyond the nineteenth-century farmstead for a comprehensive view of African and African American history. The society's members thought the new center should connect to the totality of Black experience in Brooklyn: from Africa to the Weeksville ancestors, to Afrocentricity and radi-cal movements in the 1960s, to the present. There were, however, other project stakeholders who thought the new building could and should derive from European precedents so as not to diminish

1 Final model

the presence of the historical houses of Hunterfly Road. The design solution, then, had to satisfy these opposing positions.

In the form-making logic of the Bauhaus tradition, we first created a series of geometries responding to the historical houses, then layered these with African patterns derived from art produced on the African continent. Patterns were not simply applied as decoration; rather, they were used as space-making devices. We studied ways to apply patterns not only in two dimensions but also three, through the use of light and shadow.

For the Heritage Center massing, we were cognizant of the historical houses as well as others in the neighborhood; the tall single-story spaces and stacked double-story spaces of our gateway building are in keeping with the height of those around it [Fig. 1]. The building layout relates to the one-acre landscape designed by Elizabeth Kennedy. Kennedy softened the site contours and incorporated agricultural plantings reminiscent of those in Weeksville's nineteenth-century homesteads. She also removed sections of the walking path along the old Hunterfly Road so that they now appear and disappear, leading the visitor from the modern

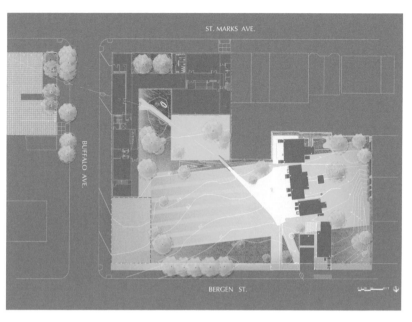

city's street grid to the site of what had been the freedman's village [Figs. 2, 3].

The building plan is an L-shape; it runs parallel to Saint Marks and Buffalo Avenues, anchoring the corner where they meet. From this corner, the historical houses stand diagonally across the site. What emerges at the site boundary is a composition of alternating solids and voids—of old and new building juxtaposed with openings to the landscape.

The extended, linear form that runs parallel to Buffalo Avenue is connected to the forms with sloping roofs on Saint Marks Avenue by a glass-roofed gallery [Figs. 4, 5]. This gallery serves as a transparent connector that begins in the Buffalo Avenue wing and runs along the landscape-side elevation to provide uninterrupted views of the historical houses from the building interior. Where the connector turns ninety degrees, simultaneous with the street grid, it becomes a transparent element along Saint Mark's that allows passersby views of the site from the sidewalk. The wing along Buffalo Avenue has two additional apertures: the fifty-foot-wide entrance in the path of former Hunterfly Road brings visitors

**3** Conceptual sketch

in from the street, guiding them along the route Weeksville settlers
would have taken; and along Buffalo Avenue, toward Bergen
Street, the facade breaks down, leaving behind a void where the
roof and exterior wall meet, and framing an important view of
the historical Hunterfly Road houses [Fig. 6].

A variety of spatial types within the building accommodate
multiple programs. Our approach to this project involved coding
primary art and performance spaces with sloped ceilings. In
addition, we made the glass-roofed gallery and other areas wide
enough to host interactions among visitors to the Heritage Center
and to serve as informal spaces for pause and reflection [Fig. 7].
The classrooms, library, shop, and offices are more conventional
and rectangular in form but benefit from strategically placed glass
to accommodate daylight.

We selected materials that would evoke the richness of West
African art. The upper floors of the building are made of African
wood; the rich brown ipe is complemented by a rough-hewn slate
base. The slate is cut and inserted in a pattern so that the texture
is reminiscent of scarification. Many of the exterior materials carry

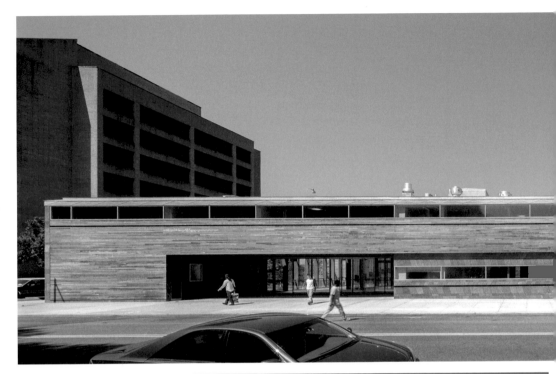

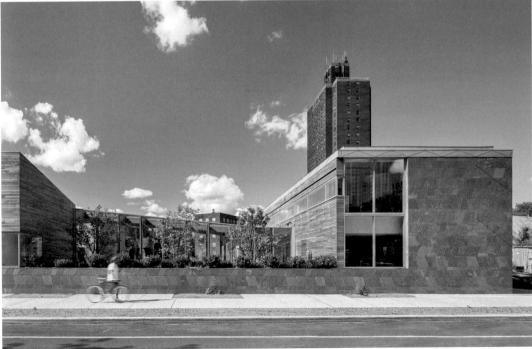

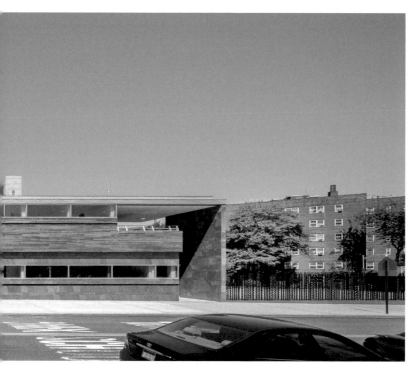

**4** Building facade,
Buffalo Avenue, 2014

**5** Building facade,
Saint Marks Place, 2014

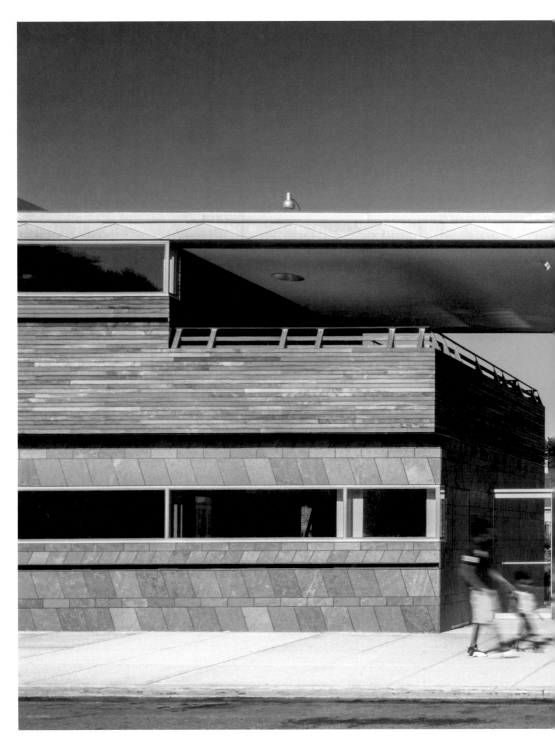

**6** Building framing
the historical houses
in the distance, 2014

through to the interior. In the glass-roofed gallery, there are also custom-shaped cast stone floor tiles and millwork cut with patterns that evoke cornrowing [Fig. 9].

Many people cautioned us against the use of patterns, which might seem cliché—or worse, be misunderstood as applied ornament and distract from the space. But we persisted by incorporating these directly into the design; for example, by arranging structural elements of the glass-roofed corridor in configurations that evoked African baskets, and by fabricating a custom picketed cast-iron fence with patterns sourced from African art to create a complex rhythm on the street.

The colors employed in this project also derive from West African art. Including the natural deep browns of the ipe wood and the black walnut millwork, there is green in the slate, purple applied to the entry ceiling, deep red in the performance room, and pumpkin yellow in the glass-roofed gallery [Fig. 10].

The placement of the building forms and openings are optimized for its orientation on the site. As such, daylight reaches more than 90 percent of the occupied spaces of this LEED Gold building. An instance of this is where the high windows lining the east side of the long, open office area on the second floor of the Buffalo Avenue wing maximize morning light; whereas the windows along the west wall are set lower to minimize afternoon glare and to direct views toward the rolling landscape and historical houses.

We knew that light would have a powerful effect on the user's experience and focused on making shadows that would draw attention to the patterned objects casting them. In the glass-roofed gallery, the central panes drop a darker shadow than those at the edge of the ceiling [Fig. 7]. This shadow pattern moves with the sun, so visitors may see it one way upon arrival at the Heritage Center and another on departure. When the sun shines, the pumpkin-colored roof supports cast shadows onto the floor and are simultaneously cast upon, themselves, by a custom frit based on a Congolese fabric once owned by Henri Matisse [Fig. 8].

Along the sidewalk at the perimeter of the site, fence pickets throw shadows of their distinctive forms. These layers of pattern help to create an immersive experience for all who visit the Weeksville Heritage Center [Fig. 11].

Today, Weeksville is no longer hidden in plain sight. Caples Jefferson's design for the Center aimed to produce a place to celebrate African American heritage and to serve as a hub for vibrant, ongoing African American creativity.

Beyond the accolades received for the design, it has been gratifying to attend the important cultural events held at the Heritage Center, and to hear people say they feel good at Weeksville, that it is their home.

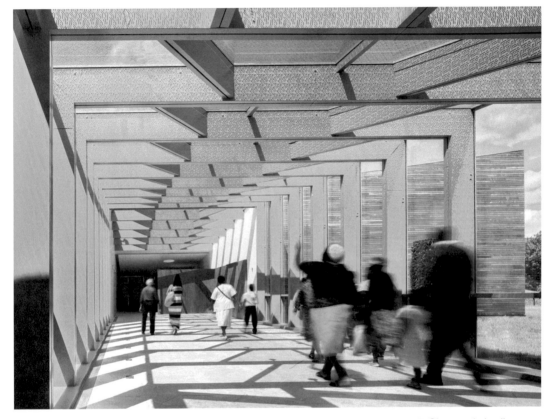

**7** Glass-roofed gallery and shadows

**8** Frit and shadows

palette

FIELDS & EPISODES

**9** Patterns sketched
for glass frit, paving,
and acoustical paneling

**10** Colors and patterns

**11** Fence shadows
on the sidewalk

# EMBODIED SILENCES: THREE MEDITATIONS ON MAPS, MUSEUMS, AND MONUMENTS

J. Yolande Daniels

Architecture is a medium for both speculative and commemorative forms of social advocacy. Daniels reveals this across the presentation of three design and installation projects that are respectively situated in a colonial era municipal monument, a typical shotgun house, and a cultural institution. Daniels draws on social and spatial narratives from the suppressed histories of the African Diaspora to theorize legacies embedded in built form. Beyond undertaking research outside official records, the consideration of absent artifacts is integral to this discovery process, which is codified as *negative monumentalization.* The objective is to transcend the effects of ignorance, fear, and violence against Black people, which often serves to erase the historical accounting of racialized subjects.

Daniels's investigations reveal the often imperceptible connection between present and past that participates in shaping the contemporary built environment. The essay argues that apprehension of African American space can be achieved through direct experience that reincorporates ellipses produced by historical suppression and effacement.

In the context of dominant societies and history, Black space, like Black culture, has often been masked, coded, hidden, erased, and even destroyed.

For the design-research projects described here, the literal and rhetorical spaces of maps, museums, and monuments serve as sites to explore the genealogy of space—both historical and contemporary—to understand the impact that race has on the constructed environment. Social, political, and cultural narratives and constructions that range from texts and images to objects, buildings, and spaces are the media of these projects. They reveal often imperceptible meanings and spatial logics obscured by disconnected events that have occurred over time in a particular location. Knowledge of the formal elements and concepts that have shaped space provides context and criteria for the built forms that we inherit, inhabit, design, and build. Such knowledge is particularly necessary to counteract the historical evasions of colonialism and past erasures caused by the destruction of records and the devaluation or decomposition of artifacts. Contrary to the material- and object-oriented discipline of architecture, the very lack of such material and objects is a central concern of this research.

*Silent Witness* (2001) is a multimedia design-research project that initially took the form of an illustrated essay, "Silent Witness: Remnants of Slave Spaces in Brazil," and was later realized as an installation [Figs.1–6].[1] Here, text and images work together to interrogate space and to embody an unrecognized aspect of the transatlantic slave trade in Brazil by registering absence. I wanted to make space for the unacknowledged trauma of histories of oppression, such as slavery, that are often hidden in plain sight.

Writing the essay produced a confrontation with myself as author. Working within the confines of an academic discipline raised specific questions: How could I maintain the critical distance needed to theorize spaces of captivity and subjection of people analogous to my own ancestors? And how could I use text and image to critique the notion of critical distance itself? I addressed

1  Yolande Daniels, "Silent Witness: Remnants of Slave Spaces," paper presented at the Whitney Independent Study Program: Critical Studies Symposium, Whitney Museum of American Art, New York, 1998.

**1** Corner projection installation, *Silent Witness,* Casa Dos Contos, 2001

these questions by inserting my (empirical) experience into the (objective) essay. Later, I extracted these personal elements to be the focus of an installation.

The essay examines Brazil's preservation and documentation of artifacts of the transatlantic slave trade in contrast to the absence of corollary archiving in the United States at the time. And it outlines the concept of negative monumentalization, a practice of theorizing societal and spatial legacies in the absence of artifacts.

A primary example of negative monumentalization is the Casa dos Contos in Ouro Preto, Brazil, a government building historically used for tax collection and for warehousing commodities and chattel, ranging from gold to enslaved people. Preserved as a municipal monument today, Casa dos Contos is intended to com-memorate the splendor of regional mining. Although most of the building's spaces are documented, the slave quarters, while physically present, are not designated on official floor plans. This absence represents a lack of acknowledgment of the historical presence of the Afro-Brazilian in Casa dos Contos and registers an act of erasure. It produces a negation that prevents the identities

**2-5** Corner projection installation, *Silent Witness,* Casa Dos Contos, 2001

of particular national subjects from being resolved. As such, it leaves them out of the acknowledged historical record through which national narratives flow and register progress.[2]

While official narratives are consolidated in symbols such as monuments and museums, the absences in historical narratives produce a labored, embodied silence which has the potential to counter established symbols and authoritative artifacts.[3] The absences and embodied silences become known through observation and persistent effort. Together they cohere as negations and acquire agency the more they compound. This gradual process develops through and despite absence; it is a negative monumentalization.

The negative monument exists outside the value systems of art and history, to which official monuments belong. It combines aspects of the unintentional and involuntary monument as defined by Aloïs Riegl, whose theory of monumentalization includes the confluence of a physical marker and collective memory, which together may generate unintended meanings long after conception. Meaning, as a projection, is open to interpretation beyond official records; value ultimately derives from memory and involuntary societal reflexes.[4] The negative monument thus liberates these projected meanings—the "syntax of silence" of official value systems—by resonating from a past that calls them into question.[5] And through this resonance, traces of the erasures that often shape official texts and cultural forms subsist to become "residual and emergent cultural forms."[6]

The images used to illustrate the essay document the house and slave quarters in Casa dos Contos and evoke the emotional and spatial experience I had in Brazil. My response to the contemporaneous condition of the monument was to rewrite the absent slave quarters over the official architectural plans and sections. To realize the installation *Silent Witness,* I highlighted my experience of the slave quarters and materialized a spatial condition resonant with the historical structure by projecting photographic images taken on site into a corner of the room. This

2 See Benedict Anderson, "Census, Map, Museum," in *Imagined Communities: Reflections on the Origin and Spread of Nationalism* (London: Verso, 2006), 163–85; and Homi K. Bhabha, "DissemiNation: Time, Narrative, and the Margins of the Modern Nation," in *Nation and Narration,* ed. Homi K. Bhabha (London: Routledge, 1990), 310–11.
3 "Embodied silence" is my elaboration of the semiotics of silence described in Raymond Ledrut, "Speech and the Silence of the City," in *The City and the Sign: An Introduction to Urban Semiotics,* ed. Mark Gottdiener and Alexandros Ph. Lagopoulous (New York: Columbia University Press, 1986), 115.
4 Aloïs Riegl, "The Modern Cult of Monuments: Its Character and Its Origin," trans. Kurt W. Forster and Diane Ghirardo, *Oppositions* 25 (Fall 1982): 23–24.
5 Bhabha, "DissemiNation," 310 (see note 3).
6 My application of "residual and emergent forms" to define the negative monument draws from Raymond Williams, "Base and Superstructure in Marxist Cultural Theory" in *Problems in Materialism and Culture: Selected Essays* (London: Verso, 1997), 40–41.

spatial superimposition also elongated the projections along the axis of movement within the slave quarters, giving the viewer a heightened sense of walking past the entry befouled by toilet sewage and toward a ledge elevated above the floor at the rear.

> *Along a path of radial paving stones, adjacent to the courtyard where the whipping post was located, one passes through the great hall until a small stair is visible. This stair has a landing seat, now a wooden board painted blue or green. A hole in this plank indicates a primitive toilet seat. Through this hole a vertical chase can be seen, carved roughly into the rock wall below. The chase travels down. It once carried a trailing stench* [Figs. 2–5].

> *Behind the stair, a trough empties at an opening in the black rock wall. One-inch-thick vertical iron bars define the view outside through this opening. A stream lined with wildflowers cuts through broken rocks that are black like the walls. Through this opening, adjacent to both sewer and stream, a deeper space becomes present. It is a space of fiction, a space of history, a liminal yet habitable space in which the present and past meet, circulating and exchanging around my body* [Fig. 6].[7]

> *The space registers as layers of blackness, through which roughhewn walls, floor, and a ledge begin to appear. Nearly five feet high, the ledge emerges and recedes again into the darkness. The only light source comes from behind a series of barred openings. I can see the perpendicular rock ledge has been worn into a soft curve. Its surface contains two carved indentations. With one foot in each hold, it might be possible to hoist oneself up. Although I try to reach the ledge, the foothold is too high. I am unable to lift myself there.*[8]

7 I used this refrain of "liminal text" to rewrite the undocumented spaces of Casa dos Contos for *Silent Witness.*
8 This text recounts my experience of the slave quarters after my first visit to Casa dos Contos in 1995.

A space of fiction, a space of history, a habitable and liminal space: In it the past and present meet and they circulate in exchange about my body.

**6** "Inscriptions: Liminal Space," *Silent Witness: Remnants of Slave Spaces,* 1999

7 House 2, Project Row Houses, Houston, Texas, 2001

8 Digital image, *intimate landscapes,* 2001

9 Sketch, *intimate landscapes,* 2001

A second project, *intimate landscapes (of the shotgun house),* 2002, was installed at Project Row Houses in Houston, Texas, as part of the exhibition *Row: Trajectories Through the Shotgun House.*[9] Of the eight shotgun houses, I was given one that had been stripped of interior partitions and painted white to serve as a conventional gallery space. Triggered by this literal act of whitewashing, I sought to recontextualize and engage the physical space through a play of material and metaphorical states, using light and shadow.

The whitewashed house was neither isolated nor empty [Fig. 7]. The doors, windows, rooms, and porches of the adjacent houses aligned to create connective paths, while the daylight and shadows indoors, and in the rear courtyards between adjacent houses, created a soothing atmosphere. These material qualities reinforced the communal network in which the houses were situated on the block. In response to this condition, *intimate landscapes* used light, shadow, and reflection to evoke slippages between the physical presence of the house and the metaphors projected onto it. These materials became media with which to retrace domestic relationships within the house. Much like the installation *Silent*

9 The group exhibition was curated by David Brown and William Williams with support from Project Row Houses and Rice University. See David Brown and William Williams, eds., *Row: Trajectories Through the Shotgun House* (Houston: Rice University School of Architecture, 2002). *intimate landscapes* was a project of studio SUMO, my office in New York. The team consisted of myself and Sunil Bald.

*Witness, intimate landscapes* attempts to embody absence [Figs. 8–16]. Falling shadows and projected text produced a spatial resonance, allowing traces of an undocumented past to register in the present.

The shotgun house typology is often associated with poor communities in the rural South. Modest in size and generic in quality, the house is framed by a metaphorical narrative derived from the alignment of the front and rear doors, such that an unobstructed path for shotgun pellets is formed. The collapse of violence onto the house encapsulates cultural antipathy to the presumed inhabitants and eclipses the domestic nature of the environment. My study of the genealogy of the shotgun typology traced back to slave-plantation housing, and through the transmission of culture, even further back to traditional West African dwellings. I expanded this research to include material analyses of Southern slave-plantation architecture by Jon Vlach and Rhys Issac, which reveal clandestine trails blazed by enslaved persons into the countryside and surrounding woods. These paths formed alternate circulation systems between neighboring slave plantations using fields, marshes, woods, and waterways to build clandestine and loosely structured networks that crossed property lines.[10]

10 Jon Vlach, *Back of the Big House: The Architecture of Plantation Slavery* (Chapel Hill: University of North Carolina Press, 1993).

**10–12** *intimate landscapes,* 2002

**13** General view of light and shadow effects caused by text/screen applied to windows, *intimate landscapes,* 2002

Acknowledging the historical network of secret paths—counter to the direct passage implied by the shotgun typology—was a critical provocation of the research and the installation. These paths had embodied the possibility of agency for enslaved persons; for *intimate landscapes,* they drove the conceptual development of material and metaphorical states integral to the project. The row house interior was zoned as a slave plantation network. Three domestic scales were represented: the collective or field, the family or hearth, and the individual or self [Figs. 8, 9].

Meditating on the architectural discourse of the house brought forth the question of domesticity in the shotgun typology. I searched for domestic traces of the house that could be drawn from the historical record, including the firsthand accounts of self-emancipated and formerly enslaved persons. While I was able to find some threads in these narratives, I unexpectedly discovered several which conveyed the fact that the will, thoughts, and feelings of enslaved persons on colonial slave plantations were not wholly subjugated.[11]

For the installation, these texts were screened on the windows of the house. The passing of the sun projected their words across the space. The shadows produced by the text evoked the shadows produced by the light-dappled tree leaves in the rear courtyards [Figs. 15, 16]. Narratives that expressed self-determination were located in "the breezeway" of the shotgun house. Those describing family and loving commitment were positioned over "the hearth." Others reflecting community and gatherings outside the auspices of slave plantation law were located in "the field."

The literal and metaphorical paths of the shotgun house were transposed; the footprints of once-removed partitions were cut into the floorboards, while the thoughts and words of individuals once captive to the slave-plantation system were projected across the interior. The shotgun house was remapped over the course of one day. Material and metaphorical states modified each other in the interplay of light and shadow, evoking a

**14** Press type on glass, *intimate landscapes,* 2002

**15** Detail, press type on glass, *intimate landscapes,* 2002

**16** General view of light and shadow effects, *light dapples,* at exterior of the shotgun house, *intimate landscapes,* 2002

11 Selected texts were drawn from collections including: *Born in Slavery: Slave Narratives from the Federal Writers' Project,* 1936–1938, United States Work Projects Administration records, 1524–1975, Manuscript Division, Library of Congress, Washington, DC, http://hdl.loc.gov/loc.mss/collmss.ms000008; and Julius Lester, *To Be a Slave* (New York: Dial Press, 1968).

dynamically changing landscape of intimacy and connectivity
and honored the self-determination that existed despite repression
[Figs. 13–15].

*intimate landscapes* created a means to expand the notion
of domesticity—and by inference, civility—by recounting the lives
of formerly enslaved persons in an intimate space, revealing
their self-determination and their desire to inhabit private domestic
space and to entertain a private self.

17 Gallery interior, MoCADA, 2006

The third and final design-research project outlined here is The Museum of Contemporary African Diasporan Arts (MoCADA), located in the Fort Greene neighborhood of Brooklyn, New York [Figs. 17, 18]. It was produced in 2006 for a client with the overall goal to design a dynamic museum space with flexible galleries.[12] The client brief also contained a request to install a map of Africa in the reception area.

In fulfilling the installation request, as the lead designer, I decided that a map of the African Diaspora would be most relevant, given the museum's mission. My desire to create slippage between two-dimensional and three-dimensional space led to the spatial-ization of the map. While the installation in the reception area in fact functions as a two-dimensional map applied to wall surfaces, the third dimension is dynamically enacted by way of extruded graphic elements which project out from the wall to form built-ins, such as shelving and other reception furniture, that meet programmatic needs. The map was drawn within the abstracted field of global time meridians to emphasize the historical migrations that define the African Diaspora in cities across the world over and above

12 MoCADA was another project of studio SUMO. The project team consisted of myself, Sunil Bald, and Laura Lee.

**18** MoCADA, 2006

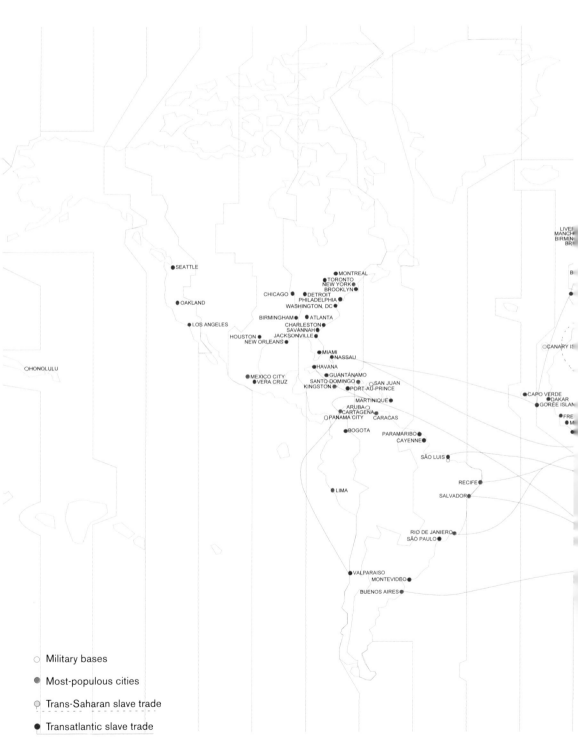

Military bases

Most-populous cities

Trans-Saharan slave trade

Transatlantic slave trade

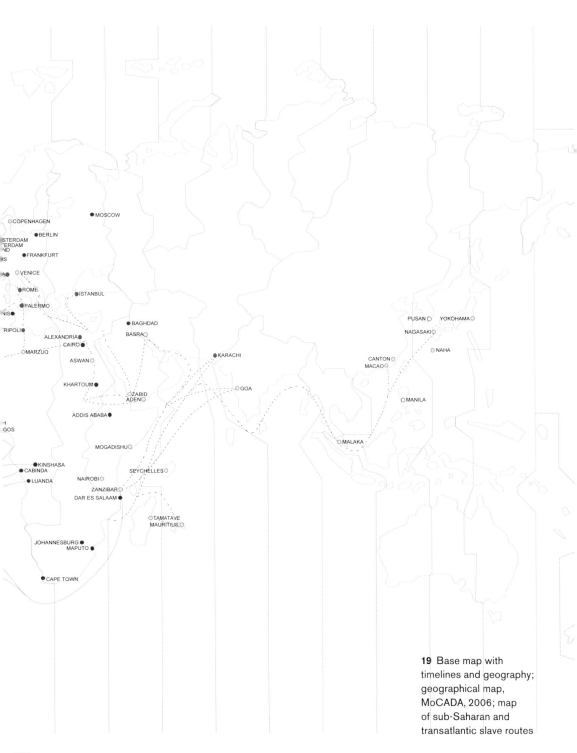

**19** Base map with timelines and geography; geographical map, MoCADA, 2006; map of sub-Saharan and transatlantic slave routes

political and geographic boundaries. This chronology takes into consideration the forced passages of the transatlantic and sub-Saharan slave trades, military exodus, and others necessitated by economic factors, drought, and famine. Cities identified on the map represent migration points across the globe where people of African descent settled. The installation simultaneously maps the time and place of various migrations, indexes the particular moment that it was created, and records the trajectory of the growing African Diaspora. As such, the map acknowledges a process that continues with new migrations today [Fig. 19].

The longitudinal lines of the global time meridians painted on the walls of the reception area form the base layer of an interconnected series of elements that are mapped three-dimensionally [Figs. 20–22]. Comprising interwoven and stacked blocks linked by dowels, the spatialized map resolves into a desk, screen, and display shelves. The formal language of woven elements was influenced by previous designs for an exhibition at the Museum for African Art on basket weaving and the transfer of rice planting culture from West Africa to the American South. On the map, place names are superimposed in red lettering.

Although the space of the museum is fixed, the map of the African Diaspora privileges migratory flows over political boundaries to construct an environmental narrative of resilience and connection, with the power to grapple with displacement as the culture of globalization is realized.

Historically, architecture has been defined through material artifacts. When it comes to understanding and defining African American and African Diasporic space, the very lack of materiality and the difficulty of recovering objects are central obstacles. The design-research projects presented here demonstrate that racialized subjects have suffered from a dearth of knowledge of the nuanced past. To move beyond the constraints of these scant conditions, it is critical to acknowledge that architecture and the built environment are cultural constructions produced by broader inequitable social systems.

**20** Reception interior, MoCADA, 2006

The remnants of colonial production range from texts and images to objects, buildings, and spaces. Despite conditions of absence, incompleteness, and negation that may be present in these material settings, they are inevitably embedded with social, political, and cultural narratives, as well as spatial constructs. Remnants often retain ideological imprints or conceptual negations. Lapses located in official acts of memorialization also hold the potential to index spatial relations that resonate from the past to the present. Each project discussed here renders visible the often-repressed histories embedded in the landscapes we inhabit. *Silent Witness: Remnants of Slave Spaces,* reveals the erasure of a historical Afro-Brazilian space within the monument Casa Dos Contos. *intimate landscapes (of the shotgun house),* transcribes a network of clandestine spaces that formed a fragmented domestic landscape for enslaved persons in the American South. The African Diaspora map at MoCADA (2006), depicts the migration patterns of African descendants as points shifting over boundaries of time rather than geography. By taking note of the silences and erasures of the built environment and the historical resonance of space, this body of work seeks to foster more conscious and more inclusive approaches to the design and building of future cities.

**21–22** Reception interior,
MoCADA, 2006

# WALKING THE GEOGRAPHY OF RACISM

Walis Johnson

An earlier version of this essay was published in 2019 as: "Walking Brooklyn's Redline: A Journey through the Geography of Race," *Journal of Public Pedagogies*, special issue *Walking in/as Publics*, http://www. publicpedagogies.org/wp-content/ uploads/2019/11/21-Walis.pdf.

As Black spatial practices and aesthetics are erased or displaced from cities that are rapidly gentrifying, artist Walis Johnson's projects attempt to reintroduce them. *Walking the Red Line* and the *Red Line Archive* begin where personal history and reflection overlap with public policy. The redlined maps produced by the Federal Home Owners' Loan Corporation in 1938 contributed to widespread reduction of services in Black neighborhoods in cities throughout the United States; this restriction of federal financing for Black property owners created lingering, long-term disadvantage. In the context of present-day gentrification, procedural walking as an intentional act—tracing the red line—takes on heightened importance. These walks culminate in *The Red Line Archive,* a mobile art project that asks the public to consider the ephemera found along walks as well as keepsakes from the artist's own family: What evidence of past redlining is visible today? The *Red Line Labyrinth,* one of which was installed at the Weeksville Heritage Center in 2017, encourages further reflection on the topic of cultural erasure and exile.

On October 24, 2013, my mother passed away. The next day I found a handwritten note from a man named Todd stuffed into the gate of the family brownstone in Clinton Hill, Brooklyn, where I grew up and now live [Fig. 1].

Over the days and months that followed, I received dozens of similar notes and phone calls from Realtors hungry to purchase my family's house. Compounding my grief was the sudden feeling of being dispossessed of my home, my neighborhood, and my sense of place.

My family moved to Brooklyn from Queens in 1968. My parents, Velma and LeRoy Johnson [Figs. 2, 3], purchased this Clinton Hill brownstone, their first home, for $12,500.[1] According to those who ventured to Brooklyn to visit us that first year, the place was a real hellhole. It had been a rooming house with multiple kitchens, urine-stained floors, and inadequate plumbing and electricity. We spent the first three months camping out indoors, cooking on a hot plate, reading by flashlight, demolishing walls, and fighting a year-long battle with swarms of cockroaches that leapt out of kitchen cabinets and closets each time someone had the audacity to turn on the lights.

1 My parents were native New Yorkers who had grown up in Harlem, Brooklyn, and Queens. Both of their families had a history of property ownership. With financial help from my maternal grandmother, they were able to scrape together the $1,250.00 down payment for their first home.

1 Letter from Todd, 2013

2 LeRoy Johnson, ca. 1970

3 Velma Johnson, ca. 1970

Brooklyn has always had a significant Black population and was historically a hub of Black activism and culture. Before 1827, when slavery was abolished in New York State, the number of enslaved Africans in New York City rivaled that of South Carolina, the center of the slave trade in the United States at that time. William J. Wilson, a correspondent for Frederick Douglass's newspaper, *The North Star,* reported that a rising class of free, Black property-owners and tradespeople were then living in downtown Brooklyn, in the vicinity of where my family settled over one hundred years later. The first school in the United States with both integrated teaching staff and student body was founded in Brooklyn.[2] Early on, the Black community published its own newspaper and established civic organizations and churches that attracted abolitionist activists determined to help enslaved persons "get free." Brooklyn remained a political center for Black activism through the 1970s, when Shirley Chisholm became the first Black woman to run for president.[3]

My parents knew some of Brooklyn's history when they purchased our brownstone. In the aftermath of the assassination of Martin Luther King and revolutionary protests by people of color in cities

2 Judith Wellman, *Brooklyn's Promised Land: The Free Black Community of Weeksville* (New York: New York University Press, 2014), 4.
3 Ibid., 1–12.

across the United States, Congress finally passed the Fair Housing Act, albeit by narrow margin. The law prohibited housing discrimination on the basis of race and made it possible for my parents to secure a low-interest Veterans Administration loan.[4] During the forty-seven years we owned it, our house increased in value by more than 2000 percent. When my mother died, it was no mystery why people wanted to buy the building; the Brooklyn brownstone had become a global capital investment commodity and even a well-marketed brand—the place everyone wanted to be. Black people like my parents made Brooklyn a cultural center through their political activism and community work when few people desired to live in the borough. Now the community they created is being recolonized by a new wave of residents, some of whom see the existing presence of Black people as a liability. Neighbors, both Black and white, have reported to me on the street that these new residents consider us relics of a previous time, who detract from the value of the real estate bought and sold at prices few Black people—or most anyone—could ever afford. My parents had wanted and invested in a home and a community; they had not expected a windfall nor had they intended to purchase a commodity that could be sold years later at the exorbitant price Brooklyn brownstones now summon.

The notes, letters, and phone calls kept coming.

My anger waned as I became more introspective and tried to embrace my newly inherited status and wealth as a Brooklyn property owner and landlord. My ancestors had once been held as property, coerced to work the land like animals without compensation. What did it mean, then, for me to inherit this property and land? I wondered where I might situate myself, a Black woman, within the larger narrative of racial capitalism that had enslaved and mortgaged, displaced, and dispossessed Black bodies since our arrival in Jamestown, Virginia, in 1619.

Thus, Todd's note became the catalyst, or provocation, for a series of artist walks and participatory artworks called *The Red Line Archive Project* (2016–ongoing). This project engages Brooklyn

4  Richard Rothstein, *The Color of Law: A Forgotten History of How Our Government Segregated America* (New York: W. W. Norton & Company, 2017), 177.

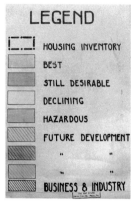

4 1938 Home Owners' Loan Corporation's redlined map of Brooklyn

5 Legend, 1938 Home Owners' Loan Corporation's redlined map of Brooklyn

residents in a conversation about race and place and the role of the 1938 Home Owners' Loan Corporation's redlined maps, which helped create the segregated urban landscapes of New York City and 238 other cities across the United States.

To redline a neighborhood is to starve it of economic investment, home mortgages, and public services based on assumptions about the race or ethnicity of the people who live there. Redlining was part of a federal policy that resulted in the exclusion of Black people from the greatest source of wealth in America: home ownership. The maps [Figs. 4, 5] were color-coded green, blue, yellow, and red, demonstrating a scale of desirability and presumed risk aversion. Green indicated the best areas for investment, where the most restrictive racial covenants were written into deeds preventing Blacks and sometimes other ethnic groups from

owning homes. Blue areas were still considered appealing; yellow, declining; and, red areas were labeled as "hazardous" and socially "inharmonious" for people of Northern European ancestry. Prior to World War II, redlined neighborhoods also housed ethnic white Europeans, but after the war, whites could access home ownership through economic incentives that Black people were systematically denied. The accumulation of wealth for Blacks over time was thereby impeded compared to their white counterparts. This legal practice excluded Black people from the hope and promise of upward mobility and the so-called American Dream, often associated with home ownership. In this country, a family history of home ownership is key to building intergenerational wealth: home equity can be leveraged to pay for children's education, for emergency expenses, or to retire in comfort.[5] Vast political and social divisions and educational inequities in the United States can be traced, in part, to the segregated geography that redlining promoted.[6]

## Walking the Red Line

*You've got to walk*
*that lonesome valley*
*Walk it yourself*
*You've gotta go*
*By yourself*
*Ain't nobody else*
*gonna go there for you*
*Yea, you've gotta go there by yourself.*
—Traditional African American gospel song

Historian Jelani Cobb once wrote, "The past haunts at the peripheries."[7] If this is true, what evidence of past redlining is still visible today? What emotions and insights might arise as I walked along the periphery of Brooklyn's redline, originally mapped in 1938? Equipped with camera and journal, in search of clues to the past hidden in present-day Black geographies, I observed homes, schools, streets, gardens, churches—places where the everyday practice of Black life is present.

5  According to a 2016 report, it will take Black families 228 years to amass the same amount of wealth that white families hold today. See Dedrick Asante-Muhammed, Chuck Collins, Josh Hoxie, and Emanuel Nieves, *The Ever-Growing Gap* (Washington, DC: CFED & Institute for Policy Studies, 2016), https://ips-dc.org/wp-content/uploads/2016/08/The-Ever-Growing-Gap-CFED_IPS-Final-2.pdf.
6  Ta-Nehisi Coates, "The Racist Housing Policies that Built Ferguson," *The Atlantic*, October 17, 2014, http://www.theatlantic.com/business/archive/2014/10/the-racist-housing-policies-that-built-ferguson/381595.
7  Jelani Cobb, "Race and the Storm," *New Yorker*, August 24, 2015, 20.

**6** Work gloves, Bedford-Stuyvesant, Brooklyn

**7** Black and white homes, Eastern Parkway, Brooklyn

As I passed along the border of Bedford-Stuyvesant and Ocean Hill-Brownsville, I paused near a set of gloves strapped to the door of an old pickup truck [Fig. 6]. The block was void of pedestrians but based on the signage in the street, I gleaned that some residents may have had roots in the South. Did these people come north during the Great Migration, when six million African Americans seeking refuge from the brutality of segregation and the poverty of the Jim Crow South moved to the urban centers of Chicago, Cleveland, Detroit, and New York, and a substantial number to this part of Brooklyn?[8] I imagined the gloves as an artifact of that era. I took a photograph. Adjacent to the truck was a bit of graffiti on the wall that read, "No Pissing." I jotted the phrase down in my journal.

The gloves, graffiti, and Black migration merged in my mind. The exclusionary practice of redlining has long-lingering effects; in the 1950s Black people were crowded into central Brooklyn, at one point making Bedford-Stuyvesant the largest Black "urban ghetto" in the United States. Without mortgages and investment in redlined communities, funding for basic services such as garbage collection, infrastructure maintenance and upgrades, and education were viciously cut, which contributed to the further decline

8 Walter Thabit, *How East New York Became a Ghetto* (New York: New York University Press, 2003), 23–25.

**8** Greater Bibleway Temple Church with Star of David, Rochester Avenue, Brooklyn

of property values. Housing segregation was in full force: "The color-line is sordid; it delineates a land of hell, where social and racial divisions are marked in the landscape."[9] And the de jure system of racial and economic apartheid prevailed, laying the groundwork for the gentrification, dispossession, and displacement of today.[10]

My journal entry on the day I encountered the gloves reflected the rage and despair I felt: "The sign said: 'No Pissing.' Yet this community has been pissed on for decades. This is the site of a crime." W. E. B. DuBois famously described the "color line" as an existential, material, and spiritual divide that separates, yet connects, two worlds in America: one Black, one white.[11] I exist uneasily in these two worlds. During my walk, I existed in a poetic space where my body, thoughts, and emotions drifted between the present and the trauma of the past. As a Black woman walking alone within a raced landscape, I began to consider a new notion of "place" to describe something beyond the built environment, beyond community, and beyond my home. As a Black woman, my body is also a "place," a geography, which holds within it a set of "knowledges, negotiations and experiences" bequeathed to me

9 Katherine McKittrick, *Demonic Grounds: Black Women and the Cartographies of Struggle* (Minneapolis: University of Minnesota Press, 2006), 22.
10 Rothstein, *The Color of Law,* vii–viii (see note 4).
11 W. E. B DuBois, *The Souls of Black Folk* (New York: Dover, 1994), 9.

**9** Highland Park Mansion, Highland Park, Brooklyn

by my ancestors who longed to be free.[12] Walking the red lines of the map allowed me to embody the emotional struggle and complexity of this painful legacy and reclaim, if only for a moment, a Black sense of space and place that historically, my ancestors were never allowed to fully possess.

In Katherine McKittrick's feminist examination of Black women's geography, *Demonic Grounds: Black Women and the Cartographies of Struggle,* she discusses the practice of inscribing Black space with "new memories" and "new histories" as a necessarily geographical and emotional task. "[A]cknowledging the real and the possible, mapping the deep poetics of black landscapes— is also painful work. The site of memory is also a sight of memory— imagination requires a return to and engagement with painful places, worlds where black people were denied humanity, belonging, formal citizenship . . . "[13]

I walk on.

I photographed adjacent homes, one dark, one light [Fig. 7] that made me think of the racial divisions artificially engineered

12 McKittrick, *Demonic Grounds*, 22 (see note 9).
13 Ibid., 23.

by redlining, as entire neighborhoods turned from majority white to majority Black within a matter of months. Sometimes white people moved out in the middle of the night right after a Black family moved in.

> "My only sin is my skin. What did I do, to be so black and blue?"
>
> —Fats Waller, "(What Did I Do to Be So) Black and Blue?," 1929

My mother had grown up along Eastern Parkway when it was primarily a Jewish neighborhood. Walking through Crown Heights near where she might have lived, I saw synagogues that had been repurposed as African American Pentecostal churches. Sometimes the Star of David had been removed and sometimes it was simply incorporated into the church facade [Fig. 8]. It is easy to forget that in 1938, ethnic white neighborhoods were redlined too, because at the time their immigrant populations were not considered "white."[14] However, a reclassification of sorts took place after World War II, when the status of ethnic white residents changed, allowing them to assimilate into suburbs, including the segregated community of Levittown, built to lure them from the city.[15]

14 Thabit, *How East New York Became a Ghetto*, 37–38 (see note 8).
15 Ibid.

**10** Auto scrap yard,
East New York, Brooklyn

**11** Vacant lot,
East New York, Brooklyn

**12** Positive Seeds of Life
community garden,
East New York, Brooklyn

**13** Yin-yang symbol,
East New York, Brooklyn

I saw evidence of Black struggle, resistance, and emotional generosity in the naming of churches, both storefront and traditional, along Rochester Avenue: Holy House of Prayer for All People and The Truly Holy, Church City of Refuge. There were multiple denominations in a row of storefronts along a single block; churches seem to have been one of the few institutions to replace the businesses and shops vacated by white flight.

As I navigated the contours of the map, I noticed changes to the soundscape as often as the architecture, typology, or physical condition of buildings. Redlined residential areas were often located at the edge of industrial zones where the noise from cars, machinery, and work is prevalent. Neighborhoods isolated from industry were preserved for middle and upper-middle classes. The matrix of residential and industrial uses that comprise East New York made my walk there—through honking traffic, zones for industrial waste, and public housing projects—challenging to my senses. The only blue, "still desirable" zone marked in the region of East New York on the 1938 map was the district of Highland Park, where well-appointed mansions sit atop a great hill [Fig. 9]. Offering panoramic views, this area was cloistered, topographically raised,

14 House facade,
East New York, Brooklyn

15 Stairs: "Love-
Community-Love-Culture,"
East New York, Brooklyn

16 Sign, Madison Street,
Brooklyn

17 Shoes with flowers,
MacDonough Street,
Brooklyn

and aurally removed from the crushing scrap metal processors
and junkyards of the surrounding neighborhood [Fig. 10]. I acknowl-
edged the painful reality of Black geographies is that we so often
occupy the least valuable land until, one day, by chance or by
design, the place where we live suddenly becomes desirable and
we again are displaced.

Walking, I think of the uprisings that took place here in the
1960s and 1970s, when Blacks and Puerto Ricans revolted against
city housing policies that obliged their communities to live in
deplorable and dehumanizing conditions. Citizens were often left
to fend for themselves, battling drugs, crime, and despair. The
relentless rumbling of the elevated trains echoed the rage that was
at the heart of those protests. Now I see fledgling gardens planted
in vacant lots as signs of local, grassroots resilience against the
government policy of neglect. The systematic denial of resources
and basic services is a deliberate strategy; an attempt to choke
community [Figs. 11, 12].

Recently, East New York has been rezoned, paving the way
for gentrification, long-awaited improvements to infrastructure,

and much-needed affordable housing.[16] Perhaps the graffiti yin-yang symbol that was tagged on a neighborhood wall reveals the ambivalence and skepticism toward these changes that may or may not benefit local residents [Fig. 13].[17] Nearby, a homeowner's public shrine to the African Yoruba goddess Oshun contained the message: "Love-Community-Love-Culture-Love." I read these words painted on the front steps of the home as an enduring expression of hope by and for a people who have lived through very rough times [Figs. 14, 15].

I was moved by this and similar markings I have seen adorning other African American spaces [Fig. 16]. In her essay "Black Vernacular: Architecture as Cultural Practice," cultural critic bell hooks writes the following: "Growing up in a world where black working class and 'po'folk,' as well as the black well-to-do, were deeply concerned with the aesthetics of space, I learned to see freedom as always and intimately linked to the issue of transforming space."[18] Further, hooks emphasizes the need to document this everyday Black aesthetic practice: "to ignore this standpoint is to reproduce a body of work that is neocolonial insofar as it violently erases and destroys subjugated knowledges that can

16 Questions remain as to how well current New York City housing policy addresses the affordable housing crisis, and whether the construction of 300,000 new units is enough to meet the needs of low-income, working-class communities. See Sadef Ali Kully, "Does Mayor's Housing Plan Help Where It's Needed? Report Offers Complex Answers," *City Limits*, February 18, 2019, https://citylimits.org/2019/02/18/does-mayors-housing-plan-help-where-its-needed-report-offers-complex-answers.
17 See Amy Plitt, "Domino Affordable Housing Gets 87,000 Applicants for 104 Apartments," *Curbed*, February 15, 2017, https://ny.curbed.com/2017/2/15/14622616/williamsburg-brooklyn-affordable-housing-domino, as an example of how few apartments are actually designated as affordable when gentrification, in the form of luxury housing, occurs.
18 bell hooks, *Art on My Mind: Visual Politics* (New York: The New Press, 1995), 147.

only erupt, disrupt, and serve as acts of resistance if they are visible, remembered."[19]

On MacDonough Street, a distinguished block in Bedford-Stuyvesant, I saw old children's shoes planted with flowers on a homeowner's stoop [Fig. 17]. This struck me as a small yet significant example of the Black vernacular that hooks urged me to recognize as evidence of Black resistance and Black refusal to be erased from the Brooklyn landscape. I observed these scattered signs of Black resistance in gardens and homes stretching from East New York to here.

## Weeksville Lady: A Free Black Woman of Color

*Many narratives of resistance struggle from slavery to the present share an obsession with the politics of space, particularly the need to construct and build houses. Indeed, black folks equated freedom with the passage into a life where they would have the right to exercise control over their space on their own behalf, where they would imagine, design, and create spaces that would respond to the needs of their lives, their communities, their families.*
—bell hooks, "Black Vernacular: Architecture as Cultural Practice," 1995

The free Black community of Weeksville emerged in the mid-1830s from the deliberate effort to create a place where Black Brooklynites could exercise self-determination and economic self-sufficiency, and where they would be guaranteed access to education and assured physical safety. Black investors purchased, subdivided, and resold land in the Weeksville area to Black buyers by advertising and marketing the development to Black readers. Only by living separately in their own enclave could the community truly explore what it meant to be a "free people of color" in the Antebellum U.S. The settlement thrived for approximately sixty years. At its peak, in the 1850s, more than five hundred formerly enslaved and free Black residents, including two native-born Africans, comprised its population. By 1910, very few physical

19 Ibid., 151.

**18** Tintype referred to as The Weeksville Lady, ca. 1890

**19** Walis Johnson
performing the *Red Line*
at Weeksville Heritage
Center, 2016

remnants of Weeksville remained. The neighborhood network of roads and paths along Hunterfly Road was overridden by the planned extension of the city grid, and its structures replaced by Italianate brownstones and tenements built for Italian immigrants relocating to Brooklyn from the slums of Manhattan. In 1939 the New York City Housing Authority (NYCHA) demolished six full blocks at the edge of old Weeksville, including several homes, to build the Kingsborough Houses, a massive public housing superblock.[20]

When the Kingsborough Houses were completed in 1941, much of old Weeksville had disappeared and the community had become a distant memory. Many of the Black families settled there had sold their houses, and others who rented were displaced and dispersed. Some moved north of Fulton Street to Bedford-Stuyvesant or even Queens, undoubtedly in search of a new space to call home.[21]

The rediscovery of Weeksville and the events leading to the grassroots historical preservation of the Hunterfly Road Houses occurred in the late 1960s. As research on the area commenced, houses at the center of historical Weeksville were slated for demolition to make way for more public housing. A helicopter flyover in 1969 confirmed that a cluster of small mid- to late-nineteenth-century wood-frame houses on former Weeksville land paralleled one of Brooklyn's oldest thoroughfares, Hunterfly Road. The local community was brought together for an archaeological investigation of the site, sponsored in part by the Pratt Institute Center for Community Development. The excavation resulted in numerous artifacts, including a tintype taken of an unnamed woman in approximately 1890: The Weeksville Lady, a free Black woman living in Brooklyn [Fig. 18].[22]

I look at an image of The Weeksville Lady and wonder: Am I free?

20 Judith Wellman, Brooklyn's Promised Land: The Free Black Community of Weeksville, New York (New York: New York University Press, 2014), 226–29.
21 Veralyn Williams and Mark Winston Griffith, "Weeksville: The Past as Destiny," Brooklyn Deep: Third Rail Podcast, episode 46, November 10, 2017, http://brooklyndeep.org/third-rail-eps-46-weeksville-the-past-as-destiny/.
22 Wellman, Brooklyn's Promised Land, 229–40 (see note 20).

## The Red Line Archive

As Black spatial practices are expunged from rapidly gentrifying cities, the walking I perform in redlined areas of Brooklyn takes on greater purpose and significance. In walking, I perform research in pursuit of truths both personal and historical. My walking is an aesthetic practice through which forgotten (or invisible) African American spatial narratives are given new life and resonance [Fig. 19].

My red line walks are documented and culminate in *The Red Line Archive Project,* an ongoing artistic intervention that engages the public, particularly Black people, in conversations about redlining and my journey to locate African American space. The first iteration of the project is a bright red "cabinet of curiosities" that I wheel along Brooklyn streets to parks in once redlined— now gentrified or aggressively gentrifying—neighborhoods such as Fort Greene, Bedford-Stuyvesant, and Crown Heights [Fig. 20]. I invite people to see and comment on found objects collected on my walks, redlined maps, personal documents, photographs, and soil samples from formerly redlined neighborhoods. Like the dialogue around these topics, the project is open-ended and thus never really complete [Figs. 21–23]. The most recent addition to the archive is *Red Line Labyrinth,* versions of which are temporarily installed in several gentrifying neighborhoods [Figs. 24, 25]. Participants are invited to walk alone or with a partner through a bright red labyrinth and to share their thoughts as they walk. In the labyrinth, my own redline walking, and all the components of the *Archive Project,* I trace the lines of the 1938 Brooklyn map to give them life, to render them visible in the present. The goal is to reclaim the African American right to the city that the redlined maps and the racist legacy of federal economic policy brutally erased.

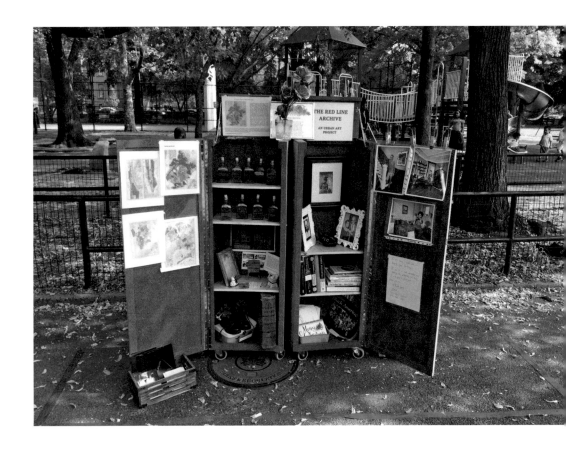

**20** *The Red Line Archive,* Von King Park, Brooklyn, 2016

**21–23** *The Red Line Archive,* shoes with flowers, soil samples from the neighborhood, family photographs, 2016

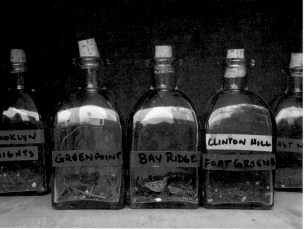

**24** *Red Line Labyrinth,*
Weeksville Heritage
Center, Brooklyn, 2017

25  *Red Line Labyrinth,*
Weeksville Heritage
Center, Brooklyn, 2017

# SEEKING SALLY HEMINGS

Marisa Williamson

Flight, liberation, satire, and fugitivity can all be qualified as actions that writer and academic Saidiya Hartman has termed "performances of opposition" under the conditions of slavery; as practices they remain vital to the articulation of African American space. Williamson relates these particular actions to her performances as Sally Hemings, who bore six of Thomas Jefferson's children within the confines of her enslavement. The performances are based on the material objects that testify to Sally Hemings's existence, such as her clothing and the floor plan and furniture of her living quarters, but also on Williamson's imagination of her interior life, as a proto-feminist and radical. In her fabulation of Hemings, matters of freedom, agency, and enslavement emerge: *How do you know when to run away? How do you know when to stay and fight? How do you know when to feel things out, make do, get creative?* Williamson's aim is to create space for Hemings and the complexity of her role in the contemporary world and to pay tribute to her particular struggles in the afterlife of slavery.

**1** *Omega 1,* digital image of studio performance with no audience at Triangle Arts Association, 2016

*How do you know when to run away and when to stay?*
*To negotiate? To sleep on it? Wait for a better opportunity?*
*Laugh to keep from crying? Sing to keep from screaming?*
*How do you know when to run away, and when to stay? And get*
*love? Give love? Be loved by someone? Give yourself away?*

The personal is political. That which we hold dearest: our consti-
tutions, ourselves; our individuality and character; our agency
and our choices comprise our political ideology. When this nation
was coming into its own, the founding fathers enshrined the
personal as political. Two-thirds of these founding fathers were
slaveowners who held this property tightly; Black lives were
a personal, political, and private matter. The bonds of Black family,
Black privacy, Black personal space and Black communal space,
Black self-possession and Black autonomy were partly, if not
completely, invalidated and suppressed. But three-fifths of a whole,
according to the 1787 compromise, was the official partiality deter-
mined by political structures.

It is no less true today than it was yesterday. The personal
is political. Historically, Black female self-ideation and the right of
determination over the Black female body—as a source of physical,
intellectual, and reproductive labor, and site of pleasure, emotion,
expression, and sexuality—were co-opted and claimed as property
by the white statesman and his government. That which had
once belonged to her was stolen systematically, according to
sanctioned structures; appropriated with force, violence, coercion,
and what we call rape. According to this structure of the state,
as maintained by the statesman, she and hers were his. This is the
narrative that has been passed down to me.

The urgency of this narrative is foregrounded in the historical
figure of Sally Hemings. Hemings came to prominence after 1998,
when DNA evidence made it indisputable and historian Annette
Gordon-Reed's work made it legible that she was not only
enslaved by Thomas Jefferson, but also the mother to six of his
children.[1]

1 Annette Gordon-Reed, *Thomas Jefferson and Sally Hemings: An American Controversy* (Charlottes-ville: University of Virginia Press, 1997), 221.

In the "monstrous intimacy" and complex network of relations that constituted the daily life of enslaved persons, Hemings was a half-sister to Jefferson's wife, Martha Wayles Jefferson.[2] Hemings was essentially Jefferson's sister-in-law; both Wayles Jefferson and the enslaved Hemings had been fathered by John Wayles. John Wayles bequeathed the Hemings family to his daughter in his will, who by marriage transferred the family to Jefferson. In keeping with *partus sequitur ventrem,* "that which is brought forward follows from the womb," a law fabricated in the colony to perpetuate chattel slavery after the 1807 Act Prohibiting Importation, allowing the institution to expand through breeding and rape, Wayles had enslaved his offspring produced by an enslaved woman.[3] In this way, Hemings came to Monticello and occupied an unusual position in the constellation of life on the slave plantation; her slave quarter was adjacent to the south wing of Monticello, giving Jefferson direct access to her physical space.

Though Hemings was certainly kept as property, her status always precarious at best, her association with Jefferson implies she may have suffered conditions marginally safer and more comfortable than that of the abject material and social deprivation generally characteristic of antebellum slavery. As such, it is hard to imagine her position as anything other than conflicted and her consciousness as anything other than profoundly "double," in the DuBoisian sense. Hemings likely experienced the politics and practices of race, power, and property in extraordinary terms. According to the strict racial calculi of the time, she was half-or three-quarters white, appearing "mighty near white" and therefore challenging the rigidity of racial stratification.[4] She had advantages such as beauty, access to exclusive physical spaces, milieus, and power structures while simultaneously being enslaved. The conflicting duality of Hemings's identity as a Black woman— a privileged possession, and herself in possession of some relative privilege—is an extreme and dramatic forebear to the complexity of contemporary Black experience.

The role Hemings and other enslaved persons played in the life and legacy of Thomas Jefferson warrants monumental recognition:

2 Christina Sharpe, *Monstrous Intimacies: Making Post-Slavery Subjects* (Durham: Duke University Press, 2010), 171.
3 Annette Gordon-Reed, *The Hemingses of Monticello* (New York: W. W. Norton & Company, 2008), 109.
4 In 1847 former Monticello slave Isaac Jefferson attested: "Sally Hemings' mother Betty was a bright mulatto woman, and Sally mighty near white … Sally was very handsome, long straight hair down her back." Jefferson, quoted in James A. Bear, Jr., ed., *Jefferson at Monticello* (Charlottesville: University of Virginia Press, 1967), 4.

making possible his fragile command of wealth, cash flow, political power, and self-sustainability; facilitating his public life during the Revolutionary era, his ambassadorship in France, his presidency, his founding of the University of Virginia, and his retirement; and enabling his personal life as a widower and father. Some have even referred to Hemings as a "first lady."[5]

Hemings was likely no older than sixteen—too young by contemporary, and even eighteenth-century standards—when she first bore a child by Jefferson.[6] Even after becoming an adult woman, she would have been considered an improper substitute for a wife. Her son, Madison, later described the informal contract between his enslaved mother and his father, the master negotiator, which bound her to slavery in exchange for her children's ultimate freedom. Thus Hemings was rendered a fixture in Jefferson's household: part of its structure.[7]

Jefferson was literate by right, and a prolific writer. Because the enslaved were not, the dominant narrative has remained fixed on Jefferson. Indeed, most accounts of the entity of Hemings and Jefferson focus on Jefferson's concurrent ideas of liberty, as they related to Enlightenment philosophy, and his ownership of slaves as a paradox, discursively casting him as a dimensional and even dynamic figure. Hemings remains a darkened silhouette; without freedom and with no evidence of an ability to write, her thoughts and philosophy have not survived. Self-authorship was taken from her, and she, in turn, taken from us.

I have embarked on a multiyear project to reconstruct Sally Hemings; to draw her from the simplistic, superficial record that has been left behind, to give depth to her character, and to bring the unexpressed crises of liberty and equality in her life to the foreground [Fig. 2]. I have sought to map her world as she navigated it—an enslaved Black woman imprisoned by the architecture of the state—and to see where it overlaps with mine. The personal has always been political. To redirect focus on Hemings, I retell her story by inhabiting it; by performing, rehearsing, and improperly reenacting it. That is, I am not limited to the known facts about

5 Evelia Jones, "It's Time to Recognize Sally Hemings as a First Lady of the United States," *Los Angeles Times*, January 4, 2019, https://www.latimes.com/opinion/op-ed/la-oe-jones-sally-hemings-first-lady-20190104-story.html.

6 "The Girl who is with her is quite a child, and Captain Ramsey is of opinion will be of so little service that he had better carry her back with him, but of this you will be a judge. she seems fond of the child and appears good Naturd." Abigail Adams to Thomas Jefferson, 27 June, 1787, Adams Family Correspondence, Volume 8, Adams Papers Digital Edition, Massachusetts Historical Society, http://www.masshist.org/publications/adams-papers/index.php/view/ADMS-04-08-02-0037.

7 Madison Hemings and S. F. Wetmore, "Life Among the Lowly, No. 1," *Pike County Republican*, March 13, 1873, https://www.encyclopediavirginia.org/_Life_Among_the_Lowly_No_1_by_Madison_Hemings_March_13_1873.

**2** *What Would Sally Do?*
Photo and video documentation of performance at Monticello, February 17, 2013

Hemings. Rather, I attempt to reconstruct the interior, private, personal, and political space of her mind. I cast myself into her fantasies, simultaneous to mine. I search for clues to her creative life, conjuring it where the record is incomplete or absent. I recuperate what has been redacted. I try to limn the space she may have kept to and for herself, and if I find it, I offer it to audiences.[8] Yet this work comes at a price, for I now am haunted by her spirit.

My performances account for Hemings's physical circumstances and surroundings. Not only confinement, enslavement, and escape, but also sexual intercourse, childbearing and child-rearing are spatially defined. Of paramount importance to a site is the nature of the space it contains; as described by floor plan and layout, walls, rooms, the location of doors and windows, even material objects including furniture, fabric, and clothing. I take license with the scant ephemeral remainders of Hemings's circumstances, understanding them as a material record of submission, domination, negotiation, and potential agency. The following questions guide my approach: ***How do you know when to run away?
How do you know when to feel things out, make do, get creative?***

8 Marisa Williamson, *What Would Sally Do?*, first performance February 17, 2013, Monticello, Charlottesville, Virginia.

3 *Handsewn Dress,*
printed and sewn by hand
in preparation for the
February 17, 2013,
performance at Monticello,
within the print are the
words "Slave to a Narrative;"
*Wallpaper* with "Slave
to a Narrative" print, 2017,
each part of *Celebration
of the Life of Sally Hemings*
installation at University of
Virginia Ruffin Gallery, 2018

I work in a space where time is compressed such that the past—
all the history leading up to the present—informs my performance.
Rather than imitate or reenact a historical figure in costume, I bring
Sally Hemings into real time; after novelists such as Toni Morrison
and Octavia Butler, who created characters from the historical
record of enslaved persons. I enable Hemings's journey through
time, for the audience of today, and in doing so evoke the
long legacy of slavery's aftermath. Sometimes my performance
is improvised, while at other times there is preconceived intent.

My first step in the process of awakening Hemings was to make a
dress. I printed the fabric and sewed the garment by hand to trace
the gestures of the enslaved person who would have produced
her own clothing [Fig. 3]. Performed in the tradition of the eighteenth
century, I understood this work as a "labor of love," conducted
for the benefit for someone dear—a mother, sister, or son—but not
for myself. I wanted to explore my own affinity with Hemings, for
example, in the way in which we have each been slave to a narrative.
I am a descendant of enslaved persons and the white masters
who enslaved them. I am an African American woman attempting
to create something for herself.

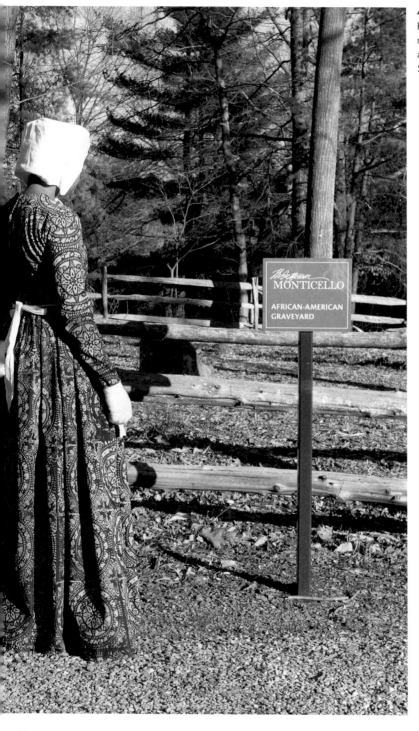

**4** *What Would Sally Do?*
Photo and video documentation of performance at Monticello, February 17, 2013

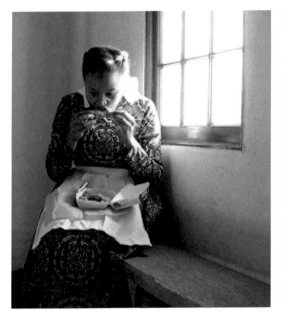 

5–6 *What Would Sally Do?* Photo and video documentation of performance at Monticello, February 17, 2013

The first site of my inhabitation of Sally Hemings was at Monticello, the celebrated home of Thomas Jefferson [Fig. 4]. When I was a child, educators there appeared in period clothing. My second cousin, a textile artist, worked in this capacity and in fact produced many of the artifacts featured in the textile factory exhibition on Mulberry Row. Monticello no longer hosts regular reenactments, making the practice ripe for critical intervention and possibly unsettling to visitors expecting a mediated version of history [Figs. 5, 6].

The presence of slavery is evident in Jefferson's design of Monticello, but so are the efforts to attenuate the central role it played in that domestic sphere [Fig. 7]. And until recently, this presence and its denial were evident in the exhibitions held there as well. During the eighteenth century, a white visitor to Monticello may have viewed the working landscape only from the distant and elevated perspective of the portico, from which point the slave quarters were obscured. Half-underground, carved into the slave plantation hillside, these quarters housed Hemings's room, the textile factory where her sisters worked, the woodshop where her brothers and sons worked, and the kitchen. Belated excavations

## Slave To A Narrative

SALLY HEMINGS (1773-1835) was part of a large family with a long history of enslaved domestic service to Thomas Jefferson and his wife, Martha Wayles', family. She served as a ladies maid to Jefferson's two daughters--traveling as a fourteen-year-old to France (where slavery was illegal) to work and live for two years in Jefferson's home abroad.

DNA testing in 1998 ties the Jefferson and Hemings families together. In addition, oral, statistical and documentary information support the widely held belief that Thomas Jefferson fathered all of Sally Hemings' six children after his wife's death.

Sally Hemings was the much younger half sister of Thomas Jefferson's wife, Martha. Martha Wayles Jefferson's father, John Wayles, is reported to have fathered children with Elizabeth Hemings, his slave, and Sally Hemings' mother.

## Monticello

Monticello is the plantation home of Thomas Jefferson, 3rd president of the United States and drafter of the Declaration. It is also the home of Sally Hemings, his enslaved biracial mistress of thirty years. It is located in Charlottesville, Virginia.

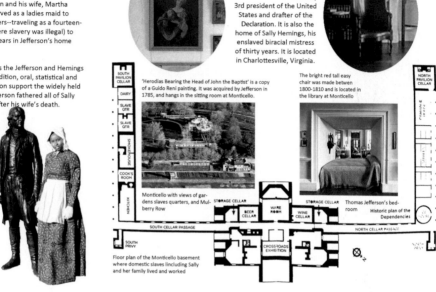

'Herodias Bearing the Head of John the Baptist' is a copy of a Guido Reni painting. It was acquired by Jefferson in 1785, and hangs in the sitting room at Monticello.

The bright red tall easy chair was made betwen 1800-1810 and is located in the library at Monticello

Monticello with views of gardens slaves quarters, and Mulberry Row

Thomas Jefferson's bedroom

Historic plan of the Dependencies

Floor plan of the Monticello basement where domestic slaves lincluding Sally and her family lived and worked

**7** Photocopied flyer for *What Would Sally Do?* performance at Monticello, February 17, 2013

have unearthed these spaces, so that visitors are now able to see the cramped rooms Hemings and her family occupied adjacent to the grand mansion of their master. Many other chambers remain hidden or buried.

*How do you know when to run away, and how do you know when to stay? How do you know when to hide, and when to let yourself be hidden? To negotiate? To sleep on it? To wait for a better opportunity? To laugh to keep from crying? To sing to keep from screaming?*

Next, I created a series of artifacts for my Hemings, some of which I imagined as representations of her feminist or otherwise radical views. For a performance series at Pioneer Works in New York City, hosted by the artist Clifford Owens, several of these items were auctioned as if they had been produced by Hemings for Jefferson. On that occasion, Hemings mounted the auction

# AUCTION

## ✳ A PERFORMANCE ✳

## BY MARISA WILLIAMSON

### SUNDAY, JULY 21ST, DOORS OPEN AT 5:30
### AS PART OF 'SEMINAR'
### A PROJECT BY CLIFFORD OWENS
### AT PIONEER WORKS
### 159 PIONEER STREET, BROOKLYN, NY 11231

TO BE SOLD, INTIMATE PERSONAL ITEMS BELONGING TO THE PRESIDENT, THOMAS JEFFERSON, MADE FOR HIM BY HIS SLAVE AND MISTRESS, SALLY HEMINGS.

8 *Auction* poster, Pioneer Works, Brooklyn, 2013

9 *Auction,* photo documentation of performance set, Hemings auctions off intimate handmade items she would have made for Jefferson, Pioneer Works, Brooklyn, 2013

platform not as an object being sold, but as a person offering the products of her labor for sale [Fig. 8]. The auction also addressed a secondary topic; for the artist, dependent on selling artwork to survive, also tendered those wares resulting from her performance, and her attempts to cultivate a following. In these ways, I sought to reverse the symbolism of the auction block, even addressing it to my own identity: as a disaffected laborer hungry for her own liberation [Fig. 9].[9]

After the reenactment at Monticello and the auction in New York— scenes of the first two Hemings performances—I moved her to Paris [Fig. 10]. With her handmade clothing and artifacts, Hemings appeared in and around the historical sites she and Jefferson occupied when they lived in that city from 1787 to 1789. Hemings went to Paris to accompany Jefferson's youngest daughter, Maria. However, slavery had been abolished in France, so while there, Hemings was paid a small wage equivalent to $2 per month in contemporary terms.[10] In theory, at the end of this two-year period, Hemings was able to decide whether to stay in France as a free person, or return to the United States and slavery in Monticello. Though still a teenager, tied to her mother and extended

9 Marisa Williamson, *Auction*, first performance July 21, 2013, Pioneer Works, Brooklyn, New York.
10 Gordon-Reed, *Thomas Jefferson and Sally Hemings* 23 (see note 1).

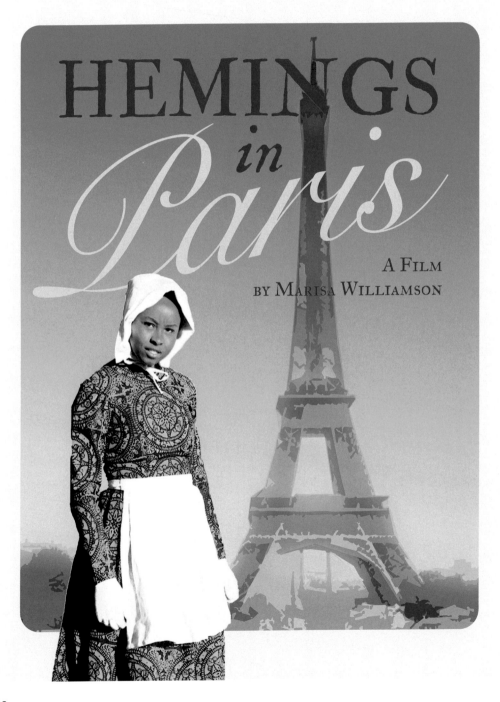

10 *Hemings in Paris* poster, 2014

11–13 *Hemings in Paris,* photo and video documentation of performances in Paris, France, 2014

family, and likely pregnant by Jefferson, this decision was a critical moment of potential agency for Hemings [Figs. 11–13].[11]

The following dialogue is excerpted from *Hemings in Paris* (2014):

[Hemings to tourists]
*"I'm really wondering if I should stay here, there seem to be so many ways to be free, but it seems to be scary. I never get to see my family again. I wonder if this is the place for me or if I should go back."*[12]

[Person 1]
*"When you're free, you can make everything you want. You can realize some crazy dreams because you're free. If you go back to the United States, the other American people, when they're looking at you, they will just say, 'she's a slave.'"*

[Person 2]
*"And if you stay in America while your kids grow up, they see you, and they'll see all the others who aren't free. They're still slaves. And they'll be like, 'what's the difference between us and them?'"*

[Hemings to female tourist]
*"Bonjour Madame. Parlez-vous Anglais? I'm an enslaved person. I work for Thomas Jefferson, and he has let me know that it's time to leave. And in the course of being here, we started a relationship and I wonder with your expertise, and just your experience being here, is there anything you'd advise?"*

What advice could the tourist in Paris give considering sexual consent is not available to an enslaved person?

Inhabiting Hemings in Paris involved not only dramatizing her life, but also posing the question she faced in staying or going to the audience there and to myself. I interviewed contemporary

11 Ibid., 21–22.
12 Jefferson did not offer Hemings her freedom if she returned to the United States but stipulated that her children would be freed when they reached the age of twenty-one. See Hemings, "Life Among the Lowly, No. 1" (see note 7).

14 Digital flier, *Sally & Monica's Hot Tub Hangout*, performance, 2014

Parisians about Hemings's life as though she were still a character today. In these interviews, which granted space to her potential agency, modern notions of intersectionality, freedom and captivity, and the familiar and the foreign could be examined.

Parisians responded by addressing Hemings's circumstances, as well as slavery and freedom, in larger philosophical and universal terms. Posing such questions in relation to Hemings made her tangible and present, and mapped the significance of her story—the impossibility of her situation, and the impossibility of her options—onto our consciousness now.

> *"I call my own name. Sally … Sally. And tell my own story—for myself and for those who follow."*[13]

Freedom is a responsibility that a formerly enslaved person must negotiate while still burdened by the effects of her subjugation. The binary condition of freedmen and slavery that drove the colonization of the Western Hemisphere lingers today.

13 Marisa Williamson, *Hemings in Paris*, video shot on March 22 and March 27, 2014, in various locations in Paris, France.

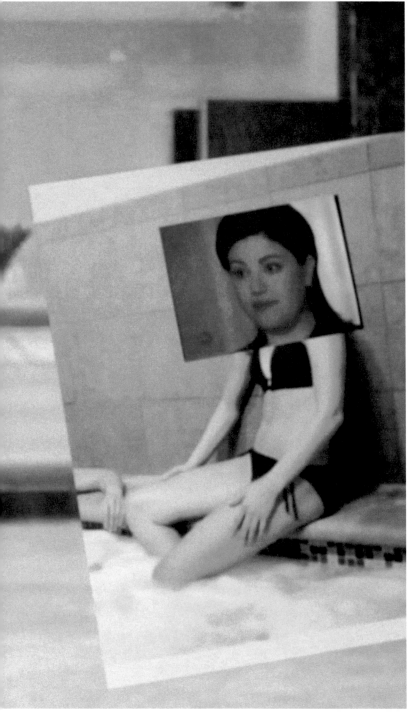

15 *Sally & Monica's Hot Tub Hangout,* video documentation of performance, 2014

**How do you know when to run away? How do you know when to stay and make friends, build networks, and strategize?**

As this project grows, it has incorporated other women who occupy complex positions within white heteropatriarchy [Fig. 14]. In trying to map my own freedom, I began to see the struggles of a broad range of people overlap with mine. Monica Lewinsky could not be precisely analogous to Hemings, yet found herself at the center of a fraught national conversation on power, politics, agency, and identity [Fig. 15].

The following dialogue is excerpted from *Sally & Monica's Hot Tub Hangout* (2014):

> [Lewinsky]
> *"I said it before; I thought he was my sexual soul mate."*

> [Hemings]
> *"Good grief, Monica. You can't be serious. Do you really think we have sexual soul mates?"*

> [Lewinsky]
> *"Yes, and the way he looked at me, and the way he held me, he brought me something—I think it is a big part of who I am today; a feeling of being wanted and being comfortable with myself. I don't have the feelings of self-worth that a woman should have."*

> [Hemings]
> *"Oh my gosh, why not? You're like such a babe. You're like wearing lipstick in a hot tub and not even sweating."*

> [Lewinsky]
> *"I think the combination of issues with my weight and having experiences that were problematic made me comfortable being ... a piece of trash. I was sort of made into the other."*

**16** Still from *Hemings & Hawings* video, 14m 43s, 2015

[Hemings]
*"I relate to your feelings of otherness and objectification. Of course, my feelings are formed by intersectionality and double-consciousness. I want to be free, but also loved. I want comfort but also power. I want to be known but not exposed. Can I have both? Can I have it all? Can any of us have it all?"*

[Lewinsky]
*"Some days I think: yes. And some days I think, no."*[14]

**How do you know when to run away, and when to stay and suck it up? How do you know when to get up in the morning, to go to your job, to make your mother happy and proud? How do you know when to get your work done? To hope your work sets you free?**

For *Sally & Monica's Hot Tub Hangout* and *Hemings and Hawings* (2015)—in which Hemings and Lewinsky are joined in conversation by Whoopi Goldberg, Oprah Winfrey, and Marilyn Monroe, in a talk-show format—I employed video montage and mash-up techniques [Fig. 16]. Lewinsky's figure was created from footage recorded at different ages. Alternating video fragments of Goldberg and Winfrey as themselves, and also various TV and movie characters, comprised the figures on the talk-show stage. Monroe's voice and giggle were heard in the distance. Ben Affleck featured as a special guest, and one of three major talking points was the discovery of his genetic tie to slaveowners on Henry Louis Gates, Jr.'s television show, *Finding Your Roots.* The conversation was frenetic. Hemings moderated the whole time, tethering the women's many disjointed voices and selves together.

Hemings had few options and chose among evils to ensure her safety and that of her family. The *Hemings and Hawings* talk show simulates a transhistorical struggle and situates the limited options of today in restrictive female stereotypes and those voices allocated to women. The audience must judge by deciphering the truth from fragmented media, with incomplete information.

14  Marisa Williamson, *Sally & Monica's Hot Tub Hangout,* August 13, 2014, ACRE Residency, Steuben, Wisconsin.

These women spoke to my own identity: as a disaffected woman hungry for her liberation and for the liberation of all women.[15]

The subsequent phase of this project began as I questioned the demands that dominant culture places on certain people to "manage" their bodies, and what it means for a body to be managed and put to work. These inquiries evolved into an exercise session, led by Hemings, in front of a projected video collage of conventional workout videos, prison workout videos, self-defense demonstrations, and footage of labor performed as such [Fig. 17].[16]

*How do you know when to run away, and when to stay and poison the soup? How do you know when to dismantle the white supremacist patriarchy from within, bide your time, weigh your options? Map the seen. Map the unseen. Scrap the map. Revise the map. Write, revise. Write, revise. Never finish the map. Fall asleep with the map unfinished. Very tired.*

I continue to experiment with persona through writing. The following is excerpted from a current work in progress:

Here is where you are. Figure out what people like. Figure out what white people like in black people. Do they like black people who help them, who are smart but not too smart? Who can read but not too well? Black women who are soft, whose boundaries are penetrable? Whose skin is smooth, whose looks are pleasing? Black people who are good at sports, singing, making things work, helping things grow? Black people with respect, preferably more for others than themselves, respectable nonetheless in their behavior; publicly, privately, but not intimately? Black bitches who fuck your shit up, hardworking women who speak only when spoken to? Do they like asses or tits? Do they like to talk about themselves or their feelings, their thoughts or their dreams? Figure out how they like their coffee. Figure out what they look for in cover letters. Do they still take standardized tests and GPAs? You will be tested; your grade will be weighed. Are they looking to diversify? Are they looking for

15 Marisa Williamson, *Hemings and Hawings*, performance and video, first performance May 22, 2015, *Live to Tape Festival*, Links Hall, Chicago, Illinois.
16 Marisa Williamson, *Workout with Sally Hemings*, first performance October 30, 2015, Skowhegan Headquarters, New York, New York.

you to bring the pain, or take theirs out with the trash? Figure out what books they read, and what movies they watch, and which characters they identify with, and which they feel intimidated by. Write a five-paragraph essay about it. Perform with affect. Ask for it, but not too directly, dramatically, desperately, enthusiastically. Give them what they want before they know they want it. Figure out how to be useful to them and perhaps you'll find a use for yourself. Fuck. Fuck them. Get them to fuck you. Moan like you want it. Wonder if it's love. Give birth to their children, care for their seed. Hide your bitterness. Don't make that face. Bite deeply with eyes closed into the sweetest and ripest parts. Learn to love the salty, acidic taste and keep from gagging—repeat until you find a way through, out, inside, or over. Then, freedom.

**"How do you know when to run away when you don't want to be enslaved forever?"**

In my work, I attempt to make known Sally Hemings's journey by retracing her steps and in this process, I locate a space for her in the contemporary world and space for all enslaved spirits for they live on and are present in the afterlife of slavery. Through Hemings, I explore how to exist as a possession and how to exist when freedom, agency, and self-possession are imminent. Hemings's navigation of these conditions shape today's racialized landscape. Sally herself is a ghost who walks through walls, transcending the confines and structure of time.

The Sally Hemings performances are based on the facts and details of her life, which I use strategically in order to create parafiction; the establishment of Hemings—a "near white" Black woman who was born into slavery—as central, destabilizes seemingly fixed power relations and acts against the historical record.[17] Sally Hemings—not Jefferson, the master politician, unreliable narrator, and powerful man—is the focus of the story; she is moral and proper, the mother of freedmen, and the creative genius who is the enduring, powerful, radical source of my resistance.

17 *Workout with Sally Hemings* poster, Skowhegan Headquarters, New York, NY, 2015

17 Carrie Lambert-Beatty, "Make-Believe: Parafiction and Plausibility," *October* 129 (2009): 51–84. Beatty uses this term on p. 54 of the article to name a category that is related to but not a member of fiction, for it has "one foot in the field of the real."

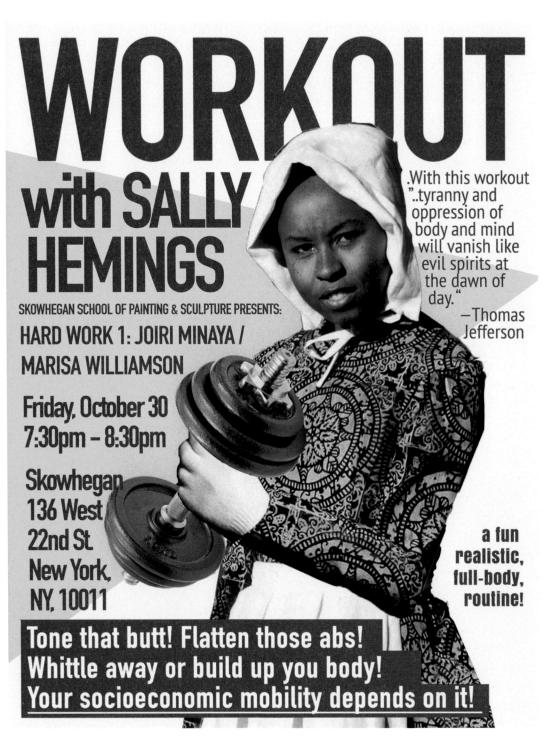

# APPENDIX

## Books

Abbott, Ira A. *The Fall of the Confederate Capitol: A Chapter of Reminiscences.* 1915.

Anderson, Benedict. *Imagined Communities: Reflections on the Origin and Spread of Nationalism.* London: Verso, 2006.

Baldwin, James. *Sonny's Blues.* New York: Penguin 60s, 2003.

Baldwin, James. "Stranger in the Village." In *James Baldwin Collected Essays.* New York: The Library of America, 1998.

Baptist, Edward E., and Ron Butler. *The Half Has Never Been Told: Slavery and the Making of American Capitalism.* New York: Basic Books, 2014.

Bartlett, John Russel. *Dictionary of Americanisms,* 2nd ed. Boston: Little, Brown and Company, 1859.

Barton, Craig Evan. *Sites of Memory: Perspectives on Architecture and Race.* New York: Princeton Architectural Press, 2001.

Bay, Mia. *The White Image in the Black Mind: African-American Ideas About White People, 1830–1925.* New York: Oxford University Press, 2000.

Bear, James A., Hamilton Wilcox Pierson, and Isaac Jefferson. *Jefferson at Monticello.* Charlottesville: University Press of Virginia, 1967.

Berlin, Ira, and Leslie M. Harris. *Slavery in New York.* New York: The New Press, 2005.

Bhabha, Homi K. "DissemiNation: Time, Narrative, and the Margins of the Modern Nation." In *Nation and Narration,* edited by Homi K. Bhabha. London: Routledge, 1990.

Bodichon, Barbara Leigh Smith, and Joseph W. Reed. *An American Diary: 1857–8.* Boston: Routledge, 2019.

Brand, Dana. *The Spectator and the City in Nineteenth-Century American Literature.* Cambridge: Cambridge University Press, 1995.

Bremer, Fredrika, and Adolph B. Benson. *America of the Fifties: Letters of Fredrika Bremer.* New York: American-Scandinavian Foundation, 1924.

Brown, David, William Williams, and Nathaniel Quincy Belcher. *Row: Trajectories through the Shotgun House.* Houston: Rice University School of Architecture, 2004.

Brown, William Wells. *Rising Son, or, the Antecedents and Advancement of the Colored Race.* Charleston: Nabu Press, 2010.

Buckingham, James Silk. *The Slave States of America.* London: Fisher, Son & Co, 1980.

Butler, Octavia E. *Kindred.* Boston: Beacon Press, 2003.

Cheng, Irene, Charles L. Davis, and Mabel O. Wilson. *Race and Modern Architecture.* Pittsburg: University of Pittsburg Press, 2020.

Chester, Thomas Morris, and R. J. M. Blackett. *Thomas Morris Chester, Black Civil War Correspondent: His Dispatches from the Virginia Front.* New York: Da Capo, 1991.

Clark, Kathleen Ann. *Defining Moments: African American Commemoration and Political Culture in the South, 1863–1913.* Chapel Hill: University of North Carolina Press, 2006.

Clay, Edward W. *Philadelphia Fashions, 1837.* New York: Henry R. Robinson, 1837.

Copeland, Huey. *Bound to Appear: Art, Slavery and the Site of Blackness in Multicultural America.* Chicago: University of Chicago Press, 2013.

Cortesi, Lawrence. *Jean duSable: Father of Chicago.* Philadelphia: Chilton Book Co., 1972.

Davis, Thadious M. *Southscapes: Geographies of Race, Region, and Literature.* Chapel Hill: University of North Carolina Press, 2014.

Deetz, James. *Small Things Considered: An Archaeology of Early American Life, 1977.* New York: Anchor Books, 1996.

DuBois, W. E. B. *The Souls of Black Folk.* New York: Millennium Publications, 2014.

DuBois, W. E. B. *John Brown,* edited by David Roediger. New York: Oxford University Press, 2007.

Eglash, Ron. *African Fractals.* New Brunswick: Rutgers University Press, 1999.

Ernest, John. *Liberation Historiography: African American Writers and the Challenge of History, 1794–1861.* Chapel Hill: University of North Carolina Press, 2005.

Fanuzzi, Robert. *Abolition's Public Sphere.* Minneapolis: University of Minnesota Press, 2003.

Farmer, Paul. *The Uses of Haiti.* Monroe: Common Courage Press, 2006.

Federal Writers' Project and Library of Congress. *Born in Slavery: Slave Narratives from the Federal Writers' Project, 1936–1938.* Washington, DC: Library of Congress, 2001.

Foster, George. *New York by Gas-Light and Other Urban Sketches,* edited by Stuart M. Blumin. Berkeley: University of California Press, 1990.

Foster, George. *New York in Slices: By an Experienced Carver.* New York: W. F. Burgess, 1849.

Franklin, John Hope. *The Emancipation Proclamation.* Wheeling: Harlan Davidson, Inc., 1995.

Franklin, John Hope. *The Free Negro in North Carolina, 1790–1860.* Chapel Hill: University of North Carolina Press, 2000.

Frohne, Andrea E. *The African Burial Ground in New York City: Memory, Spirituality, and Space.* Syracuse, NY: Syracuse University Press, 2015.

Girard, Philippe R. *Slaves Who Defeated Napoleon: Toussaint Louverture and the Haitian War of Independence, 1801–1804.* Tuscaloosa: University of Alabama Press, 2014.

Glissant, Édouard. *Caribbean Discourses: Selected Essays,* translated by J. Michael Dash. Charlottesville: University of Virginia Press, 1989.

Gooden, Mario. *Dark Space: Architecture, Representation, Black Identity.* New York: Columbia Books on Architecture and the City, 2016.

Gordon, Anna D., and Bettye Collier-Thomas. *African American Women and the Vote, 1837–1965.* Amherst: University of Massachusetts Press, 1997.

Gordon-Reed, Annette. *Thomas Jefferson and Sally Hemings: An American Controversy.* Charlottesville: University Press of Virginia, 1997.

Gordon-Reed, Annette. *The Hemingses of Monticello: An American Family.* New York: W. W. Norton, 2009.

Gottdiener, Mark, and Alexandros Ph. Lagopoulos. *The City and the Sign: An Introduction to Urban Semiotics.* New York: Columbia University Press, 1986.

Grant, Bradford. "Accommodation, Resistance and Appropriation in African American Building." In *Sites of Memory: Perspectives on Architecture and Race.* New York: Princeton Architectural Press, 2001.

Gunning, Sandra, Tera W. Hunter, and Michele Mitchell. *Dialogues of Dispersal: Gender, Sexuality and African Diasporas.* Malden: Blackwell, 2004.

Hamilton, Thomas. *The Anglo-African Magazine. v. 1– 1859–.* New York: Arno Press and New York Times, 1968.

Hartman, Saidiya V. *Scenes of Subjection: Terror, Slavery, and Self-Making in Nineteenth-Century America.* New York: Oxford University Press, 1997.

Hegel, Georg Wilhelm Friedrich. *Philosophy of History.* New York: Dover Classics, 1956.

hooks, bell. *Art on My Mind: Visual Politics.* New York: New Press, 1998.

Hunter, Marcus Anthony, and Zandria F. Robinson. *Chocolate Cities: The Black Map of American Life.* Berkeley: University of California Press, 2017.

James, C. L. R., and James Walvin. *The Black Jacobins: Toussaint L'Ouverture and the San Domingo Revolution.* London: Penguin Books, 2001.

Kelley, Wyn. *Melville's City: Literary and Urban Form in Nineteenth-Century New York.* Cambridge: Cambridge University Press, 1996.

Lankford, Nelson D. *Richmond Burning: The Last Days of the Confederate Capital.* New York: Penguin, 2003.

Lefebvre, Henri. *The Production of Space,* translated by Donald Nicholson-Smith. Oxford: Blackwell Publishing, 1991.

Lester, Julius. *To Be a Slave.* New York: Dial Press, 1968.

Levine, Robert. *Martin Delany, Frederick Douglass, and the Politics of Representative Identity.* Chapel Hill: University of North Carolina Press, 1997.

Lorde, Audre. "The Master's Tools Will Never Dismantle the Master's House." In *Sister Outsider: Essays and Speeches.* Berkeley: Crossing Press, 2007.

McKittrick, Katherine. *Demonic Grounds: Black Women and the Cartographies of Struggle.* Minneapolis: University of Minnesota Press, 2006.

McLaughlin, Jack. *Jefferson and Monticello: The Biography of a Builder.* New York: Henry Holt, 1988.

Miller, Monica L. *Slaves to Fashion: Black Dandyism and the Styling of Black Diasporic Identity.* Durham: Duke University Press, 2010.

Morrison, Toni. *Beloved.* New York: Random House, 1987.

Morrison, Toni. *Mouth Full of Blood: Essays, Speeches, Meditations.* London: Chatto & Windus, 2019.

Moten, Fred, and Stefano Harney. *The Undercommons: Fugitive Planning and Black Study.* Durham: Duke University Press, 2011.

O'Brien, John Thomas. *From Bondage to Citizenship: The Richmond Black Community, 1865–1867.* New York: Garland, 1990.

Ochieng' Nyongó, Tavia Amolo. *The Amalgamation Waltz: Race, Performance, and the Ruses of Memory.* Minneapolis: University of Minnesota Press, 2009.

Olmsted, Frederick Law. *A Journey in the Seaboard Slave States with Remarks on Their Economy.* New York: Dix & Edwards, 1856.

Peterson, Carla L. *Black Gotham: A Family History of African Americans in Nineteenth-Century New York City.* New Haven: Yale University Press, 2012.

Porter, David Dixon. *Incidents and Anecdotes of the Civil War.* New York: D. Appleton and Co., 1886.

Raboteau, Albert J. *Slave Religion: The "Invisible Institution" in the Antebellum South.* New York: Oxford University Press, 2004.

Rachleff, Peter J. *Black Labor in the South: Richmond, Virginia, 1865–1890.* Philadelphia: Temple University Press, 1984.

Rael, Patrick. *Black Identity and Black Protest in the Antebellum North.* Chapel Hill: University of North Carolina Press, 2002.

Rothstein, Richard. *The Color of Law: A Forgotten History of How Our Government Segregated America.* New York: W. W. Norton & Company, 2017.

Sharpe, Christina Elizabeth. *Monstrous Intimacies: Making Post-Slavery Subjects.* Durham: Duke University Press, 2010.

Sharpe, Christina. *In the Wake: On Blackness and Being.* Durham: Duke University Press, 2016.

Smith, Shawn Michelle. *American Archives: Gender, Race, and Class in Visual Culture.* Princeton: Princeton University Press, 1999.

Stauffer, John. *Black Hearts of Men: Radical Abolitionists and the Transformation of Race.* Cambridge, MA: Harvard University Press, 2002.

Takagi, Midori. *Rearing Wolves to Our Own Destruction: Slavery in Richmond, Virginia, 1782–1865.* Charlottesville: University Press of Virginia, 2002.

Tamarkin, Elisa. *Anglophilia: Deference, Devotion, and Antebellum America.* Chicago: University of Chicago Press, 2007.

Tarbell, Ida Minerva. *The Life of Abraham Lincoln,* vol. 2. New York: Lincoln History Society, 1907.

Thabit, Walter. *How East New York Became a Ghetto.* New York: New York University Press, 2003.

Tobin, Jacqueline L., and Raymond G. Dobard. *Hidden in Plain View: A Secret Story of Quilts and the Underground Railroad.* New York: Anchor Books, 1999.

Vitruvius. *Ten Books on Architecture.* New York: Dover Press, 1960.

Vlach, John Michael. *Back of the Big House: The Architecture of Plantation Slavery.* Chapel Hill: University of North Carolina Press, 1993.

Wade, R. C. *Slavery in the Cities: The South, 1820–1860.* London: Oxford University Press, 1967.

Wallace, Maurice O. *Constructing the Black Masculine: Identity and Ideality in African American Men's Literature and Culture, 1775–1995.* Durham: Duke University Press, 2002.

Warren, Kenneth W. *What Was African American Literature?* Cambridge, MA: Harvard University Press, 2012.

Washington, Booker T. *Up from Slavery.* New York: A. L. Burt Company, 1901.

Wellman, Judith. *Brooklyn's Promised Land: The Free Black Community of Weeksville.* New York: New York University Press, 2014.

White, Shane, and Graham White. *Stylin': African-American Expressive Culture from Its Beginnings to the Zoot Suit.* Ithaca: Cornell University Press, 1998.

Wilder, Craig Steven. *A Covenant with Color: Race and Social Power in Brooklyn.* New York: Columbia University Press, 2000.

Williams, Raymond. "Base and Superstructure in Marxist Cultural Theory." In *Problems in Materialism and Culture: Selected Essays.* London: Verso, 1997.

Wilson, Ivy G. *Specters of Democracy: Blackness and the Aesthetics of Nationalism in the Antebellum U.S.* New York: Oxford University Press, 2011.

Wilson, Ivy G. "The Brief Wondrous Life of the Anglo-African Magazine, or, Antebellum African American Editorial Practice and Its Afterlife." In *Publishing Blackness: Textual Constructions of Race Since 1850,* edited by George Hutchinson and John K. Young. Ann Arbor: University of Michigan Press, 2013.

Wilson, Mabel O. *Begin with the Past.* Washington, DC: Smithsonian Books, 2016.

### Journals

Blackwood, S. "Fugitive Obscura: Runaway Slave Portraiture and Early Photographic Technology." *American Literature* 81, no. 1 (2009).

Brown, Elsa Barkley, and Gregg D. Kimball. "Mapping the Terrain of Black Richmond." *Journal of Urban History* 21, no. 3 (March 1, 1995).

Copeland, Huey, and Frank B. Wilderson III. "Red, Black, and Blue: The National Museum of African American History and Culture and the National Museum of the American Indian." *Artforum* 56, no. 1 (September 2017).

Ferguson, Jeffrey. "Race and the Rhetoric of Resistance." *Raritan* 28, no. 1 (Summer 2008).

Lambert-Beatty, Carrie. "Make-Believe: Parafiction and Plausibility." *October* 129 (Summer 2009).

Lauster, M. "Walter Benjamin's Myth of the Flâneur." *Modern Language Review* 102 (2007).

Liebman, Bennett. "The Quest for Black Voting Rights in New York State." *Albany Government Law Review* 11 (2018).

McKittrick, Katherine. "On Plantations, Prisons, and a Black Sense of Place." *Social & Cultural Geography* 12, no. 8 (2011).

O'Brien, John T. "Reconstruction in Richmond: White Restoration and Black Protest, April–June 1865." *Virginia Magazine of History and Biography* 89, no. 3 (July 1981).

Riegl, Alois. "The Modern Cult of Monuments: Its Character and Its Origin." *Oppositions* 25 (1982).

Spillers, Hortense J. "Mama's Baby, Papa's Maybe: An American Grammar Book." In "Culture and Countermemory: The 'American' Connection." *Diacritics* 17, no. 2 (Summer, 1987).

Sweeney, Fionnghuala. "Visual Culture and Fictive Technique in Frederick Douglass's *The Heroic Slave.*" *Slavery & Abolition* 33, no. 2 (2012).

Vlach, John Michael. "The Shotgun House: An African Architectural Legacy, Part I." *Pioneer America* 8, no. 1 (January 1976).

Wilson, Victor-Emmanuel Roberto, and Jacqueline Van Baelen. "The Forgotten Eighth Wonder of the World." *Callaloo* 15, no. 3 (1992).

## Periodicals

Coates, Ta-Nehisi. "The Racist Housing Policies That Built Ferguson." *Atlantic,* October 17, 2014.

Cobb, Jelani. "Race and the Storm." *New Yorker,* August 24, 2015.

Jones, Evelia. "It's Time to Recognize Sally Hemings as a First Lady of the United States." *Los Angeles Times,* January 4, 2019.

Kully, Sadef Ali. "Does Mayor's Housing Plan Help Where It's Needed? Report Offers Complex Answers." *City Limits,* February 18, 2019.

Lerner, Jonathan. "Unearthed and Unforgotten." *Landscape Architecture Magazine,* September 9, 2014.

"Mitch Landrieu's Speech on the Removal of Confederate Monuments in New Orleans." *New York Times,* May 23, 2017.

Morrison, Toni. "'I Wanted to Carve Out a World Both Culture-Specific and Race-Free': An Essay by Toni Morrison." *Guardian,* August 9, 2019.

*New National Era,* 1871–1874.

Reitman, Janet. "U.S. Law Enforcement Failed to See the Threat of White Nationalism. Now They Don't Know How to Stop It." *New York Times Magazine,* November 3, 2018.

Shah, Haleema. "This South Carolina Cabin is Now a Crown Jewel in the Smithsonian Collections." *Smithsonian Magazine,* November 2, 2018.

Williams, Michael Paul. "Monumental Issue Goes Unresolved in Richmond." *Richmond Times-Dispatch,* October 9, 2017.

Williams, Michael Paul. "400 Years of History Doesn't Sweep Away with Rumors of War Unveiling in Richmond, But It's a Start." *Richmond Times-Dispatch,* December 10, 2019.

## Web and Other Sources

"All Monuments Must Fall: A Syllabus." Antioch College.

"Controversy over 'Silent Sam' Continues." *NPR,* December 8, 2019.

Douglass, Frederick. Papers. "Remarks at Dedication Ceremonies at the Haitian Pavilion, World's Columbian Exposition, Chicago" [1893]. Manuscripts Division, Library of Congress, Washington, DC.

Kennedy, Elizabeth. "Designing for Community Continuity." *Archpaper.com,* September 29, 2014.

Lee, Spike, dir. *Do the Right Thing.* Brooklyn, NY: 40 Acres and a Mule Filmworks, 1989.

Matsoukas, Melina, dir. *Queen & Slim.* Screenplay by Lena Waithe. Universal City, CA: Universal Pictures, 2019.

Plitt, Amy. "Domino Affordable Housing Gets 87,000 Applicants for 104 Apartments." *Curbed,* February 15, 2017.

**Jeffrey Hogrefe** is a professor of humanities and media studies, and founding coordinator of the Writing Program at the Pratt Institute School of Architecture. He is the creator of the Abolitionist Landscape Project, a cultural remapping of the Potomac River Valley. His work has received support from the Graham Foundation for Advanced Studies in the Fine Arts and the US Department of Education Fund for Improvement of Post-Secondary Education. He has been published widely by organizations that include the Modern Language Association, Association of Collegiate Schools of Architecture, Association for Study of Art of the Present, and the International Society for the Study of Surrealism. He received his bachelor of arts in critical theory from the University of California at Berkeley.

**Scott Ruff** is an adjunct associate professor of architecture at Pratt Institute and the New York Institute of Technology School of Architecture. In 2017 Ruff was honored as the Yale School of Architecture Louis I. Kahn visiting assistant professor. He is the principal of RuffWorks Studio, a research and design studio specializing in culturally informed projects and community engagement. His work has been supported by the Graham Foundation for Advanced Studies in the Fine Arts, the New York State Council of the Arts, and the Harlem School of the Arts. Ruff has received awards for diversity inclusion and community outreach from the American Institute of Architects (2013) and Association of Collegiate Schools of Architecture (2012). In 2020 Ruff's article "Gullah Geechee Institute" appeared in *Within or Without,* published by the Yale School of Architecture. He also has articles in *Thresholds,* a journal produced by the Massachusetts Institute of Technology Department of Architecture, which include "Signifying: An African-American Language to Landscape" and "Spatial 'wRapping': A Speculation on Men's Hip-Hop Fashion." Ruff received his first professional bachelor of architecture degree from Cornell University and a master's of architecture from Cornell University.

**Carrie Eastman** is a writer, designer, and educator who is the coauthor of a forthcoming book that examines the social, political, and cultural factors that contributed to the rise and fall of the urban waterfront (Oro Editions, 2020). She practices landscape architecture independently after having spent fifteen years working on large-scale public projects in and around New York City. She presently teaches courses on architectural history and urban theory for the College of Architecture, Planning and Landscape Architecture at the University of Arizona, Tucson. She has a master's degree in landscape architecture from the University of Virginia and a bachelor's degree in the history of art and architecture from Brown University.

**Ashley Simone** is a writer, photographer, and educator whose practice investigates the intersection of architecture, art, and culture. She is the editor of *A Genealogy of Modern Architecture: Comparative Critical Analysis of Built Form* (Zurich: Lars Müller Publishers, 2015), *Absurd Thinking Between Art and Design* (Zurich: Lars Müller Publishers, 2017), *Two Journeys* (Zurich: Lars Müller Publishers, 2018), and *Frank Gehry Catalogue Raisonné,* vol. 1. *1954–1978* (Paris: Cahiers d'Art, 2020). Simone is a visiting assistant professor of architecture at Pratt Institute, Brooklyn. Her work has been supported by grants from Columbia University and Pratt Institute. She holds a master's degree in architecture from the Columbia University Graduate School of Architecture, Planning and Preservation, and a bachelor of arts in economics from the College of William and Mary.

**Tina M. Campt** is a black feminist theorist of visual culture and contemporary art, and the Owen F. Walker Professor of Humanities and Modern Culture and Media at Brown University. One of the founding researchers in Black European Studies, her early work theorized gender, racial, and diasporic formation in Black communities in Europe, focusing on the role of vernacular photography in processes of historical inter-pretation. Her books include *Other Germans: Black Germans and the Politics of Race, Gender and Memory in the Third Reich* (University Michigan Press, 2004), *Image Matters: Archive, Photography and the African Diaspora in Europe* (Duke University Press, 2012), and *Listening to Images* (Duke University Press, 2017). Her recently completed book manuscript, *A Black Gaze* (MIT Press 2021), engages our contemporary moment of visualizing blackness through a series of encounters with art and with artists that challenges readers to engage in embodied practices of witnessing that center race and gender as crucial to these experiences.

**Sara Caples and Everardo Jefferson** are the founding principals at Caples Jefferson Architects. Their work demonstrates a commitment to creating architecture in communities often underserved by the design profes-sions. They began their practice approximately two decades ago with humble projects for the New York Housing Authority and the design of a preschool for children with AIDS in the Bronx. Presently, the scope of their work includes educational, community, and cultural centers for underserved neighborhoods. Notable projects by Caples Jefferson are the Weeksville Heritage Center, Heritage Health and Housing Headquarters, the Queens Theatre, The Africa Center, and the Louis Armstrong Museum Education Building.

**Radiclani Clytus** works at the intersections of new media and nineteenth-century American literature and visual culture. He has written extensively on transatlantic abolitionist imagery and is the editor of two prose compilations by poet Yusef Komunyakaa. "Committed to the Image," his most recent essay on photographer Roy DeCarava, accompanies the second edition of *The Sound I Saw: Improvisation on a Jazz Theme.* As a documentary filmmaker, Clytus has received commissions from Luhring Augustine, Steinway & Sons, and the Gullah Geechee Cultural Heritage Corridor Commission (a division of the United States National Park Service). His first film, *Looks of a Lot* (2014), premiered at the Hirshhorn National Museum of Modern Art. He is the principal of RoundO Films LLC.

**J. Yolande Daniels** is a cofounding design principal of studioSUMO in New York and founder of studioSUMO/West in Los Angeles, where she is an assistant professor of architecture at the University of Southern California. studioSUMO has received grants from the New York State Council on the Arts and New York Foundation for the Arts, including the Emerging Voices Award, the Design Vanguard Award, the League Prize, and the American Academy of Arts and Letters Architecture Award; and design excellence awards from the New York City AIA, New York State AIA, Chicago Athenaeum, German National Design Council, and Japan National Design Council. Yolande received architecture degrees from Columbia University and City College, CUNY, and has taught at universities including Columbia University, Massachusetts Institute of Technology, and Yale University. Her independent research has been supported by fellowships including the Rome Prize and Whitney Independent Study Fellowship as well as a travel grant from the AIA New York Chapter.

**Ann S. Holder** is associate professor of history at Pratt Institute. Her research focuses on the rise of Black citizenship movements in the nineteenth century, and particularly the political battles over citizenship from Emancipation through Reconstruction. She traces the complex social, sexual, and cultural dynamics that undermined legal equality—and produced extralegal barriers—for those emerging from slavery, as well as for Americans of African descent who lived as free people before the war. Her work highlights neglected communities of resistance, surfacing intellectual and political arguments for equity as well as everyday acts of defiance.

**Walis Johnson** is a Brooklyn-based artist whose work documents the poetics of the urban landscape through oral history, artist walking practices, film, and installation. Her *Red Line Archive Project* has been presented in New York City and internationally. She holds a bachelor of arts in history from Williams College and a Master of fine arts from Hunter College in integrative media and documentary film. She has taught at Parsons School of Design.

**Elizabeth J. Kennedy** is a landscape architect recognized for her work preserving culturally significant sites through creative design; achieving resiliency for these types of landscapes is paramount and to that end, employing sustainable best practices is central to Kennedy's work. A Design Trust for Public Space

research fellow, juror for the ASLA 2018 Student Awards, and a graduate of Cornell University, she leads Elizabeth Kennedy Landscape Architect, PLLC, a collaborative and interdisciplinary social justice practice noted for excellence in innovative landscape preservation, development, and management.

**Rodney Leon** is the founder and principal of Rodney Leon Architects. He is the designer of the African Burial Ground Memorial in New York City, which is the first National Monument in the United States dedicated to the contributions of people of African descent, and is also the designer of the United Nations Permanent Memorial to the Victims of Slavery and the Transatlantic Slave Trade. Leon's practice, located in New York City, focuses on culturally contextual design that emphasizes the impact of history, culture, and sustainability on the contemporary design of public space.

**Marisa Williamson** is a project-based artist who works in video, image-making, installation, and performance. She has produced site-specific works at Thomas Jefferson's Monticello, Storm King Art Center, the Metropolitan Museum of Art, University of Virginia, and by commission from the National Park Service. Her work has been featured in exhibitions in New York City, Philadelphia, Chicago, Los Angeles, and Rome. She was a 2012 participant in the Skowhegan School of Painting & Sculpture and the Whitney Museum's Independent Study Program in 2014–2015 and holds degrees from Harvard University and CalArts. Williamson is an assistant professor of media arts at the University of Hartford and she lives and works in Newark, New Jersey.

# Acknowledgments

The work that grew into this anthology began years ago and continues today as conversations persist between the contributors, their colleagues, friends and family, and the extensive list of individuals and institutions that have helped to make this publication possible. It is this extended and informal discourse that is characteristic of the varied kinds of knowledge formations that are at the foundation of African American space.

We would like to begin by thanking the Graham Foundation for Advanced Studies in the Fine Arts for endorsing the project with their prestigious publication grant. Our thanks is also extended to the Pratt Institute Faculty Development Fund for providing the seed money to develop the anthology, and to Tom Hanrahan and Harriet Harriss, who, as Deans of the School of Architecture at Pratt Institute, provided financial support alongside Arlene Keizer, Chair of the Department of Humanities and Media Studies. Without the foregoing support, a publication in this form would not have been possible.

We are grateful to Pratt faculty member Frederick Biehle, whose shared vision for the pressing topics that this anthology addresses prompted us to seek an opportunity for collaboration, which we realized through a symposium that was developed in tandem with his undergraduate architecture studio based on the Underground Railroad. Equally integral to this endeavor were Deborah Gans and Duks Koschitz, who held colloquiums for the students who performed research for the anthology: Corey Arena, Harpreet (Harry) Chadha, Jason Compere, Brenda Kang, Yeon Kyu (Andy) Kim, Li Jin, Joseph Mendoza, Akil Philip, and Massi Surratt. Special appreciation must be noted for Performance Studies scholar and poet Tracie Morris, who was integral to furthering discourse about African American space at Pratt Institute; Fred Moten, who as a visiting scholar at Pratt generously gave his time to extended talks on the topics of African American studies and love; Christina Sharpe, who introduced us to the concept of "wake work" when she visited campus to deliver a lecture at the same time plans for the symposium were being made; volume contributors Ann Holder and Marisa Williamson, who devoted time outside of their teaching schedules to a labor of love, gathering with us and Thom Donovan to strategize about both the symposium and anthology. These individuals and their expansive efforts brought together the contributors to the volume: Sara Caples, Radiclani Clytus, Yolande Daniels, Everardo Jefferson, Walis Johnson, Elizabeth Kennedy, and Rodney Leon. To each contributor, we offer our deepest gratitude and respect for possessing the courage to advocate for a discourse of individual and collective experience in the face of increasing violence toward people of color.

We owe a special thanks to Ashley Simone, who made it possible for us to produce a book with Lars Müller Publishers, and, together with co-editors Carrie Eastman and Kari Rittenbach, provided a rigorous rhetorical style for us to follow and have proved integral to refining this volume. Appreciation is also due to Barbara Miglietti for her editorial assistance organizing and maintaining a vast file of images, captions, footnotes, and bibliographies, and to Stephen Zacks, who assisted her with the final version of the bibliography. This enormous effort has allowed us to realize *In Search of African American Space* in a form that is scholarly, significant, and magnificent as an object in and of itself. We set out to produce a book with full-color images and a fine design sensibility as an antidote to anti-Black racism. With their exacting standards, Lars Müller and his design and production team, including Esther Butterworth and Maya Rüegg, have allowed us to realize so much more.

Acknowledgment must be made of serendipity: A chance meeting between the two of us at an annual meeting of the Association of Collegiate Schools of Architecture brought forward a beautiful and provocative conversation that has extended for many years. Finally, we would like to thank our closest friends and family for having faith in us, and for listening to and informing the work in indirect and unexpected ways. Included in this close circle are: Fatima Hafiz-Wahid, Onaje Muid, Richard Rosa, Nathan Williams, and our wives, Susan Weller and Denise Woodall-Ruff.

Jeffrey Hogrefe and Scott Ruff

# Image Credits

COVER
Cover art design by Integral Lars Müller, made possible by Adjaye Associates and the Smithsonian Institution
Back cover image: Courtesy of *The Advocate,* Baton Rouge, New Orleans, Acadiana/Eliot Kamenitz

FOREWORD / INTRODUCTION
1 Courtesy of The British Library
2 Courtesy of the Library of Congress/United States Work Projects Administration
3 Courtesy of the Library of Congress

THE TERRAIN OF POLITICS
1 Courtesy of the Cook Collection, Valentine Museum
2 Courtesy of Rachel Pappo
3 Courtesy of the Library of Congress/Andrew J. Russel
4 B. B. Russell & Co.
5 Courtesy of Library of Congress/Frederick W. Beers
6 Courtesy of the Valentine Museum
7 Courtesy of Cornell University, Division of Rare Manuscript Collections
8 Courtesy of the Library of Virginia
9 Courtesy of the Valentine Museum/Hathaway
10, 11 Courtesy of the Library of Virginia, General Architectural Files Collection
12 Courtesy of the Library of Congress/1958 H. I. Adams Survey
13 Elsa Barkley Brown and Gregg Kimball, "Mapping the Terrain of Black Richmond," *Journal of Urban History* 21, no. 3 (March 1995)
14 Courtesy of the Library of Congress/Alexander Gardner
15 Courtesy of *The Advocate,* Baton Rouge, New Orleans, Acadiana/Eliot Kamenitz

BLACK VISUALITY IN ANTEBELLUM NEW YORK
1–3, 8 Courtesy of the Library Company of Philadelphia
4, 5 Courtesy of the Library of Congress, Prints and Photographs Division
6 Courtesy of Driscoll Babcock, from the private collection of Henry Adams
7, 9 Courtesy of the American Antiquarian Society
10 Courtesy of the David Rumsey Map Collection at Stanford University Libraries/John F. Harrison
11 Courtesy of the American Antiquarian Society/Thomas Benecke

CULTURAL TRANSLATIONS AND TROPES OF AFRICAN AMERICAN SPACE
1–4, 18, 19 Courtesy of Alan Karchmer/NMAAHC
5 Google Maps
6 Courtesy of the Library of Congress, Prints and Photographs Division
7 Courtesy of Norm Shafer/Washington Post
8 Courtesy of Alexey Sergeev
9 Sketch by Scott Ruff
10 Courtesy of the Special Collections Research Center at NC State University Libraries
11 Courtesy of Mattia Insolera
12–17 Courtesy of the NMAAHC
20 Photograph by Scott Ruff

DIASPORIC MONUMENTS AND THE TRANSLATION OF CONTEXT
1 Courtesy of James P. Blair/Getty Images
2 Courtesy of John Seaton Callahan/Getty Images
3 Courtesy of the Library of Congress Online Catalog
4–7 Courtesy of John Bartelstone Architectural Photography
8–10, 15 Courtesy of Rodney Leon/Rodney Leon Architects
11–14 Courtesy of Alan Stevenson

WEEKSVILLE REVISITED—Heritage Center Landscape
1 Courtesy of the New York Public Library Collection
2 Frederick Van Wyck, in *Keskachauge: Or the First White Settlement on Long Island, G.P. Putnam's Sons,* 1924
3 Courtesy of the Brooklyn Public Library Collection
4 Courtesy of Elizabeth Kennedy Landscape Architect
5 Courtesy of the Weeksville Heritage Center
6 Courtesy of the Weeksville Heritage Center/Rylee Eterginoso

WEEKSVILLE REVISITED—Heritage Center Building
1 Courtesy of Caples Jefferson Architects
2 Courtesy of Elizabeth Kennedy Landscape Architect
3 Courtesy of Everardo Jefferson/Caples Jefferson Architects
4–8, 11 Courtesy of Nic Lehoux
9, 10 Courtesy of Sara Caples/Caples Jefferson Architects

EMBODIED SILENCES
1–7 Courtesy of Yolande Daniels
8 Courtesy of Sunil Bald/studioSUMO
9, 14–16 Courtesy of Yolande Daniels/studioSUMO
10–12, 17, 18, 20–22 Courtesy of studioSUMO
13 Photograph by Luke Bulman
19 MoCADA/studioSUMO/Yolande Daniels/Laura Lee,
2006. Source: UNESCO

WALKING THE GEOGRAPHY OF RACISM
1–3, 6, 7, 11, 13, 16, 17, 20–23 Courtesy of Walis Johnson
4, 5 Courtesy of the National Archives and Records
Administration
8–10, 12, 14, 15, 19, 24, 25 Courtesy of Murray Cox
18 Courtesy of the Weeksville Heritage Center

SEEKING SALLY HEMINGS
1, 2, 4, 5, 6, 11–13 Courtesy of Avery Williamson
3, 7, 8, 10, 14, 16, 17 Courtesy of Marisa Williamson
9 Courtesy of Wilmot Kidd
15 Courtesy of Harold Batista

**IN SEARCH OF AFRICAN AMERICAN SPACE**
**Redressing Racism**

Editors: Jeffrey Hogrefe, Scott Ruff,
with Carrie Eastman and Ashley Simone
Authors: Sara Caples and Everardo Jefferson, Tina M. Campt,
Radiclani Clytus, J. Yolande Daniels, Jeffrey Hogrefe,
Ann S. Holder, Walis Johnson, Elizabeth J. Kennedy,
Rodney Leon, Scott Ruff, Marisa Williamson
Editorial assistance: Barbara Miglietti
Copyediting: Kari Rittenbach
Proofreading: Keonaona Peterson
Design: Integral Lars Müller/Lars Müller and
Esther Butterworth
Production: Martina Mullis
Lithography: prints professional, Berlin, Germany
Printing and binding: DZA Druckerei zu Altenburg, Germany
Paper: Profibulk 1.3, 135 gsm

Lars Müller Publishers is supported by the Swiss Federal
Office of Culture with a structural contribution for the years
2016–2020.

Lars Müller Publishers
Zürich, Switzerland
www.lars-mueller-publishers.com

ISBN 978-3-03778-633-8

Distributed in North America by ARTBOOK | D.A.P.
www.artbook.com

Printed in Germany